The Selma Erving Collection

Nineteenth and Twentieth Century Prints

Published by the Smith College Museum of Art, Northampton, Massachusetts, with the aid of funds provided by The National Endowment for the Arts, Washington, D.C., a federal agency. Additional funds provided by the Maxine Weil Kunstadter '24 Fund, Mrs. James E. Pollak (Mabel Brown '27), Mrs. William A. Evans, Jr. (Charlotte Cushman '29), and the Museum Members.

Printed in the United States of America by The Studley Press, Dalton, Massachusetts.

ISBN 0-87391-036-2

Library of Congress Catalog Card Number: 85-080045

Photographer: David Stansbury

Cover: Edouard Vuillard, *Jeux d'enfants,* cat. 253.

The Selma Erving Collection

Nineteenth and Twentieth Century Prints

Essays by Charles Chetham
and Elizabeth Mongan

CATALOGUE PREPARED BY COLLES BAXTER,
SARAH ULEN HENDERSON, LESLIE MITCHELL,
ELIZABETH MONGAN, LINDA MUEHLIG,
NANCY SOJKA, CHRISTINE SWENSON, AND
MARILYN SYMMES; EDITED BY NANCY SOJKA
AND CHRISTINE SWENSON

Smith College Museum of Art

Northampton, Massachusetts 1985

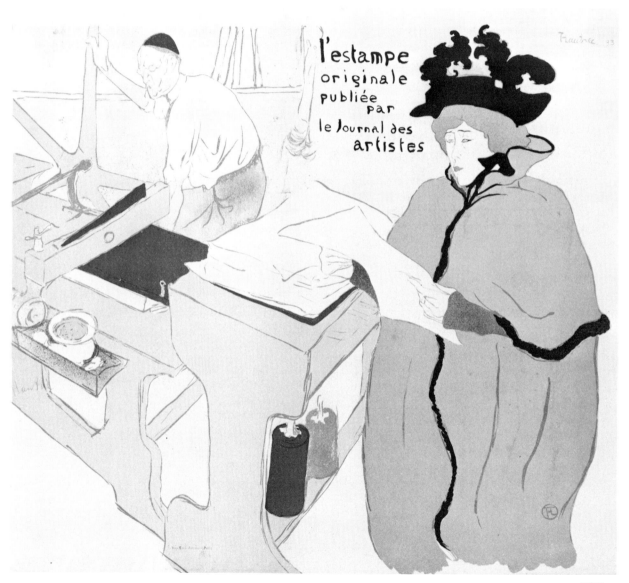

Selma Erving (1906-80) and the Print Room

One winter's afternoon in 1965 I received a telephone call from a Miss Erving of West Hartford. She mentioned that she was a member of the Class of 1927 and had for a number of years been collecting modern prints and drawings. She believed that some of them might need conservation. Could I recommend a conservator? I suggested that she get in touch with Christa Gaehde of Arlington, Massachusetts, one of the best private paper conservators in this country and indeed in Western Europe. Miss Erving thanked me. I made a mental note to visit her.

A month or so later, at dinner in the home of Joachim and Christa Gaehde, Christa said that she had visited Miss Erving and had been overwhelmed by what she had seen. Wasn't Smith lucky to have such a perceptive alumna, and wasn't I lucky to have an alumna who thought so well of the Museum? Sheepishly, I admitted that I did not know Miss Erving apart from our single conversation and that I did not know her collection.

The next day I telephoned Miss Erving. I repeated Christa's remarks to her and asked if I might call on her to introduce myself and to see her collection. She was extremely cordial and as I was soon to realize she was a kind, gentle woman, very shy but full of love and courage. She was capable of the keenest perceptions about quality in art and quality in people.

The Victorian house stood a distance from the street and was surrounded by lawns, great trees and gardens. Next to it some 300 yards away was a second, similar house, the home of her brother Dr. Henry Erving. After passing through a darkened hallway I was shown into the light-filled living room. The walls were covered with prints and drawings of a splendor that came as a considerable shock. Above the mantel hung a painting which had come into the family literally by chance. Her maternal grandfater, a Norwegian who was at one time Vice-Consul for Norway and Sweden in Boston, as a young man belonged to a professional club in Oslo. On a regular basis members could buy chances on works of art by local artists. One day, having won the week's raffle, Gjert Lootz (d. 1919) carried home an oil painting on paper by the then unknown Edvard Munch!

During the visit and on later occasions, her conversation and her collection revealed that Miss Erving was a perfectionist, albeit a gentle one. Her concern for quality had led her to collect rare and beautiful objects, and to learn to care for them according to the highest professional standards—thus her interest in discovering the best conservator available. Although she was extremely self-effacing one was still apt to learn interesting personal facts in the course of some casual conversation. Her interest in art was bred in the family. Her grandfather, Henry Wood Erving (1851-1941), had been one of the earliest collectors of American furniture. Wallace Nutting recognized Erving's more than sixty year activity by dedicating his *Furniture Treasury* to him. Although a banker his entire life, he found time to pursue a wide range of interests, among them the authorship of publications on banking, American furniture, and even the discovery of anesthesia. Miss Erving's father, William Gage Erving (1877-1923), her mother, Emma Lootz Erving (1875-1955) and her brother Henry William Erving (b. 1909), were each medical doctors who, variously, collected oriental, Pre-Columbian, European and American art. William Gage Erving's life was not without adventure. In 1911, for example, he accompanied Hiram Bingham as surgeon and assistant naturalist on the Yale University Peruvian Expedition, on which Bingham discovered the Incan city of Machu Picchu. Her father and mother had been classmates at Johns Hopkins Medical School which was at the beginning of this century one of the few such institutions in the country to accept women for training. Another of Emma Lootz's classmates was Gertrude Stein. Although Stein dropped out of Hopkins she and Emma Lootz remained friends and

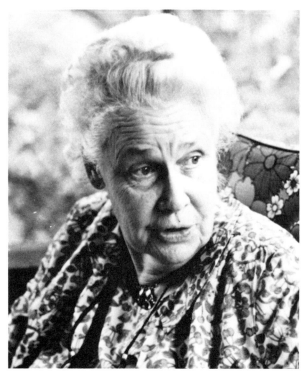

Selma Erving, from a photograph by Mrs. John C. White

carried on a correspondence that lasted for many years.

More than anything, Miss Erving wanted to be a doctor. Following her graduation from Smith in 1927, she began studying medicine at Johns Hopkins, but in the summer following her first year she developed tuberculosis. With this illness that made her at times an invalid, her plans for a medical career had to be abandoned. Many years were spent simply coping with her debility, but a mind as rich and active as hers needed an outlet. Her family's interest in art certainly indicated a direction for her energies.

In time she focussed her attention on prints and drawings and further specialized in finding prints, drawings and illustrated books of the late 19th and early 20th centuries, many related to one another. In this she sought the advice of several people, among them the Swiss dealer and framer Jon Wyss, then living in West Hartford. When her health permitted she would journey to Boston or to New York to study possible additions. At times she was able to travel to Europe, and particularly to Norway, which she loved. At other times she would buy from auction catalogues or from travelling dealers who would bring prints to her. The collection which she would give to Smith grew to 100 illustrated books, 540 prints and 74 drawings, or a total of 724 items.

In the early 1960s Smith College announced its plan to build a new Museum building. At that time it was impossible to study either our print or drawing collections, both of which contained works of considerable importance. Stored in solander boxes, one sitting on the other, floor to ceiling, the collection was for the most part inaccessible. Furthermore, with a staff of only three persons, there were no specialists to study the collection and to separate the wheat from the chaff.

My own interest in works of art on paper grew out of many experiences, among them more than a year of graduate work in Amsterdam in the Print Room of the Rijksmuseum, studying prints and drawings from all periods, and in the Drawing Room of the Stedelijk Museum, studying 19th and 20th century drawings for a doctoral thesis. Later I conducted a seminar on 19th century drawings at the University of Michigan. After coming to Smith in 1962 I gave a lecture course in prints and a seminar in drawings because no such courses were then being given. I hoped that in the future the College would see the value of study from actual objects. Furthermore, the Museum was ideally equipped to foster this kind of education. In the intervening years as the Museum grew, a number of distinguished print and drawing curators, some beginning their careers, some at the height of their careers, worked at the Museum. The first was Michael Wentworth (1968-70), who assisted in the print seminar. Mr. Wentworth has recently published a distinguished book on the artist James Tissot (Michael Wentworth, *James Tissot*, Oxford, 1984), a study which he began when he was in his early teens. He was followed in 1970 by Elizabeth Mongan, the Museum's first specialist in prints. Although she had retired from the Curatorship of Prints at the National Gallery, I

persuaded her to come to our new Museum to help set the standards and routines for our new Print Room. Miss Mongan, who served as our Curator of Prints and Drawings from 1970 to 1975, was awarded a well-deserved honorary degree by Smith College in May of 1985. She has written a memoir of Miss Erving which follows this note. Miss Mongan was assisted by Marilyn Symmes, then a National Endowment for the Arts Intern from the University of Michigan and now Curator of Graphic Arts at The Toledo Museum of Art. Colles Baxter, who had been in the Print Room at the Fogg Art Museum, Harvard University, followed Miss Mongan and in time Christine Swenson succeeded her. Miss Swenson, now Associate Curator, had been an NEA Intern at our Museum and had had training in

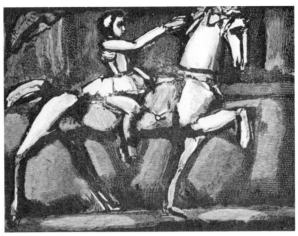

(173)

The Art Institute of Chicago's Department of Prints and Drawings under Harold Joachim. She is at present assisted by Ann Sievers who had worked at the drawing cabinet of the Uffizi and in the Education Department of the Museum of Fine Arts, Boston, and by Nancy Sojka, our current NEA Intern.

In 1966 Mrs. Roger Williams Bennett (Margaret Goldthwait '21), who was then our Chair, and I invited Miss Erving to join the Museum's Visiting Committee. Early in our association Miss Erving told me that her collection would one day come to Smith and she followed and advised with keen interest the development of the plans for the Print Room and for its staff. The promise of her collection allowed me to argue successfully for a very substantial Print Room, one in which students and scholars could study as easily as security allowed. The plan became a reality when Priscilla Cunningham and her father, the late Charles C. Cunningham, donated funds for the room in memory of Eleanor Lamont Cunningham ('32). To this day Priscilla Cunningham ('58) remains a generous donor to the Print Room, as she is to other goals of the Museum and of the College.

When the Museum opened in 1972 Elizabeth Mongan was already teaching a seminar in prints to a number of fortunate students, many of whom have

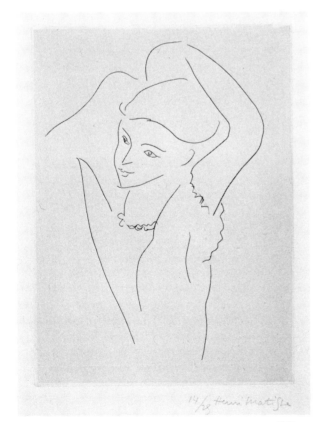

(89)

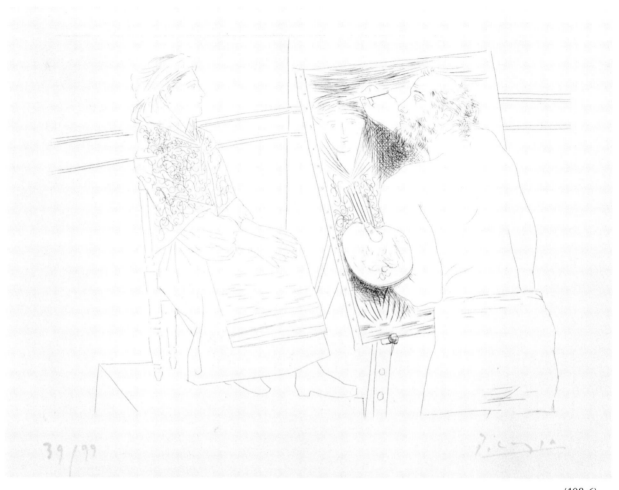

39/99

(108:6)

made substantial careers in the arts. She did this for five years during which time she regularly held exhibitions of prints and drawings.

In 1972 Miss Erving also made the first major gift to the Museum which Miss Mongan and Miss Swenson describe in their notes. Miss Mongan and Marilyn Symmes began to catalogue the prints immediately. Within the next few years John Lancaster, who subsequently became Keeper of Special Collections at Amherst, and other staff members, began to catalogue the illustrated books. Although these were received

after the first group of prints they were the first works to be published. They formed the first volume of a projected three volume set (*The Selma Erving collection: modern illustrated books,* Smith College Museum of Art, 1977). Our colleague Ruth Mortimer, Curator of Rare Books and Assistant Librarian in the Smith College Library, wrote its introduction. The present publication is the second volume. The third publication will catalogue the drawing collection.

A handsome installation of the illustrated books became the focus of the Members Day celebration of

May 1977. On that day Hyatt Mayor, then a member of the Museum's Visiting Committee and Curator of Prints at the Metropolitan Museum, delivered a lecture on the collection. He described these as among the most beautiful, tasteful and sensitive selections he knew and congratulated Smith on its good fortune.

At my request the retiring President Thomas Corwin Mendenhall (1959-1975) and the new President, Jill Ker Conway (1975-1985), agreed that the print exhibition gallery should be named in honor of Selma Erving on the occasion of the publication of the first Erving catalogue. Miss Erving was deeply touched, but she was willing to come to Hyatt Mayor's lecture and the gallery's dedication only on the condition that no one call attention to her. On that day, in the presence of hundreds, accompanied by her brother, Dr. Henry Erving, and her close friends, Dr. Agnes Wilson and Jean Wilson, she stood virtually unnoticed near the back of the gallery and listened to the dedication.

In 1977 Miss Erving invited members of the Museum's curatorial staff to begin the cataloguing of her drawing collection, and for a period of days several of us photographed the drawings and took notes about them in the West Hartford house.

Although her health was always precarious, we were nevertheless stunned the day we learned of her passing. Betsy Jones, Associate Director of this Museum, and I journeyed to West Hartford for the last time to a memorial service which was held in Miss Erving's house in rooms alive with her drawings and prints. The house was filled with friends and relatives. Although she had been obliged to spend her life under the burden of poor health, she had touched a great many people by her goodness, her wisdom and her generosity. Members of the Museum staff, Elizabeth Mongan, who became a close friend and whom Miss Erving profoundly admired, Marilyn Symmes, Colles Baxter, Christine Swenson, and myself feel our lives were enriched simply by having had the opportunity to know her.

The gift she made to the College is one of the greatest the Museum has ever received. For the years to come students who use Miss Erving's collection will

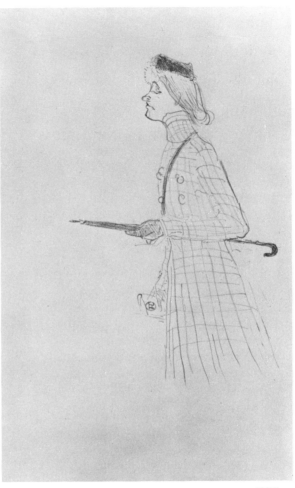

(196)

make contact through it with a rare and unusual spirit, and, perhaps without knowing it, will be guided to the perception of great quality. If they learn about the person they will realize that her life was an affirmation of the highest aims of the College. She proved that intelligence and talent can find another objective and excel in it when a desired goal cannot be realized.

CHARLES CHETHAM
Director

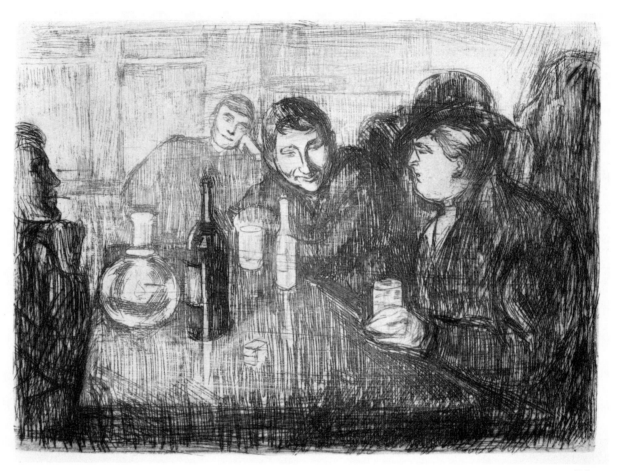

(94)

A Reticent Collector

Charles Chetham has asked me to write a short memoir of Selma Erving as I came to know her during my years at the Smith College Museum of Art. It was at his suggestion that I first went to see her at West Hartford, Connecticut. Her red brick house was set well back from the street. Inside the entrance to the right was a music room filled with plants; to the left, a charming sitting room with a large landscape, an oil by Edvard Munch, hung over the fireplace. Everywhere there were drawings and prints. After a little tour of the house (her grandfather collected 18th-century furniture, her mother owned Pre-Columbian artifacts) we went into the dining room where we had tea. We talked about books, prints and drawings. Never at that time nor during many later visits did we talk about personalities, the usual gossip of collectors and dealers.

In the fall of 1972 I had a telephone call from Selma Erving. She asked if I were free for lunch. On the way back from the Faculty Club, she said in a casual way, "I have a surprise in my station wagon." We unloaded nine new solander boxes and took them up to the Print Room. There as we opened the boxes and laid their contents on tables were prints by Gauguin, Manet, Degas, Toulouse-Lautrec, Matisse, Klee and Picasso. All were on rag mats, impeccably conserved, but not restored. They were to be a gift to the College for teaching and publication.

When Miss Erving graduated from Smith College in 1927 she had been accepted by Johns Hopkins University to work for a degree in medicine. Subsequently she developed tuberculosis. She decided to find a facet of collecting that her frail health might permit. She was blessed with mind and imagination. Her first purchases were colored reproductions of French Impressionist and Post-Impressionist painters. Mr. Jon Wyss, a Swiss citizen, was at that time in charge of the firm of Raymond & Raymond at the Hartford branch. He became a friend. Very soon, under his guidance she began to acquire a few original prints by the painters she admired, Manet, Toulouse-Lautrec and Renoir. As her interest grew, so also did a definite personal taste. She formed a working library and began to follow closely auction sales both at home and abroad. All this was done very quietly with a growing surety of course. A flair for the unusual and a predilection for a poetic image are evident in the collection.

Very few donors have the satisfaction of seeing their gifts used as they intended. My last spring at Smith I asked Selma to come and talk to my senior seminar. The students had mounted an exhibition selected from her gift. Her first reaction was predictable. "I will come, but I will not talk." My fondest memory: Selma seated at a table with eighteen students; she was smiling and talking.

ELIZABETH MONGAN
Curator Emeritus

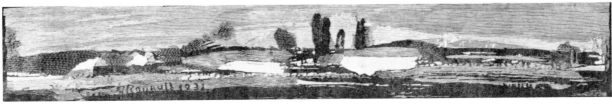

Acknowledgments

As Selma Erving intended, her collection of prints, drawings and modern illustrated books has indeed been a resource for study and enjoyment. Those who have used her print collection, whether for classes, exhibitions, research or for personal enjoyment, have in some way contributed to this catalogue. As a result, it is a catalogue that has grown and changed throughout the years since Elizabeth Mongan, then Curator of Prints and Drawings at the Museum, and Marilyn Symmes, a National Endowment for the Arts Intern at Smith and now Curator of Graphic Arts at The Toledo Museum of Art, initiated the project in 1972. In that year Miss Erving made her first major contribution of works of art to the Museum, presenting a selection of her collection to the Museum's new Print Room named in honor of Eleanor Lamont Cunningham, Class of 1932. This gift of 143 prints by Degas, Gauguin, Matisse, Munch and Villon, among others, had been preceded by two smaller, but no less remarkable, gifts of prints by Rouault and Picasso in 1969 and 1970. Equally impressive additions to the Museum's collection followed in 1975, 1976 and 1978, including more prints by Bonnard, Redon, Toulouse-Lautrec and Vuillard. With each new gift Miss Erving endowed the Museum with unusual and, in many cases, exceedingly rare prints, all in superb condition. Miss Mongan and Miss Symmes compiled a catalogue of the first three gifts and thereby established the foundation for the project that developed. Everyone who has worked on the catalogue is indebted to their efforts and the standards they set. After Miss Mongan retired in 1975, Colles Baxter was appointed Assistant Curator of Prints and Drawings and assumed the responsibility for carrying on the catalogue. Linda Muehlig and Sarah Ulen Henderson, then our National Endowment for the Arts Interns and now, respectively, Assistant Curator of Painting and Sculpture at Smith and Registrar at the Albright-Knox Art Gallery in Buffalo, assisted Miss Baxter in documenting Miss Erving's later gifts. Dur-ing the last decade and a half many Smith students have researched the prints, both as part of their class work and as work study assignments in the Print Room. They all deserve credit for their hard work and insights, but Leslie March Mitchell, Class of 1984, made particular use of the collection in a way that would have greatly pleased Miss Erving. For her Senior Special Studies Mrs. Mitchell studied the entire collection, prepared selected catalogue entries and assisted with the 1984 exhibition of the prints.

The Museum was awarded a National Endowment for the Arts grant which has provided the means and impetus to complete and publish the catalogue. This writer and Nancy Sojka, the current Endowment Intern, assembled the material prepared over the years, updated it and elaborated it. We could not have completed the work without the generous advice and assistance of many friends and colleagues to whom we are deeply grateful. Recognition is due John Lancaster, Head, Special Collections and Archives, Amherst College Library, and Charles Chetham, Director of this Museum, for their design of the catalogue, *The Selma Erving collection: modern illustrated books* (1977), the first of a projected three volume publication of Miss Erving's collection. This second volume follows that design and was executed by Jonathon Nix of Studley Press with the advice of the writer, Mr. Chetham and the Museum's Associate Director, Betsy Jones. Ruth Mortimer, Curator of Rare Books, Smith College Library, deserves special thanks for her wise counsel on many matters. In addition, we are indebted to the following individuals and gratefully acknowledge their assistance: Phillip Dennis Cate, Director, The Jane Voorhees Zimmerli Art Museum, Rutgers University; Richard S. Field, Curator of Drawings, Prints and Photographs, Yale University Art Gallery; Eleanor S. Garvey, Curator, Department of Printing and Graphic Arts, Harvard College Library; Lucien Goldschmidt; Steven Kern, Assistant Curator/Exhibitions, Museum

of Fine Arts, Springfield; Suzanne F. McCullagh, Associate Curator, Department of Prints and Drawings, The Art Institute of Chicago; Sue Welsh Reed, Assistant Curator, Department of Prints, Drawings and Photographs, Museum of Fine Arts, Boston; Nesta Spink; and, of course, Miss Mongan and Miss Symmes whose continued interest and support have been invaluable. The photograph of Miss Erving that appears in Mr. Chetham's essay was kindly supplied by Mrs. John C. White (Leslie Winslow, Class of 1927) who allowed us to copy her informal portrait of a friend for this catalogue. Finally, we express sincere thanks to Kathryn Woo, Assistant Director for Administration, and Betsy Jones for their generous help throughout the project; to Michael Goodison, the Museum's Archivist, and Linda Muehlig for their conscientious scrutiny of all the material; and to Drusilla Kuschka, Secretarial Assistant, for patiently typing and retyping the manuscript.

CHRISTINE SWENSON
Associate Curator of Prints and Drawings

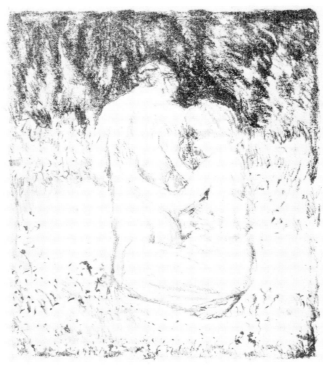

(16)

This is the catalogue of Selma Erving's collection of prints. Two books not listed in the 1977 catalogue of her collection of modern illustrated books are described following the presentation of the prints. A third volume will document the drawings from Miss Erving's collection.

The catalogue is arranged alphabetically by artist with prints listed chronologically. One catalogue number is given for each print. In the case of portfolios and complete suites, one number is given to the portfolio or suite and the individual prints are given part numbers. Titles are taken from the standard catalogue raisonné for each artist. Dimensions are given in centimeters and inches, height preceding width. Measurements are given for plate marks (engravings and etchings) or image area (lithographs and woodcuts) and for the sheet. When known, the printer, publisher and edition size are provided for each print.

The following short forms are used for frequently cited references:

Garvey, *Artist and the book*
> Garvey, Eleanor. *The artist and the book 1860-1960 in Western Europe and the United States* [exh. cat.]. Boston, Museum of Fine Arts; Cambridge, Harvard College Library, 1961 (rev. ed., Boston [1972]).

Lugt
> Lugt, Frits. *Les marques de collections de dessins et d'estampes*. Amsterdam, 1921.

Lugt, *Suppl.*
> Lugt, Frits. *Les marques de collections de dessins et d'estampes. Supplement*. The Hague, 1956.

SCMA, *Modern illustrated books*
> Northampton, Smith College Museum of Art. *The Selma Erving collection: modern illustrated books* [exh. cat.]. Northampton, 1977.

Other references abbreviated in the entries are given in full in the selected bibliography for each artist.

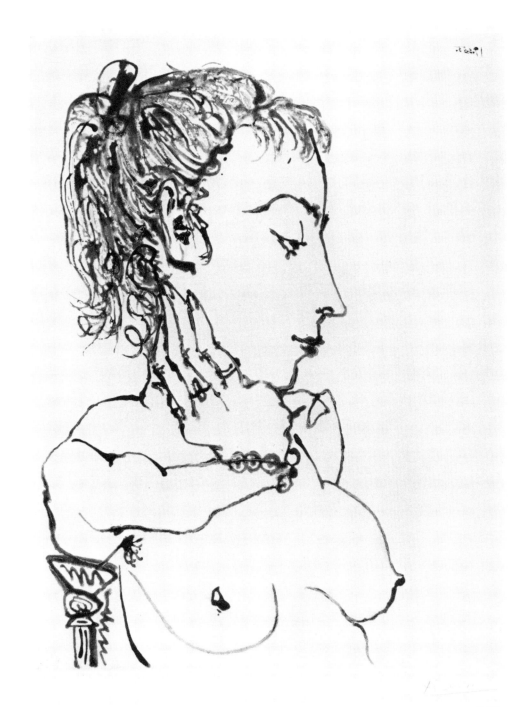

(128)

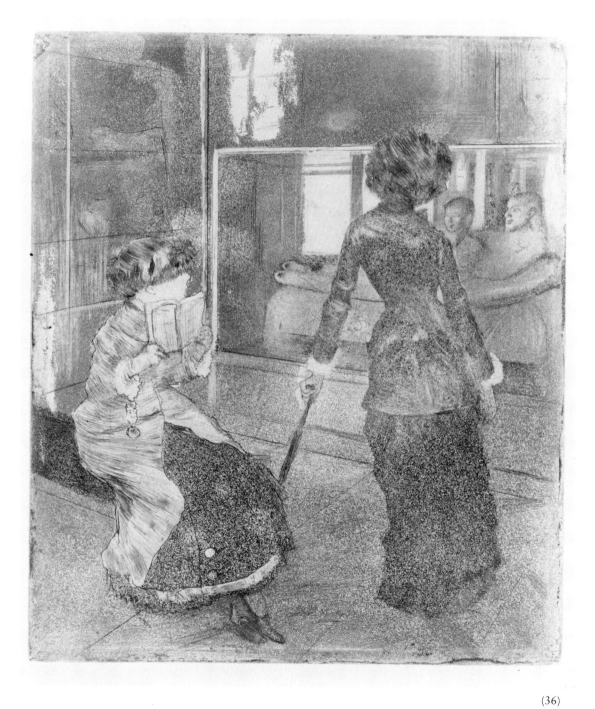

(36)

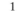

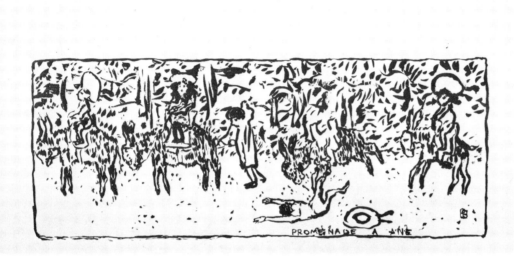

(1)

Pierre Bonnard 1867 – 1947

(1)

PROMENADE À ÂNE, ca. 1893

For Claude Terrasse, *Petites scènes familières pour piano*

Lithograph printed in black on china paper, proof before music

Image: 3⁹⁄₁₆ x 9¼ inches (90 x 235 mm)

Sheet: 7 x 13⁵⁄₁₆ inches (177 x 338 mm)

Monogrammed in red ink, u.r.; initialed on the stone, l.r.: PB; titled on the stone, l.r.: PROMENADE A ANE

Printer: M. Fleurot, Paris

Publisher: E. Fromont, Paris

Edition: 20 monogrammed proofs on china paper and an unspecified published edition

Ref.: Roger-Marx 16; Bouvet 16; Garvey, *Artist and the book*, 25 (*Petites scènes familières pour piano*)

1976:18-15

Note: see SCMA, Modern illustrated books, *no. 3* (Petites scènes familières pour piano)

(2)

LES CHIENS, 1893

For the journal *L'Escarmouche*

Transfer lithograph printed in brownish-black ink on wove paper

Image: 14³⁄₈ x 10¼ inches (365 x 260 mm)

Sheet: 15¹⁄₁₆ x 11 inches (382 x 280 mm)

Signed and numbered in pencil, l.l.: 16 PBonnard; initialed on the stone, l.l.: PB

Printer: Eugène Verneau, Paris

Publisher: Georges Darien, Paris

Edition: 120 impressions (100 signed and numbered on

wove paper, 20 on japan paper); reproduced in *L'Escarmouche,* no. 5, 10 December 1893

Ref.: Roger-Marx 25; Bouvet 25

1976:18-2

(2)

(3)

GARDE MUNICIPAL, 1893

For the journal *L'Escarmouche*

Transfer lithograph printed in brownish-black ink on wove paper

Image: 10¼ x 6¾ inches (260 x 171 mm)

Sheet: 15 1/16 x 11⅛ inches (383 x 282 mm)

Signed and numbered in pencil, l.l.: n 12/PBonnard; initialed on the stone, l.l.: PB; blind stamp, l.r.: LIBRERIA PRANDI REGGIO E

Printer: Eugène Verneau, Paris

Publisher: Georges Darien, Paris

Edition: 120 impressions (100 signed and numbered on wove paper, 20 on japan paper); reproduced in *L'Escarmouche,* no. 8, 31 December 1893

Ref.: Roger-Marx 26; Bouvet 26

1976:18-9

(4)

JEUNE FEMME AUX BAS NOIRS, 1893

For the journal *L'Escarmouche*

Transfer lithograph printed in brownish-black ink on wove paper

Image: 11 5/16 x 5 inches (287 x 127 mm)

Sheet: 14 15/16 x 11⅛ inches (380 x 281 mm)

Signed and numbered in pencil, l.l.: no 12 PBonnard; initialed on the stone, l.r.: PB

Printer: Eugène Verneau, Paris

Publisher: Georges Darien, Paris

Edition: 120 impressions (100 signed and numbered on wove paper, 20 on japan paper; also some known on dark blue paper); reproduced in *L'Escarmouche,* no. 2 (second year), 14 January 1894

Ref.: Roger-Marx 27 (*Femme en chemise,* 1894); Bouvet 27

1976:18-8

(5)

CONVERSATION, 1893

For the journal *L'Escarmouche*

Lithograph printed in brownish-black ink on wove
paper

Image: 11¾ x 9¾ inches (297 x 248 mm)

Sheet: 15⅜ x 11¹⁄₁₆ inches (391 x 281 mm)

Signed and numbered in pencil, l.l.: no. 36 PBonnard

Printer: Eugène Verneau, Paris

Publisher: Georges Darien, Paris

Edition: 120 impressions (100 signed and numbered on
wove paper, 20 on japan paper); intended to be repro-
duced in *L'Escarmouche* but never issued

Ref.: Roger-Marx 28; Bouvet 28

1976:18-14

(6)

LA REVUE BLANCHE, 1894

Poster for *La revue blanche*

Lithograph printed in four colors on wove paper

Image: 29¹¹⁄₁₆ x 22⅞ inches (754 x 581 mm)

Sheet: 31¼ x 23⅛ inches (793 x 586 mm)

Signed and dated on the stone, ctr.l.: PBonnard / 94

Printer: Edw. Ancourt, Paris

Ref.: Roger-Marx 32; Bouvet 30

1984:10-67

(7)

SALON DES CENT, 1896

Poster for the twenty-third group exhibition of the Salon
des Cent, 31 rue Bonaparte, August – September 1896

Lithograph printed in three colors on wove paper

Image: 22½ x 15⅜ inches (571 x 391 mm)

Sheet: 24¼ x 17½ inches (616 x 445 mm)

Initialed and dated on the stone, l.r.: PB aout –
septembre 1896

Printer: Chaix (Ateliers Chéret), Paris

Publisher: La plume

Ref.: Roger-Marx 45; Bouvet 39

1984:10-68

(4)

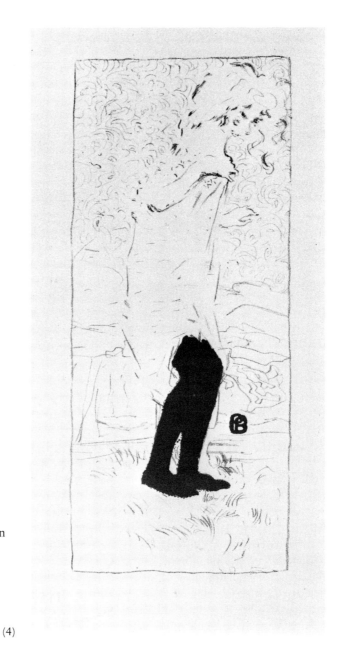

(8)

L' ALBUM D'ESTAMPES ORIGINALES DE LA GALERIE
VOLLARD, 1897

Cover/title page for Ambroise Vollard's second album

Lithograph printed in four colors on china paper

Image: 22¹³⁄₁₆ x 34 inches (580 x 865 mm)

Sheet: 27⅛ x 36⅛ inches (702 x 919 mm)

Signed in pencil, l.l.: PBonnard; initialed on the stone, ctr.: PB

Printer: Auguste Clot, Paris

Publisher: Ambroise Vollard, Paris

Edition: 100 impressions

Ref.: Roger-Marx 41; Bouvet 41

1984:10-66

(9)

LE CANOTAGE, 1897

For *L'Album d'estampes originales de la Galerie Vollard*

Lithograph printed in four colors on china paper
Image: 10⁵⁄₁₆ x 18⅝ inches (263 x 474 mm)
Sheet: 16 x 21⅜ inches (406 x 543 mm)
Signed in pencil, l.l.: PBonnard

Printer: Auguste Clot, Paris

Publisher: Ambroise Vollard, Paris

Edition: 100 impressions (some trial proofs printed in black)

Ref.: Roger-Marx 44; Bouvet 42

1978:1-2

(10)

LA COMPLAINTE DE M. BENOIT, 1898

Sheet music with cover by Bonnard for a song in the Répertoire des pantins, music by Claude Terrasse, lyrics by Franc-Nohain

Transfer lithograph printed in black on wove paper
Image: 11⅞ x 9⅛ inches (301 x 232 mm)
Sheet: 13¾ x 10¾ inches (349 x 272 mm)

Publisher: *Mercure de France* for Répertoire des pantins, Paris

Ref.: Roger-Marx 49; Bouvet 46

1976:18-3

Note: The Théâtre des Pantins was a puppet theater founded by Alfred Jarry, Franc-Nohain and Claude Terrasse. Bonnard lithographed six sheet music covers for songs by Franc-Nohain. He also worked with the group in making the marionettes.

(11)

QUELQUES ASPECTS DE LA VIE DE PARIS, 1899

Suite of twelve transfer lithographs printed in color on wove paper and cover/title page printed on china paper

Printer: Auguste Clot, Paris

Publisher: Ambroise Vollard, Paris

Edition: 100 impressions (some trial proofs printed in black)

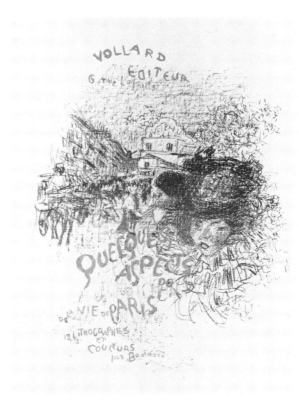

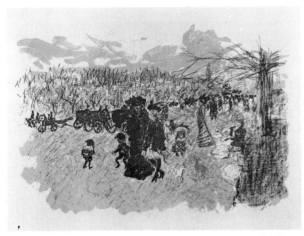

(11:2)

11:4 MAISON DANS LA COUR
Transfer lithograph printed in four colors on wove paper
Image: 13¾ x 10³⁄₁₆ inches (349 x 258 mm)
Sheet: 21⅛ x 16 inches (536 x 406 mm)
Signed and numbered in pencil, l.r.: No 58 / PBonnard
Ref.: Roger-Marx 59; Bouvet 61
1978:1-7

Note: Some years after publication a few complete suites were returned to Bonnard who then signed each individual print and again released them for sale. Nos. 11:4, 11:6, and 11:11 in this collection come from such sets.

11:1 COVER/TITLE PAGE
Transfer lithograph printed in two colors on china paper
Image: 16¼ x 13¼ inches (413 x 337 mm)
Sheet: 21⅛ x 16 inches (535 x 406 mm)
Provenance: E. Laffon (Lugt, *Suppl.*, 877ª)
Ref.: Roger-Marx 56; Bouvet 58
1978:1-4

11:2 AVENUE DU BOIS
Transfer lithograph printed in five colors on wove paper
Image: 12⅜ x 18 inches (314 x 458 mm)
Sheet: 16⅛ x 20¹³⁄₁₆ inches (410 x 529 mm)
Provenance: E. Laffon (Lugt, *Suppl.*, 877ª)
Ref.: Roger-Marx 57; Bouvet 59
1978:1-5

11:3 COIN DE RUE
Transfer lithograph printed in four colors on wove paper
Image: 10¾ x 13½ inches (272 x 342 mm)
Sheet: 16 x 20⅞ inches (406 x 530 mm)
Ref.: Roger-Marx 58; Bouvet 60
1978:1-6

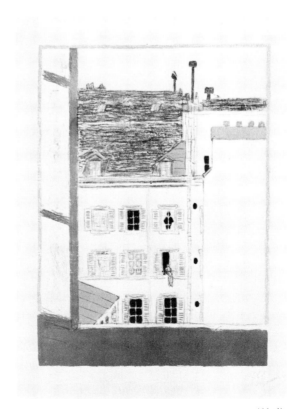

(11:4)

11:5 RUE VUE D'EN HAUT

Transfer lithograph printed in three colors on wove paper

Image: 14⁷⁄₁₆ x 8¹⁵⁄₁₆ inches (368 x 228 mm)

Sheet: 20⁷⁄₈ x 15⁷⁄₈ inches (531 x 403 mm)

Ref.: Roger-Marx 60; Bouvet 62

1978:1-8

11:6 BOULEVARD

Transfer lithograph printed in four colors on wove paper

Image: 6⁷⁄₈ x 17⅛ inches (175 x 436 mm)

Sheet: 14⅛ x 20⁷⁄₈ inches (359 x 531 mm)

Signed and numbered in pencil, l.r.: no 9 PBonnard

Ref.: Roger-Marx 61; Bouvet 63

1978:1-9

11:7 PLACE LE SOIR

Transfer lithograph printed in four colors on wove paper

Image: 10⁷⁄₈ x 15 inches (276 x 381 mm)

Sheet: 15⁷⁄₈ x 21 inches (403 x 534 mm)

Ref.: Roger-Marx 62; Bouvet 64

1978:1-10

11:8 MARCHAND DES QUATRE-SAISONS

Transfer lithograph printed in five colors on wove paper

Image: 11⅜ x 13¼ inches (288 x 337 mm)

Sheet: 16¹⁄₁₆ x 20⁷⁄₈ inches (408 x 531 mm)

Ref.: Roger-Marx 63; Bouvet 65

1978:1-11

11:9 LE PONT

Transfer lithograph printed in four colors on wove paper

Image: 10¼ x 16 inches (261 x 406 mm)

Sheet: 16 x 20¾ inches (406 x 527 mm)

Ref.: Roger-Marx 64 *(Le Pont des Arts);* Bouvet 66

1978:1-12

11:10 AU THÉÂTRE

Transfer lithograph printed in four colors on wove paper

Image: 8 x 15¾ inches (204 x 400 mm)

Sheet: 16 x 21⅛ inches (406 x 537 mm)

Provenance: E. Laffon (Lugt, *Suppl.,* 877[a])

Ref.: Roger-Marx 65; Bouvet 67

1978:1-13

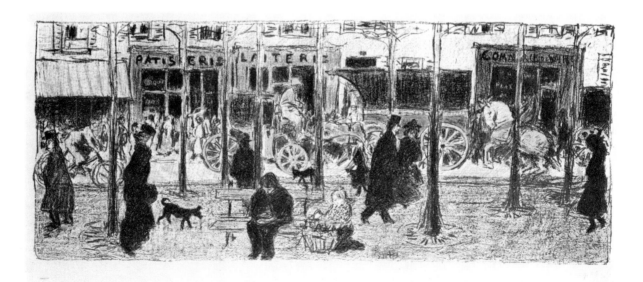

(11:6)

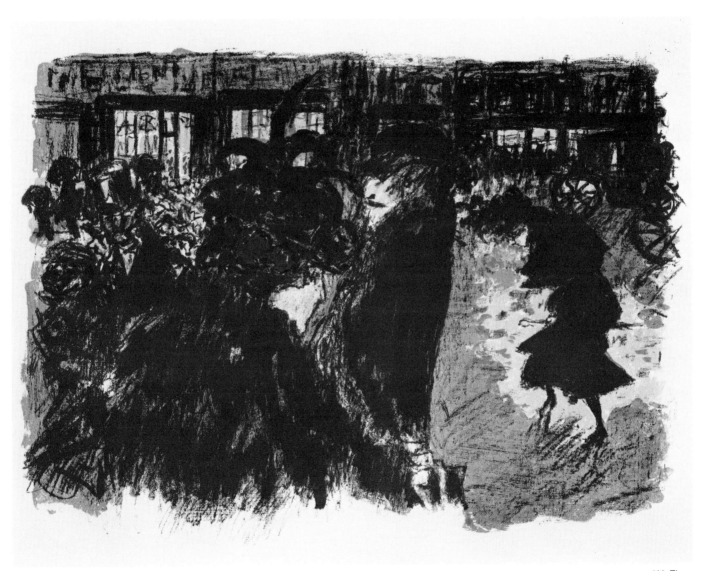

(11:7)

11:11 RUE, LE SOIR, SOUS LA PLUIE
Transfer lithograph printed in five colors on wove paper
Image: 10⅛ x 14 inches (257 x 356 mm)
Sheet: 16 x 21 inches (406 x 534 mm)
Signed and numbered in pencil, l.r.: No 9 PBonnard
Ref.: Roger-Marx 66; Bouvet 68
1978:1-14

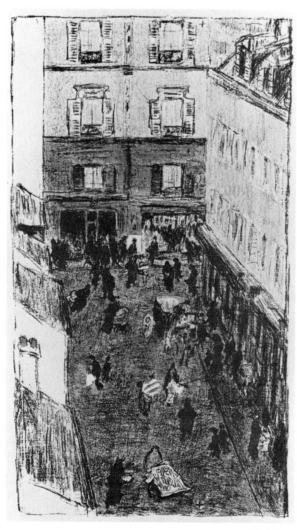

(11:13)

11:12 L'ARC DE TRIOMPHE
Transfer lithograph printed in five colors on wove paper
Image: 12½ x 18⅜ inches (318 x 468 mm)
Sheet: 16 x 21 inches (406 x 534 mm)
Ref.: Roger-Marx 67; Bouvet 69
1978:1-15

11:13 COIN DE RUE VUE D'EN HAUT
Transfer lithograph printed in four colors on wove paper.
Image: 14⅝ x 8⅜ inches (372 x 213 mm)
Sheet: 21 x 16⅛ inches (534 x 410 mm)
Ref.: Roger-Marx 68; Bouvet 70
1978:1-16

(12)
LE VERGER, 1899
For the album *Germinal*
Lithograph printed in five colors on wove paper
Image: 13⅛ x 14¼ inches (334 x 362 mm)
Sheet: 16½ x 18⅛ inches (420 x 461 mm)
Signed in pencil, l.r.: PBonnard
Publisher: Julius Meier-Graefe, Paris
Edition: 100 impressions
Ref.: Roger-Marx 48; Bouvet 56
1978:1-3

(13)
DANS LA RUE, ca. 1900
Lithograph printed in four colors on wove paper
Image: 10⁷⁄₁₆ x 5⅜ inches (265 x 136 mm)
Sheet: 19⅜ x 12½ inches (492 x 318 mm)
Signed and numbered in pencil, l.l.: no 8 PBonnard;
initialed on the stone, u.l.: PB
Edition: 100 impressions
Ref.: Roger-Marx 46; Bouvet 71
1976:18-5

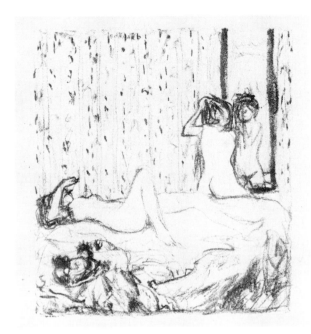

(14)

(14)

UNTITLED (TWO WOMEN ON A BED), 1900

Extra illustration for Paul Verlaine, *Parallèlement*

Lithograph printed in maroon on china paper

Image: 5⅜ x 5 inches (136 x 128 mm)

Sheet: 11⅝ x 9⅝ inches (296 x 245 mm)

Signed on the stone, u.ctr.: BONNARD

Printer: Auguste Clot, Paris

Publisher: Ambroise Vollard, Paris

Edition: the book was issued in 200 copies (30 on china paper, including 10 with an extra set of lithographs, 170 on holland wove paper)

Ref.: Not catalogued in Roger-Marx 94 *(Parallèlement);* or Bouvet 73 *(Parallèlement);* or Garvey, *Artist and the book,* 27 *(Parallèlement)*

1976:18-11

Note: This lithograph was included with the extra set of lithographs accompanying some copies of Parallèlement.

(15)

UNTITLED (DAPHNIS AND CHLOE), 1902

For Longus Sophista, *Les pastorales, ou Daphnis et Chloé*

Transfer lithograph printed in black on Van Gelder laid paper, watermark: DAPHNIS ET CHLOE; proof without text

Image: 6¹⁄₁₆ x 5½ inches (154 x 140 mm)

Sheet: 11⅝ x 9⅝ inches (295 x 245 mm)

Printer: Auguste Clot, Paris

Publisher: Ambroise Vollard, Paris

Edition: the book was issued in an edition of 250 copies (200 on Van Gelder paper with the watermark DAPHNIS ET CHLOE, 40 on china paper with two extra sets of lithographs in blue, and 10 on japan paper with two extra sets of lithographs in rose)

Ref.: Roger-Marx 95 *(Les pastorales ou Daphnis et Chloé);* Bouvet 75 *(Les pastorales ou Daphnis et Chloé);* Garvey, *Artist and the book,* 28 *(Les pastorales, ou Daphnis et Chloé)*

1976:18-10

(16)

ALBUM BONNARD, 1925

A suite of four transfer lithographs in the series *Maîtres et petits-maîtres d'aujourd'hui*

Publisher: Galerie des Peintres-Graveurs (Edmond Frapier), Paris

16:1 LA COUPE ET LE COMPOTIER

Transfer lithograph printed in black on wove paper

Image: 7½ x 10¼ inches (190 x 270 mm)

Sheet: 12⅞ x 19½ inches (327 x 495 mm)

Signed in pencil, l.r.: PBonnard; numbered in pencil, l.l.: 47/100; initialed on the stone, l.r.: PB; blind stamp, l.r.: GALERIE DES PEINTRES-GRAVEURS PARIS (Lugt, *Suppl.,* 1057ᵇ)

Edition: 125 impressions (ordinary edition of 100, deluxe edition of 25)

Ref.: Roger-Marx 80 ii/ii; Bouvet 93 iii/iii

1976:18-4

16:2 Femme debout dans sa baignoire
Transfer lithograph printed in black on wove paper
Image: 11⁹⁄₁₆ x 7½ inches (293 x 190 mm)
Sheet: 19½ x 12⅞ inches (498 x 328 mm)
Signed in pencil, l.r.: PBonnard; numbered in pencil, l.l.:
50/100; initialed on the stone, u.r.: PB (twice, once in
lithographic crayon, once scratched in); blind stamp,
l.r.: GALERIE DES PEINTRES-GRAVEURS PARIS (Lugt,
Suppl., 1057ᵇ)
Edition: 125 impressions (ordinary edition of 100, de-
luxe edition of 25)
Ref.: Roger-Marx 80 ii/ii; Bouvet 93 iii/iii
1976:18-4

16:3 Paysage du Midi
Transfer lithograph printed in black on wove paper,
proof
Image: 8¾ x 11⅝ inches (222 x 295 mm)
Sheet: 13 x 19½ inches (330 x 496 mm)
Signed in pencil, l.r.: PBonnard
Stamped in black ink, l.l., indicating proof of third state
(Lugt, *Suppl.,* 2921ᵉ and 2921ᵇ); blind stamp, l.r.:
GALERIE DES PEINTRES-GRAVEURS PARIS (Lugt, *Suppl.,*
1057ᵇ)
Edition: 125 impressions (deluxe edition of 25, ordinary
edition of 100)
Ref.: Roger-Marx 82 iii/iv; Bouvet 95 iii/iv
1976:18-13

16:4 La toilette assise
Transfer lithograph printed in black on wove paper
Image: 13 x 7⅞ inches (330 x 228 mm)
Sheet: 19⅜ x 12¹¹⁄₁₆ inches (492 x 322 mm)
Signed in pencil, l.r.: PBonnard
Blind stamp, l.r.: GALERIE DES PEINTRES-GRAVEURS
PARIS (Lugt, *Suppl.,* 1057ᵇ)
Edition: 125 impressions (deluxe edition of 25, ordinary
edition of 100)
Ref.: Roger-Marx 82 ii/iii; Bouvet 95 ii/iii (with scraping
but without monogram)
1976:18-16

(17)
Etude de nu, ca. 1925
Transfer lithograph printed in black on wove paper,
proof
Image: 11⁷⁄₁₆ x 6¾ inches (290 x 172 mm)
Sheet: 19½ x 12½ inches (495 x 326 mm)
Signed in pencil, l.r.: PBonnard
Stamped in black, l.l., indicating proof of second state
(Lugt, *Suppl.,* 2921ᵈ and 2921ᵇ); blind stamp, l.r.:
GALERIE DES PEINTRES-GRAVEURS PARIS (Lugt, *Suppl.,*
1057ᵇ)
Publisher: Galerie des Peintres-Graveurs (Edmond
Frapier), Paris
Edition: 35 signed impressions (25 printed in black, 10
printed in sanguine)
Ref.: Roger-Marx 84 ii/ii; Bouvet 97 ii/ii
1976:18-6

(18)
Mon fils m'a abandonnée, 1930
Hors texte illustration for Ambroise Vollard, *Sainte
Monique*
Transfer lithograph on Arches wove paper
Image: 10⅞ x 7¹¹⁄₁₆ inches (275 x 195 mm)
Sheet: 12⅞ x 9¹³⁄₁₆ inches (327 x 250 mm)
Initialed on the stone, l.r.: PB
Publisher: Ambroise Vollard, Paris
Edition: the book was issued in 385 numbered copies
(nos. 1-8 on antique japan paper; nos. 9-33 on japan
imperial paper; nos. 34-83 on hand-made wove paper
from the *Papeteries d'Arches;* nos. 1-83 have a suite of
the etchings and lithographs on Arches wove paper
initialed by the artist and author; nos. 84-340 on Arches
wove paper; nos. I-XXX and A-O *hors commerce)*
Ref.: Roger-Marx 96 *(Sainte Monique); Bouvet 111
(Sainte Monique)*
1976:18-12
Note: see SCMA, Modern illustrated books, *no. 5*
(Sainte Monique).

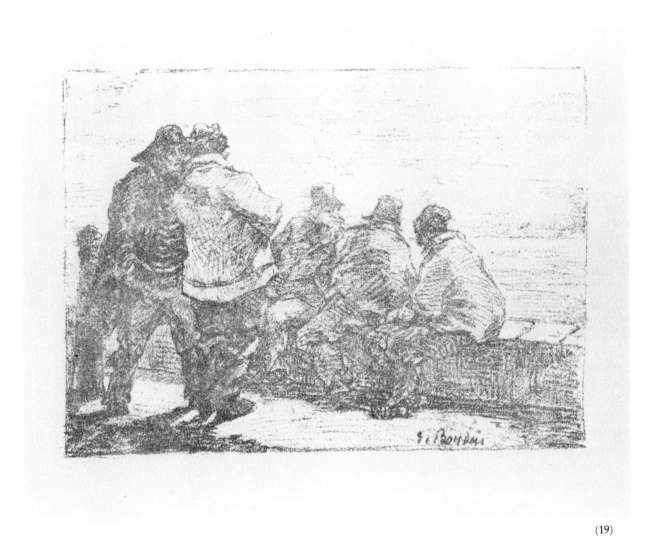

(19)

Eugène Boudin 1824 – 1898

(19)
MATHURINS, 1897
For L. Roger-Miles, *Art et nature*
Lithograph printed in blue on japan paper
Image: 4⅜ x 6⅛ inches (112 x 156 mm)
Sheet: 9⅞ x 12⅞ inches (256 x 326 mm)

Signed on the stone, l.r.: E. Boudin
Publisher: G. Boudet, Paris
Edition: 525 impressions (25 on japan, 500 on wove)
Ref.: Melot B2
1976:18-19

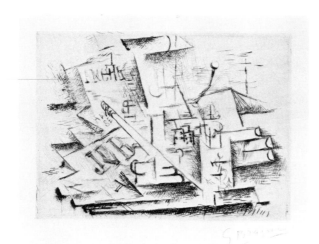

(20)

Georges Braque 1882 – 1963

(20)

Job, 1911

Etching and drypoint printed in black on Arches laid paper

Plate: 5⅝ x 7⅞ inches (142 x 198 mm)

Sheet: 17⅜ x 22⅝ inches (442 x 575 mm)

Signed in pencil, l.r.: G. Braque

Printer: Eugène Delâtre, Paris

Publisher: Daniel-Henry Kahnweiler, Paris

Edition: 100 impressions published in 1912

Ref.: Hofmann 4; Engelberts 4; Vallier 5

1972:50-1

(21)

Composition (nature morte I), 1911

Etching printed in black on Arches wove paper

Plate: 13¾ x 8⅝ inches (349 x 219 mm)

Sheet: 22⅜ x 14¹⁵⁄₁₆ inches (568 x 378 mm)

Signed in pencil, l.r.: G. Braque; numbered in pencil, l.l.: 16/50

Printer: Georges Visat, Paris

Publisher: Aimé Maeght, Paris

Edition: 50 impressions plus 10 *hors commerce* published in 1950

Ref.: Hofmann 8; Engelberts 8; Vallier 8

1972:50-2

(22)

Composition (nature morte aux verres), 1912

Etching printed in black on Arches wove paper

Plate: 13⅝ x 8⁵⁄₁₆ inches (346 x 210 mm)

Sheet: 22⁷⁄₁₆ x 14⅞ inches (570 x 378 mm)

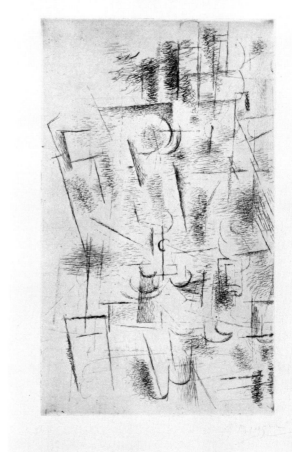

(22)

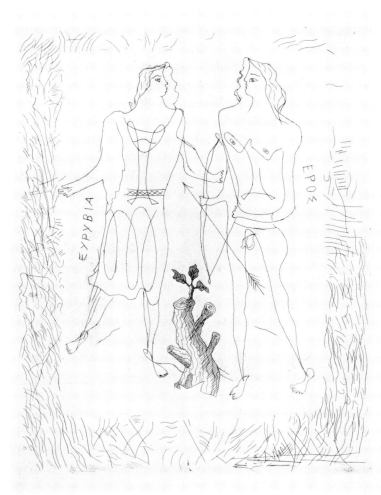

(23)

Signed in pencil, l.r.: G. Braque; numbered in pencil, l.l.: 26/50

Printer: Georges Visat, Paris

Publisher: Aimé Maeght, Paris

Edition: 50 impressions plus 10 *hors commerce* published in 1950

Ref.: Hofmann 9; Engelberts 9; Vallier 11

1972:50-3

(23)

EURYBIA ET EROS

Etching printed in black on laid paper

Plate: 14⅜ x 11¾ inches (366 x 299 mm)

Sheet: 19⅛ x 13¾ inches (486 x 350 mm)

Ref.: not in Hofmann or Engelberts; Vallier 21

1972:50-4

Note: This is an extra plate not used in the Vollard suite, Théogonie *(1932), nor in the 1955 Maeght edition of the Hesiod text. See SCMA, Modern illustrated books, no. 7 (Théogonie).*

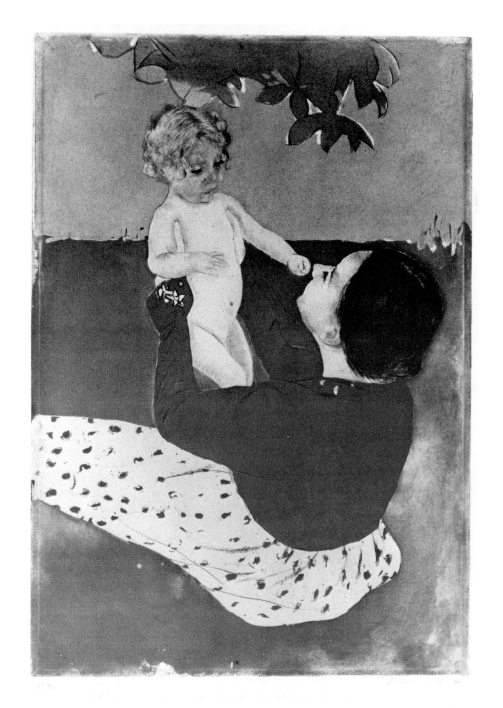

Mary Cassatt 1844 – 1926

(24)

LYDIA READING, TURNED TOWARD THE RIGHT, 1881

Soft-ground etching and aquatint printed in black on laid paper

Plate: 7 x 4¾ inches (178 x 110 mm)

Sheet: 13¹³/₁₆ x 8¼ inches (357 x 210 mm)

Signed in pencil, l.r.: Mary Cassatt

Ref.: Breeskin 63 ii/ii

1972:50-7

(25)

UNDER THE HORSE CHESTNUT TREE, 1898

Etching, drypoint and aquatint printed in five colors on laid paper

Plate: 16 x 11⅜ inches (406 x 289 mm)

Sheet: 19⅞ x 17½ inches (505 x 445 mm)

Signed in pencil, l.r.: Mary Cassatt; numbered in pencil, l.l.: No. 33

Ref.: Breeskin 162 iv/iv

1972:50-8

Paul Cézanne 1839 – 1906

(26)

SELF-PORTRAIT, ca. 1896-98

Transfer lithograph printed in black on laid paper

Image: 12¾ x 11 inches (325 x 280 mm)

Sheet: 24¾ x 18⅝ inches (629 x 474 mm)

Printer: Auguste Clot, Paris

Publisher: Ambroise Vollard, Paris

Edition: at least 100 impressions printed in 1920

Ref.: Venturi 1158; Cherpin 8; Druick II ii/ii

1972:50-9

Note: This lithograph was apparently intended for Vollard's third, and unpublished, album of original prints. In 1914 Auguste Clot printed a first edition of at least 100 impressions in gray. This impression is from the second edition, which was printed in black in 1920.

Marc Chagall 1887-1985

(27)

DIE GROSSMUTTER, 1922

For *Mein Leben*

Etching and drypoint printed in black on laid paper

Plate: 8⅛ x 6¼ inches (207 x 159 mm)

Sheet: 14¾ x 10⁹/₁₆ inches (375 x 268 mm)

Signed in pencil, l.r.: Marc Chagall; numbered in pencil, l.l.: 85/110

Publisher: Paul Cassirer, Paris

Edition: 110 impressions (84 on laid paper, 26 on japan paper)

Ref.: Kornfeld 4 c/c; Garvey, *Artist and the book*, 49 (*Mein Leben*)

1972:50-10

Note: The twenty etchings of Mein Leben *are Chagall's first prints. In 1922 Paul Cassirer asked him to illustrate the autobiography Chagall had written during and after World War I. He made over fifty etchings for the project but only twenty were published. They appeared in 1923 without the text which was delayed by translation difficulties. See also no. 28.*

(28)

VOR DEM TORE, 1922

For *Mein Leben*

Etching and drypoint printed in black on laid paper

Plate: 8¼ x 6¼ inches (210 x 152 mm)

Sheet: 15 x 11⅛ inches (382 x 283 mm)

Signed in pencil, l.r.: Marc Chagall; numbered in pencil, l.l.: 11/110

Publisher: Paul Cassirer, Paris

Edition: 110 impressions (84 on laid paper, 26 on japan paper)

Ref.: Kornfeld 14 c/c; Garvey, *Artist and the book*, 49 (*Mein Leben*)

1972:50-11

Note: see also no. 27.

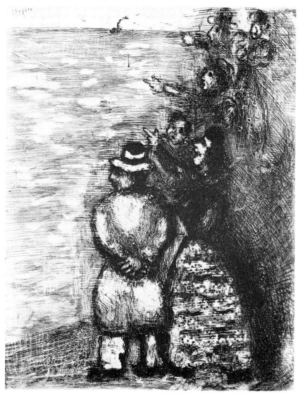

(29)

hors commerce); in addition 100 albums of only the etchings were issued on Montval laid paper

Ref.: Garvey, *Artist and the book*, 52 *(La Fontaine fables)*; Sorlier, *Chagall et Vollard*, 134

1972:50-13

(30)

L' ECHELLE DE JACOB, ca. 1931-39

For *La Bible*

Etching printed in black on laid paper

Plate: 11⅝ x 9⅝ inches (295 x 245 mm)

Sheet: 15⅝ x 11⅞ inches (397 x 302 mm)

Signed in pencil, l.r.: Marc Chagall

Printer: Maurice Potin, Paris

Edition: possibly a proof before the edition. The text edition was published by Tériade in 1956 in an edition of 295 signed and numbered copies on Montval wove paper, including 20 *hors commerce;* in addition 100 albums of the prints were issued on Arches wove paper with the plates hand-colored by the artist

Ref.: Garvey, *Artist and the book*, 53 *(La Bible);* Sorlier, *Chagall et Vollard*, 212

1972:50-14

After Marc Chagall

(31)

UNTITLED

For Claire Goll, *Journal d'un cheval* [1952]

Lithograph printed in three colors on wove paper

Image: 8½ x 6⅛ inches (227 x 156 mm)

Sheet: 12¾ x 9¾ inches (324 x 248 mm)

Numbered in pencil, l.l.: 6/25

Publisher: Manuel Bruker, Paris

Ref.: not in Mourlot or Sorlier

1972:50-12

(32)

SAINT-JEAN-CAP-FERRAT, 1952

Poster for a one-man exhibition at the Ponchettes Gallery in Nice

(29)

LE CHAMEAU ET LE BÂTON FLOTTANT, ca. 1927-30

For *Les fables de La Fontaine*

Etching printed in black on laid paper

Plate: 11¾ x 9⁵⁄₁₆ inches (299 x 237 mm)

Sheet: 15½ x 11⅞ inches (394 x 302 mm)

Signed in the plate, u.l.: Chagall

Printer: Maurice Potin, Paris

Publisher: Efstratios Tériade, Paris, 1952 (originally begun by Ambroise Vollard)

Edition: the text edition was issued in 200 numbered copies (1-40 with the etchings hand-colored by the artist and two suites of etchings, one on japan *nacré* and another on Montval; 41-85 with the etchings hand-colored by the artist and one suite of the etchings on Montval; 86-185 with uncolored etchings; and I-XV

Lithograph after a gouache of 1949, printed in seven colors on wove paper, proof without text
Image: 26¹⁵/₁₆ x 19½ inches (685 x 495 mm)
Sheet: 36⅜ x 24⅝ inches (925 x 625 mm)
Signed in pencil, l.r.: Marc Chagall; signed and dated on the stone, l.r.: 1949 / MARC CHAGALL
Printer: Mourlot Frères, Paris

Edition: several signed, unnumbered proofs without text on Arches wove paper; 750 with text plus an additional 150 with different text for a Milan exhibition

Ref.: Sorlier CS4
1984:10-69

Henri-Edmond Cross 1856 – 1910

(33)
SUR LES CHAMPS-ELYSÉES, 1898
For *Pan,* fourth year, no. 1 (July 1898)
Lithograph printed in four colors on china paper

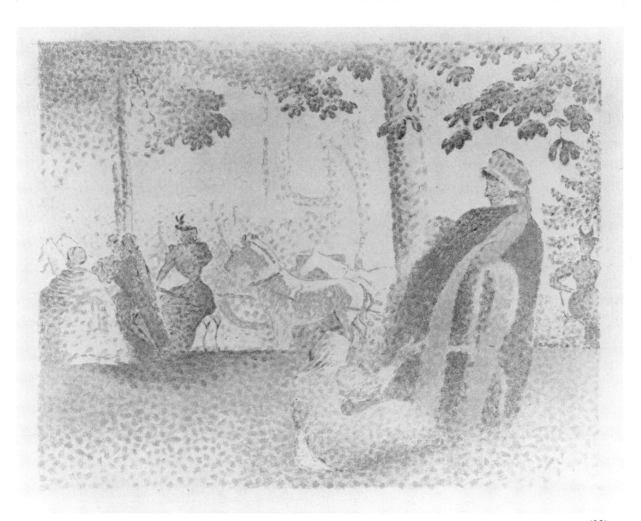

(33)

Image: 8 x 10⅜ inches (203 x 263 mm)
Sheet: 10⅞ x 14½ inches (276 x 369 mm)
Printer: Auguste Clot, Paris
Publisher: F. Fontane & Co., Berlin
Edition: this issue of *Pan* was printed in 1213 copies
(1100 for the regular trade edition; 38 numbered copies
on japan imperial for the special *Künstlerausgabe* edition; and 75 numbered copies for the *Vorzugsausgabe*
edition)
1976:18-20

Edgar Degas 1834 – 1917

(34)
ELLEN ANDRÉE, 1879
Etching and drypoint printed in black on wove paper
Plate: 4⁷⁄₁₆ x 3⅛ inches (112 x 80 mm)
Sheet: 6⅞ x 4¹³⁄₁₆ inches (174 x 122 mm)
Stamped in red, verso: ATELIER / ED. DEGAS (Lugt 657)
Ref.: Delteil 20 iii/iii; Adhémar 52 ii/ii; Reed-Shapiro 40
iii/iii
1972:50-16

(35)
SORTIE DU BAIN, ca. 1879-80
Etching, aquatint and drypoint printed in black on wove
paper
Plate: 5¹⁄₁₆ x 5¹⁄₁₆ inches (127 x 127 mm)
Sheet: 8¼ x 6⅞ inches (210 x 175 mm)
Stamped in red, verso: ATELIER / ED. DEGAS (Lugt 657)
Ref.: Delteil 39 ix/xvii; Adhémar 49; Reed-Shapiro 42
xiii/xxii
1972:50-19

(36)
MARY CASSATT AU LOUVRE: MUSÉE DES ANTIQUES,
ca. 1879-80
Etching, aquatint and drypoint printed in black on
japan paper
Plate: 10⅝ x 9⁵⁄₁₆ inches (270 x 237 mm)
Sheet: 14 x 10⅝ inches (356 x 269 mm)

Edition: probably 50 impressions; intended for the
unpublished journal *Le jour et la nuit*
Ref.: Delteil 30 vi/vi; Adhémar 53 vi/vi; Reed-Shapiro
51 ix/ix
1972:50-17

(37)
LUDOVIC HALÉVY TROUVE MADAME CARDINAL DANS
LES LOGES, ca. 1880
For Ludovic Halévy, *La famille Cardinal*
Monotype printed in black, the second of two impressions, on laid paper
Image: 8⁷⁄₁₆ x 6¼ inches (214 x 159 mm)
Sheet: 9½ x 6⅞ inches (242 x 175 mm)
Stamped in red, verso: ATELIER / ED. DEGAS (Lugt 657)
Ref.: Janis 214; Adhémar and Cachin 65
1972:50-21

*Note: This is one of twenty-six monotypes Degas
made to illustrate Ludovic Halévy's novel, La famille
Cardinal. The monotypes were to be reproduced by a
photogravure process. The project was never completed,
however, and the monotypes remained in Degas' studio
until his death. In 1938 an edition of the novel was
issued with etchings by Maurice Potin after Degas'
monotypes.*

(38)
PROGRAMME DE LA SOIRÉE DES ANCIENS ÉLÈVES DU
LYCÉE DE NANTES, 1884
Lithograph transferred from soft ground etching printed
in black on wove paper
Image: 9⅛ x 11⅜ inches (232 x 289 mm)
Sheet: 10¹⁵⁄₁₆ x 15¼ inches (278 x 388 mm)
Signed on the stone (in reverse), u.r.: Degas
Printer: Aglaüs Bouvenne, Paris
Ref.: Delteil 58; Adhémar 56; Reed-Shapiro 54
1972:50-20

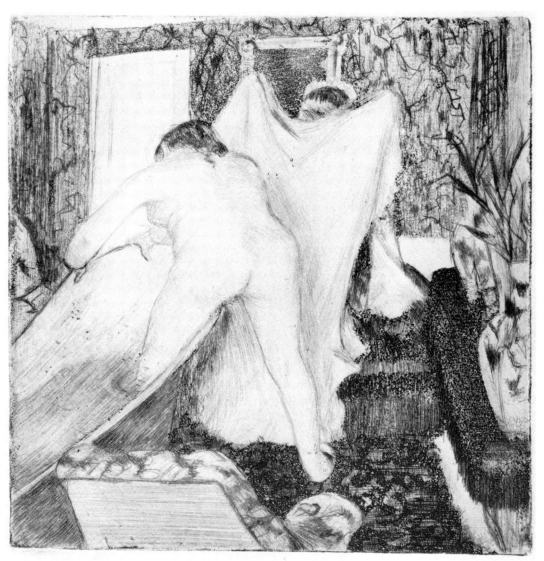

(35)

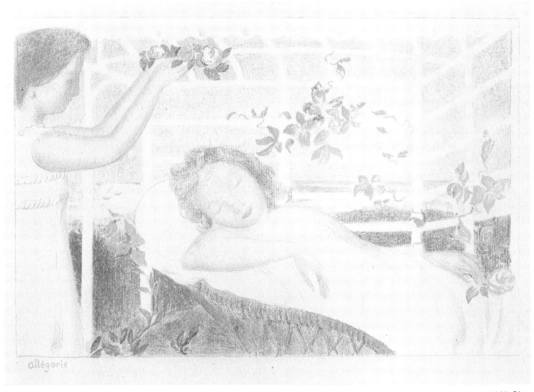

(41:2)

(39)

Danseuse mettant son chausson, ca. 1888
Etching printed in black on wove paper
Plate: 7⅛ x 4⅝ inches (181 x 118 mm)
Sheet: 9⅞ x 6⅞ inches (251 x 175 mm)
Ref.: Delteil 36; Adhémar 60; Reed-Shapiro 55 ii/ii
1972:50-18

Loys Delteil 1869 – 1927

(40)

Untitled (family group)
Transfer lithograph printed in black on japan paper
Image: 12⅛ x 9⅛ inches (307 x 232 mm)
Sheet: 14⅝ x 11 inches (371 x 280 mm)
Signed in pencil, l.r.: Loys Delteil; signed on the stone,

l.r.: Loys Delteil
1976:18-21

Maurice Denis 1870 – 1945

(41)

Amour, 1899
Suite of twelve transfer lithographs printed in color on
wove paper and cover/title page printed in color on
china paper
Printer: Auguste Clot, Paris
Publisher: Ambroise Vollard, Paris
Edition: 100 impressions

41:1 Cover/title page
Transfer lithograph printed in three colors on

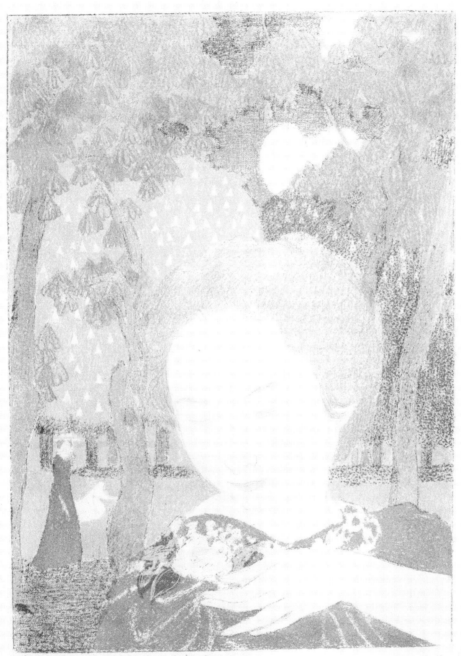

Les altitudes sont faciles et chastes

(41:3)

china paper
Image: 20¾ x 16¼ inches (527 x 413 mm)
Sheet: 23¼ x 17½ inches (591 x 444 mm)
Signed on the stone vertically, u.l.: MAUD
Provenance: R. L. Mayer (not in Lugt)
Ref.: Cailler 107
1972:50-22

41:2 ALLÉGORIE
Transfer lithograph printed in four colors on wove paper
Image: 10½ x 16⅛ inches (267 x 410 mm)
Sheet: 16 x 21 inches (407 x 534 mm)
Provenance: R. L. Mayer (not in Lugt)
Ref.: Cailler 108
1972:50-23

41:3 LES ATTITUDES SONT FACILES ET CHASTES
Transfer lithograph printed in six colors on wove paper
Image: 15⅛ x 10⅞ inches (385 x 275 mm)
Sheet: 20⅞ x 16⅛ inches (530 x 410 mm)
Signed in pencil, l.r.: Maurice Denis
Provenance: R. L. Mayer (not in Lugt)
Ref.: Cailler 109
1972:50-24

41:4 LE BOUQUET MATINAL, LES LARMES
Transfer lithograph printed in three colors on wove paper
Image: 14¹⁵⁄₁₆ x 11 inches (380 x 280 mm)
Sheet: 21 x 16 inches (534 x 407 mm)
Signed in pencil, l.r.: Maurice Denis
Provenance: R. L. Mayer (not in Lugt)
Ref.: Cailler 110
1972:50-25

41:5 CE FÛT UN RELIGIEUX MYSTÈRE
Transfer lithograph printed in five colors on wove paper
Image: 16¼ x 11½ inches (413 x 292 mm)
Sheet: 20⅞ x 16 inches (530 x 407 mm)
Ref.: Cailler 111
1972:50-26

41:6 LE CHEVALIER N'EST MORT À LA CROISADE
Transfer lithograph printed in three colors on wove paper
Image: 15³⁄₁₆ x 10⅞ inches (386 x 276 mm)
Sheet: 20⅞ x 16 inches (530 x 407 mm)
Signed and numbered in pencil, l.r.: no 32 / Maurice Denis; monogrammed on the stone, t.ctr.
Provenance: R. L. Mayer (not in Lugt)
Ref.: Cailler 112
1972:50-27

41:7 LES CRÉPUSCULES ONT UNE DOUCEUR D'ANCIENNE PEINTURE
Transfer lithograph printed in four colors on wove paper
Image: 15⅝ x 11⅝ inches (389 x 295 mm)
Sheet: 20¾ x 15¹⁵⁄₁₆ inches (527 x 405 mm)
Signed and dated in pencil, l.r.: Maurice Denis 89 [sic]; signed and dated on the stone vertically, l.r.: MAUD 98
Provenance: R. L. Mayer (not in Lugt)
Ref.: Cailler 113
1972:50-28

41:8 ELLE ÉTAIT PLUS BELLE QUE LES RÊVES
Transfer lithograph printed in four colors on wove paper
Image: 15⅞ x 11⅝ inches (404 x 296 mm)
Sheet: 21 x 15⅞ inches (533 x 404 mm)
Ref.: Cailler 114
1972:50-29

41:9 ET C'EST LA CARESSE DE SES MAINS
Transfer lithograph printed in four colors on wove paper
Image: 15⅜ x 11⁵⁄₁₆ inches (390 x 287 mm)
Sheet: 20¾ x 16⅛ inches (528 x 410 mm)
Signed in pencil, l.r.: Maurice Denis; monogrammed on the stone, l.ctr.
Provenance: R. L. Mayer (not in Lugt)
Ref.: Cailler 115
1972:50-30

41:10 Nos âmes en des gestes lents
Transfer lithograph printed in four colors on wove paper
Image: 11 x 15¾ inches (279 x 400 mm)
Sheet: 16⅛ x 20⅞ inches (410 x 530 mm)
Provenance: R. L. Mayer (not in Lugt)
Ref.: Cailler 116
1972:50-31

41:11 Sur la canapé d'argent pâle
Transfer lithograph printed in five colors on wove paper
Image: 15¾ x 11¼ inches (401 x 285 mm)
Sheet: 20⅞ x 15¹⁵⁄₁₆ inches (530 x 405 mm)
Provenance: R. L. Mayer (not in Lugt)
Ref.: Cailler 117
1972:50-32

41:12 La vie devient précieuse, discrète
Transfer lithograph printed in five colors on wove paper
Image: 10¹¹⁄₁₆ x 15¹⁵⁄₁₆ inches (271 x 405 mm)
Sheet: 15⅞ x 20⅞ inches (404 x 530 mm)
Signed and numbered in pencil, l.r.: Maurice Denis 34;
monogrammed on the stone, l.ctr.
Ref.: Cailler 118
1972:50-33

41:13 Mais c'est le coeur qui bat trop vite
Transfer lithograph printed in four colors on wove paper
Image: 17⅜ x 11⁹⁄₁₆ inches (442 x 294 mm)
Sheet: 20⅞ x 15¹⁵⁄₁₆ inches (530 x 404 mm)
Signed in pencil, l.r.: Maurice Denis; monogrammed on
the stone, l.r.
Provenance: R. L. Mayer (not in Lugt)
Ref.: Cailler 119
1972:50-34

After Raoul Dufy 1877 – 1953

(42)

Untitled (flowers)
Photolithographic half-tone printed in four colors on

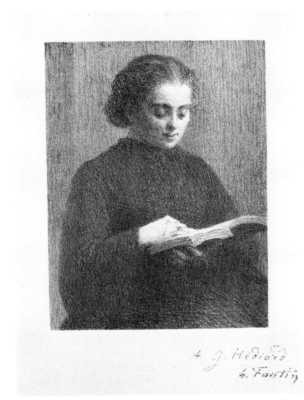

(43)

wove paper
Image: 17⅛ x 22¾ inches (435 x 578 mm)
Sheet: 19⅜ x 25⅜ inches (493 x 644 mm)
Numbered in pencil. l.l.: 10/15; signed on the plate, l.l.:
Raoul Dufy
Edition: 15 impressions
1984:10-70

Henri Fantin-Latour 1836 – 1904

(43)

La lecture, 1897
Transfer lithograph printed in black on laid paper
Image: 6⅜ x 5 inches (161 x 127 mm)
Sheet: 17¼ x 12⅝ inches (439 x 320 mm)
Signed on the stone (scratched in), u.l.: Fantin; inscribed
on the stone, l.r.: A. G. Hédiard / h. Fantin

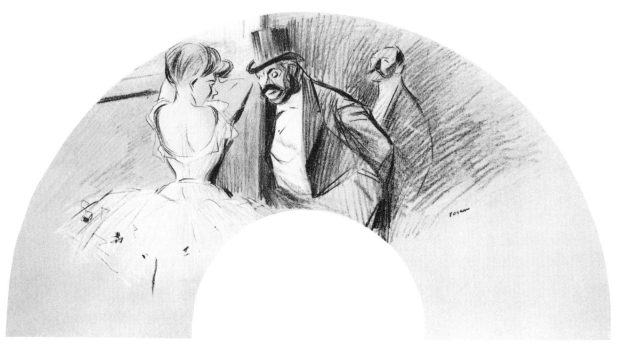

(44)

Printer: Auguste Clot, Paris
Ref.: Hédiard 136 i/ii; Fantin-Latour 1682
1976:18-22

Jean-Louis Forain 1852 – 1931

(44)

L'Eventail, 1903
For *Le bal Gavarni*
Transfer lithograph printed in three colors on wove paper
Image (height and width of fan): 10 x 19½ inches (254 x 495 mm)
Sheet: 12½ x 19⅞ inches (318 x 505 mm)
Ref.: Guérin 70; Faxon 254
1976:18-24

(45)

Portrait d' Ambroise Vollard, ca. 1910
Lithograph printed in black on wove paper
Image: 10⅜ x 9⅝ inches (263 x 245 mm)
Sheet: 20 x 13 inches (508 x 330 mm)
Signed on the stone, l.r.: forain
Ref.: not in Guérin; Faxon 275
1972:50-36

(46)

La péroraison
Lithograph printed on black on wove paper
Image: 15½ x 12 inches (394 x 305 mm)
Sheet: 26⅜ x 18⅜ inches (667 x 467 mm)
Initialed on the stone, l.r.: f
Ref.: not in Guérin; Faxon 287
1976:18-23

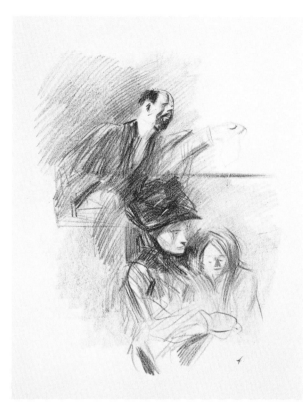

(46)

After Jean-Louis Forain

(47)

DEUXIÈME SALON DU CYCLE

Reduction for *Les maîtres de l'affiche*, v. II (1897), of Forain's 1894 poster

Lithograph printed in four colors on wove paper

Sheet (image printed to edge of sheet): 17⅝ x 42¾ inches (448 x 1087 mm)

Printer: H. Hérold, Paris

Ref.: Guérin 87 (*Deuxième salon du cycle,* 1894); Faxon 296

1984:10-84

Paul Gauguin 1848 – 1903

(48)

BAIGNEUSES BRETONNES, 1889

Lithograph on zinc printed in black on imitation japan paper

Image: 9¼ x 7¹⁵⁄₁₆ inches (236 x 202 mm)

Sheet: 18¹⁄₁₆ x 12¹¹⁄₁₆ inches (459 x 321 mm)

Signed on the plate, l.l.: P. Gauguin

Printer: Auguste Clot, Paris

Publisher: Ambroise Vollard, Paris

Edition: unspecified number of impressions on imitation japan paper issued by Vollard between 1893-95; 50 impressions on yellow paper printed in 1889

Ref.: Guérin 3

1972:50-37

(49)

MISÈRES HUMAINES, 1889

Lithograph on zinc printed in black with pale yellow-green and tan hand-coloring on imitation japan paper

Image: 11⁷⁄₁₆ x 9⅜ inches (291 x 238 mm)

Sheet: 12¾ x 11⁵⁄₁₆ inches (323 x 286 mm)

Signed and dated on the plate, l.r.: P. Gauguin 89

Printer: Auguste Clot, Paris

Publisher: Ambroise Vollard, Paris

Edition: unspecified number of impressions on imitation japan paper issued by Vollard between 1893-95; 50 impressions on yellow paper printed in 1889

Ref.: Guérin 5

1972:50-38

(50)

LES LAVEUSES, 1889

Lithograph on zinc printed in black on imitation japan paper

Image: 8⁷⁄₁₆ x 10⅜ inches (215 x 262 mm)

Sheet: 12¾ x 18⅝ inches (324 x 473 mm)

Signed on the plate, l.r.: P. Gauguin

Printer: Auguste Clot, Paris

Publisher: Ambroise Vollard, Paris

Edition: unspecified number of impressions on imitation japan paper issued by Vollard between 1893-95; 50 impressions on yellow paper printed in 1889

Ref.: Guérin 6

1972:50-39

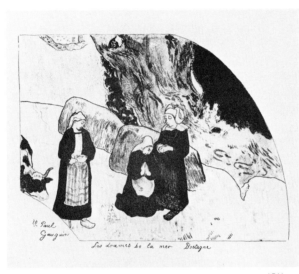

(51)

(51)

LES DRAMES DE LA MER, BRETAGNE, 1889

Lithograph on zinc printed in black on yellow wove paper

Image: 6⁹⁄₁₆ x 8¹⁵⁄₁₆ inches (167 x 226 mm)

Sheet: 19⁹⁄₁₆ x 25⁹⁄₁₆ inches (497 x 649 mm)

Signed and dated on the plate, l.l.: 89 Paul / Gauguin ("9" printed in reverse); inscribed on the plate, l.ctr.: Les drames de la mer Bretagne

Printer: Edw. Ancourt, Paris

Edition: 50 impressions on yellow paper printed in 1889; unspecified number of impressions on imitation japan paper issued by Ambroise Vollard between 1893-95

Ref.: Guérin 7

1972:50-40

(52)

LES DRAMES DE LA MER (UNE DESCENTE DANS LE MAELSTROM), 1889

Lithograph on zinc printed in black on yellow paper

Image: 6¹³⁄₁₆ x 10¹³⁄₁₆ inches (172 x 275 mm)

Sheet: 19⁹⁄₁₆ x 25⁹⁄₁₆ inches (497 x 649 mm)

Signed and inscribed on the plate, l.l.: Les drames de la mer P Gauguin

Printer: Edw. Ancourt, Paris

Edition: 50 impressions on yellow paper printed in 1889; unspecified number of impressions on imitation japan paper issued by Ambroise Vollard between 1893-95

Ref.: Guérin 8

1972:50-41

(53)

PASTORALES MARTINIQUE, 1889

Lithograph on zinc printed in black on yellow wove paper

Image: 6¹⁵⁄₁₆ x 8¹³⁄₁₆ inches (177 x 223 mm)

Sheet: 19¹¹⁄₁₆ x 16⁷⁄₁₆ inches (500 x 417 mm)

Signed and inscribed on the plate, l.l.: Pastorales Martinique Paul Gauguin

Printer: Edw. Ancourt, Paris

Edition: 50 impressions on yellow paper printed in 1889; unspecified number of impressions on imitation japan paper issued by Ambroise Vollard between 1893-95

Ref.: Guérin 9

1972:50-42

(54)

LES CIGALES ET LES FOURMIS (SOUVENIR DE LA MARTINIQUE), 1889

Lithograph on zinc printed in black on yellow wove paper

Image: 7⅞ x 10⁵⁄₁₆ inches (200 x 261 mm)

Sheet: 12¾ x 19¹¹⁄₁₆ inches (323 x 500 mm)

Signed and dedicated in pencil, l.r.: à Amedée

Schuffenecker / Paul Gauguin; signed and inscribed on the plate, l.l.: Paul Gauguin / Les Cigales et les fourmis

Printer: Edw. Ancourt, Paris

Edition: 50 impressions on yellow paper printed in 1889; unspecified number of impressions on imitation japan paper issued by Ambroise Vollard between 1893-95

Ref.: Guérin 10

1972:50-43

(55)

LES VIEILLES FILLES (ARLES), 1889

Lithograph on zinc printed in black on imitation japan paper

Image: 7¹¹⁄₁₆ x 8⁵⁄₁₆ inches (195 x 212 mm)

Sheet: 12⁵⁄₈ x 18³⁄₁₆ inches (320 x 462 mm)

Signed on the plate, l.l.: P. Gauguin

Provenance: Arthur B. Spingarn (Lugt, *Suppl.*, 83ᵇ)

Printer: Auguste Clot, Paris

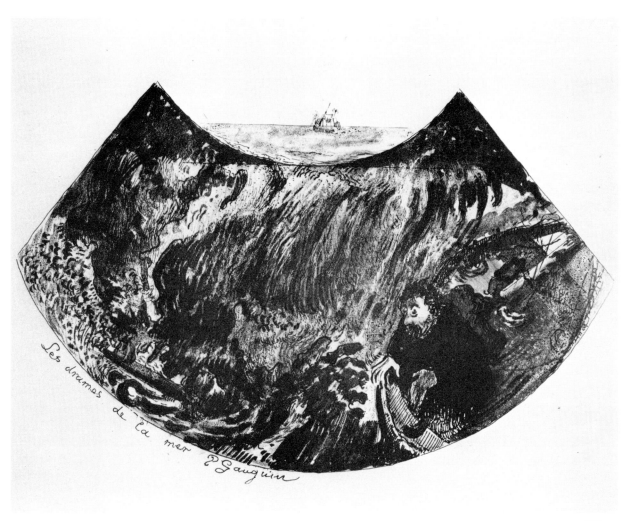

(52)

Publisher: Ambroise Vollard, Paris
Edition: unspecified number of impressions on imitation japan paper issued by Vollard between 1893-95; 50 impressions on yellow paper printed in 1889
Ref.: Guérin 11
1972:50-44

(56)

MANAO TUPAPAU (ELLE PENSE AU REVENANT), ca. 1894
Woodcut printed in three colors (black, bistre, olive-green) on japan paper
Image: 8⅛ x 14¹⁄₁₆ inches (206 x 357 mm)
Sheet: 12³⁄₁₆ x 15⁵⁄₁₆ inches (309 x 389 mm)
Initialed in the block, l.l.: PGO; inscribed in the block, u.l.: Manao tupapau
Printer: Tony Beltrand, Paris, before 1918.
Ref.: Guérin 20
1972:50-45

(57)

NAVE NAVE FENUA (TERRE DÉLICIEUSE), ca. 1894
Woodcut printed in three colors (black, brown, yellow) on Vidalon wove paper
Image: 14³⁄₁₆ x 8³⁄₁₆ inches (360 x 208 mm)
Sheet: 17¹⁵⁄₁₆ x 11 inches (456 x 280 mm)
Printer: Louis Roy, Paris
Ref.: Guérin 29
1972:50-46

Note: Guérin mentions red as a fourth color. Red is not apparent in this impression.

(58)

MAHANA ATUA (LA NOURRITURE DES DIEUX)
Woodcut printed in black on china paper
Image: 7³⁄₁₆ x 8¹⁄₁₆ inches (183 x 204 mm)
Sheet: 10½ x 16¾ inches (266 x 425 mm)
Inscribed in pencil, l.l.: Paul Gauguin fait; l.r.: Pola Gauguin imp; numbered in pencil, u.l.: No 21; initialed in the block, l.l.: PGO; inscribed in the block, l.r.: Mahana Atua

Printer: Pola Gauguin, Copenhagen
Publisher: Siedenburg, Copenhagen
Edition: 100 impressions on china paper printed in 1921
Ref.: see Guérin 42
1972:50-47

(59)

NOA NOA (EMBAUMÉ, EMBAUMÉ), 1893-95
Woodcut printed in black over an irregular orange-yellow undertone on wove paper
Sheet (trimmed to image): 5¹⁵⁄₁₆ x 4¹¹⁄₁₆ inches (152 x 119 mm)
Initialed vertically in the block, l.r.: PGO
Ref.: Guérin 47
1972:50-48

(60)

FEMME CUEILLANT DES FRUITS ET OVIRI, ca. 1895
Woodcut printed in black on japan tissue
Image: 4⅛ x 3⁹⁄₁₆ inches (105 x 90 mm)
Sheet: 4¹⁵⁄₁₆ x 4¼ inches (125 x 107 mm)
Initialed in pencil, l.r.: PG
Ref.: Guérin 49
1972:50-49

(61)

INTÉRIEUR DE CASE, ca. 1899
Woodcut printed in black on japan tissue
Image: 4⁵⁄₈ x 8³⁄₈ inches (117 x 212 mm)
Sheet: 5⁵⁄₁₆ x 8⁹⁄₁₆ inches (135 x 218 mm)
Initialed vertically in the block, l.ctr.: PG; numbered in ink, l.ctr.: 20
Edition: 30 impressions
Ref.: Guérin 56
1972:50-50

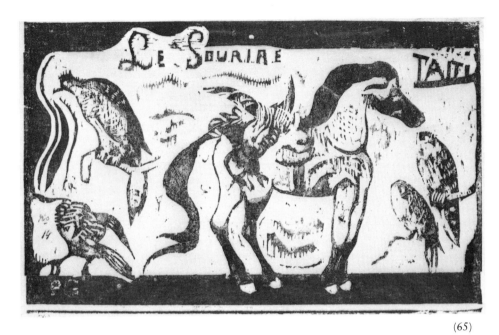

(65)

(62)

LE PORTEUR DE FÉÏ, 1895

Woodcut printed in black on japan tissue

Image: 6⁷/₁₆ x 11⁵/₁₆ inches (163 x 287 mm)

Sheet: 8¹⁵/₁₆ x 12 inches (228 x 305 mm)

Initialed in the block, l.l.: PG; numbered in ink, l.l.: 16

Edition: 30 impressions

Ref.: Guérin 64

1972:50-51

(63)

LE CALVAIRE BRETON (SOUVENIR DE BRETAGNE), ca. 1895

Woodcut printed in black on japan tissue

Sheet (trimmed to image): 5⁷/₈ x 9 inches (150 x 229 mm)

Initialed and numbered in ink, l.r.: PG / 20

Edition: 30 impressions on japan tissue; 25 impressions on japan paper printed by Pola Gauguin in 1921

Ref.: Guérin 68

1972:50-52

(64)

LE CHAR À BOEUFS (SOUVENIR DE BRETAGNE), ca. 1899

Woodcut printed in black on japan tissue

Image: 7¹/₈ x 12¹/₈ inches (181 x 308 mm)

Sheet: 8¹⁵/₁₆ x 12¹/₈ inches (228 x 308 mm)

Initialed and numbered vertically in ink, l.r.: PG 12

Edition: 30 impressions

Ref.: Guérin 70

1972:50-53

(65)

TITRE DU SOURIRE, 1899

Woodcut printed in black on japan tissue

Image: 5⁹/₁₆ x 8¹³/₁₆ inches (141 x 221 mm)

Sheet: 6 x 9 inches (153 x 229 mm)

Initialed in the block, l.l.: PG; numbered in ink, l.l.: no / 14

Provenance: Marcel Louis Guérin (Lugt, *Suppl.*, 1872[b])

Edition: 30 impressions

Ref.: Guérin 74

1972:50-54

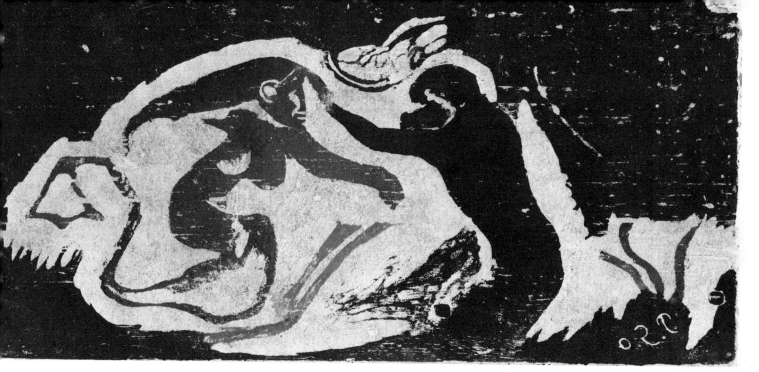

(66)

TITRE DU SOURIRE, 1899
Woodcut printed in black on china paper
Image: 4 x 7¼ inches (101 x 184 mm)
Sheet: 10⁹⁄₁₆ x 16⅞ inches (268 x 429 mm)
Inscribed in pencil, l.l.: Paul Gauguin fait; l.r.: Pola
Gauguin imp.; numbered in pencil, u.l.: No 21;
inscribed in the block, l.l.: P Gauguin [not in the artist's
hand]
Printer: Pola Gauguin, Copenhagen
Publisher: Siedenburg, Copenhagen
Edition: 100 impressions on china paper printed by
Pola Gauguin in 1921; 30 impressions on japan tissue
printed in 1899
Ref.: Guérin 75
1972:50-55

(67)

TITRE DU SOURIRE, 1899
Woodcut printed in black on japan tissue
Image (trimmed along bottom edge): 4⁷⁄₁₆ x 7⅜ inches
(112 x 187 mm)

Sheet (trimmed within image along bottom edge):
6³⁄₁₆ x 9 inches (156 x 228 mm)
Initialed in ink, l.l.: PG; numbered in ink, l.r.: 14
Edition: unspecified number of impressions on japan
tissue; 25 impressions on japan paper printed by Pola
Gauguin in 1921
Ref.: Guérin 76
1972:50-56

(68)

SIRÈNE ET DIEU MARIN
Woodcut printed in four colors on china paper
Image: 7¹⁵⁄₁₆ x 16⁹⁄₁₆ inches (202 x 421 mm)
Sheet: 10¹¹⁄₁₆ x 19¹⁵⁄₁₆ inches (271 x 506 mm)
Initialed in the block (in reverse), l.r.: PGO
Ref.: not in Guérin; Gray 124
1972:50-57

*Note: This is presumably a posthumous impression
from a lost relief. The suggestion of rough wood as well
as the format and style relate the image to reliefs Gau-
guin carved during his second stay in Tahiti (1895-1903).*

Juan Gris 1887 – 1927

(69)

LA GOSSE, 1921

Lithograph printed in brown on china paper
Image: 12⅝ x 10 inches (320 x 254 mm)
Sheet: 15¾ x 12⅞ inches (400 x 327 mm)
Signed and numbered in pencil, l.r.: Juan Gris 2/50;
signed and dated on the stone, l.l.: Juan Gris / 3-21

Publisher: Galerie Simon, Paris

Edition: 50 impressions

Ref.: Kahnweiler 3

1972:50-60

(70)

JEAN LE MUSICIEN, 1921

Lithograph printed in brown on china paper
Image: 13 x 9¼ inches (331 x 235 mm)
Sheet: 15⅞ x 12⅝ inches (404 x 321 mm)
Signed and numbered in pencil, l.l.: Juan Gris 9/50;
signed and dated on the stone, l.r.: Juan Gris / 4-21

Publisher: Galerie Simon, Paris

Edition: 50 impressions

Ref.: Kahnweiler 4

1972: 50-58

(71)

MARCELLE LA BRUNE, 1921

Lithograph printed in green on china paper
Image: 11¹³⁄₁₆ x 8¹⁵⁄₁₆ inches (300 x 228 mm)
Sheet: 15⅞ x 12¹³⁄₁₆ inches (403 x 325 mm)
Signed and numbered in pencil, l.r.: Juan Gris 44/50;
signed and dated on the stone, l.l.: Juan Gris / 3-21

Publisher: Galerie Simon, Paris

Edition: 50 impressions

Ref.: Kahnweiler 2

1972:50-59

Childe Hassam 1859 – 1935

(72)

OLD TOLL BRIDGE, 1915

Etching printed in black on wove paper
Plate: 6¹⁵⁄₁₆ x 5⁷⁄₁₆ inches (176 x 137 mm)
Sheet: 8 x 6⅝ inches (204 x 169 mm)
Monogrammed in pencil beneath image, l.r.: initialed
and dated in the plate, l.l.: CH 1915

Ref.: Clayton 33

1976:18-25

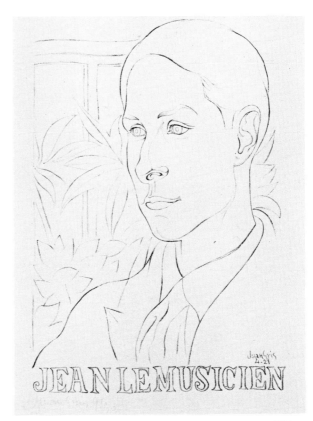

(70)

Paul Klee 1879 – 1940

(73)

BAHNHOF, 1911

Drypoint on celluloid printed in black on wove paper

Plate: 5⅞ x 7⅞ inches (150 x 200 mm)

Sheet: 10⅞ x 14⅞ inches (276 x 378 mm)

Signed in pencil, l.r.: Klee; inscribed in pencil, l.l.: Bahnhof 1911 26 21/30; dated in the plate, u.r.: 1911 26

Printer: Heinrich Wetteroth, Munich

Edition: 30 impressions

Ref.: Kornfeld 37 [b/b]

1972: 50-61

(73)

Käthe Kollwitz 1867 – 1945

(74)

SELBSTBILDNIS AM TISCH, ca. 1893

Etching and aquatint printed in brown on japan paper

Plate: 7 1/16 x 5⅛ inches (179 x 130 mm)

Sheet: 13¾ x 9⅝ inches (349 x 244 mm)

Publisher: A. von der Becke, Berlin, 1931

Ref.: Klipstein 14 5[a]/5[b]

1976: 18-27

(75)

ZWEI SCHWÄTZENDE FRAUEN MIT ZWEI KINDERN, 1930

Lithograph printed in black on wove paper

Image: 11 13/16 x 10⅛ inches (300 x 257 mm)

Sheet: 19⅞ x 14⅜ inches (505 x 364 mm)

Signed in pencil, l.r.: Käthe Kollwitz

Edition: approximately 150 impressions

Ref.: Klipstein 240 c/c

1976: 18-26

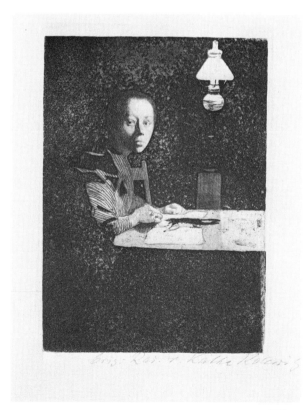

(74)

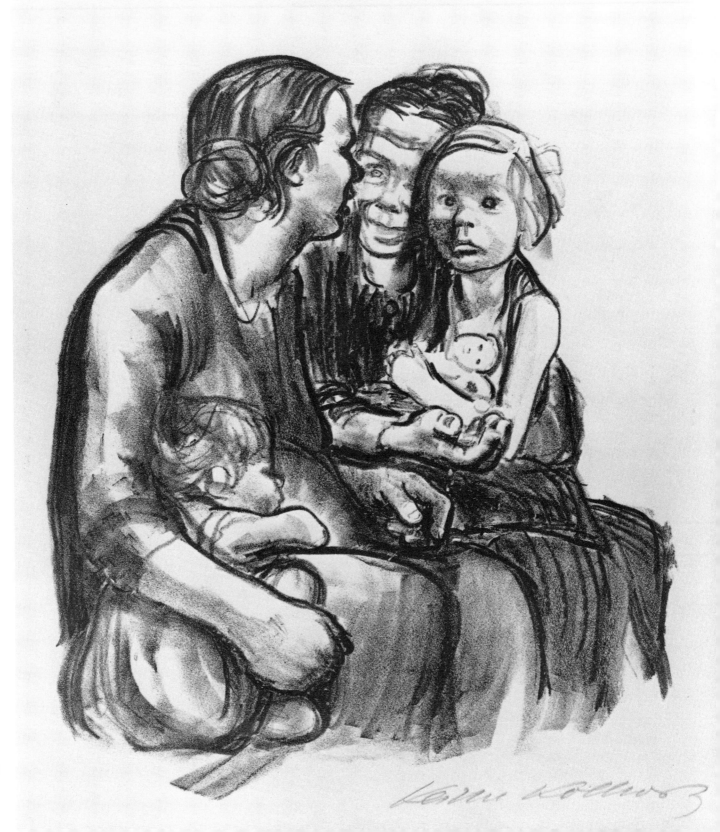

(75)

(77:1)

(77:7)

(77:15)

Marie Laurencin 1885 – 1956

(76)

SELF-PORTRAIT

Lithograph printed in two colors on japan paper
Image: 8½ x 6 inches (216 x 153 mm)
Sheet: 11¾ x 9⅛ inches (298 x 233 mm)
Signed and numbered in pencil, l.r.: 14/30 Marie
Laurencin
1978:18-28

Aristide Maillol 1861 – 1944

(77)

DAPHNIS ET CHLOÉ, BOIS ORIGINAUX D'ARISTIDE
MAILLOL, ca. 1937
Portfolio of forty-nine woodcuts printed in black on
laid paper
Sheets: 7⅞ x 5⅛ inches (200 x 130 mm)
Printer: Philippe Gonin, Paris
Publisher: Philippe Gonin, Paris

77:1 CHLOE BATHING
Image: 2⅝ x 3 1/16 inches (67 x 78 mm)
Ref.: Rewald 69
1976:18-115[1]

77:2 DAPHNIS AND CHLOE
Image: 3¾ x 2 inches (95 x 50 mm)
Ref.: Rewald 70
1976:18-115[2]

77:3 THREE GOATS
Image: 4⅛ x 2¾ inches (103 x 70 mm)
Ref.: Rewald 71
1976:18-115[3]

77:4 TWO NYMPHS DANCING
Image: 3 11/16 x 2⅝ inches (92 x 67 mm)
Ref.: Rewald 72
1976:18-115[4]

77:5 DAPHNIS AND CHLOE PICKING FLOWERS
Image: 3⅜ x 3⅜ inches (85 x 85 mm)
Ref.: Rewald 75
1976:18-115[5]

77:6 DAPHNIS PLAYING HIS PIPE FOR CHLOE
Image: 3⅞ x 3⅞ inches (99 x 99 mm)
Ref.: Rewald 76
1976:18-115[6]

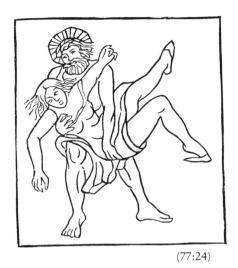

(77:24)

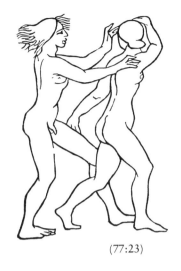

(77:23)

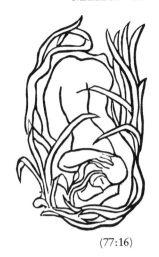

(77:16)

77:7 DAPHNIS PLAYING HIS PIPE FOR CHLOE
Image: 3⅜ x 3⅜ inches (85 x 85 mm)
Ref.: Rewald 77
1976:18-115[7]

77:8 CHLOE WASHING DAPHNIS IN THE CAVE OF THE NYMPHS
Image: 3³⁄₁₆ x 3³⁄₁₆ inches (84 x 84 mm)
Ref.: Rewald 78
1976:18-115[8]

77:9 CHLOE KISSES DAPHNIS
Image: 4⁵⁄₁₆ x 2 inches (109 x 50 mm)
Ref.: Rewald 79
1976:18-115[9]

77:10 CHLOE PUTS A CHAPLET UPON DAPHNIS' HEAD
Image: 3⅜ x 3⅜ inches (85 x 85 mm)
Ref.: Rewald 80
1976:18-115[10]

77:11 DAPHNIS TEACHES CHLOE TO PLAY ON THE PIPE
Image: 3¹¹⁄₁₆ x 3¹⁄₁₆ inches (93 x 81 mm)
Ref.: Rewald 81
1976:18-115[11]

77:12 DAPHNIS OBSERVES THE SLEEPING CHLOE
Image: 2½ x 3⅜ inches (64 x 85 mm)
Ref.: Rewald 82
1976:18-115[12]

77:13 DAPHNIS DRAWS THE GRASSHOPPER FROM CHLOE'S BOSOM
Image: 3⅝ x 3³⁄₁₆ inches (92 x 81 mm)
Ref.: Rewald 83
1976:18-115[13]

77:14 CHLOE CASTING DAPHNIS INTO HER ARMS
Image: 3¹⁵⁄₁₆ x 3⅜ inches (100 x 85 mm)
Ref.: Rewald 84
1976:18-115[14]

77:15 CHLOE WASHING HER NAKED LIMBS
Image: 3⅞ x 3⅜ inches (98 x 86 mm)
Ref.: Rewald 85
1976:18-115[15]

77:16 CHLOE BATHING
Image: 3 x 1¾ inches (76 x 45 mm)
Ref.: Rewald 86
1976:18-115[16]

(77:27)

(77:29)

(77:28)

77:17 THE VINTAGE
Image: 2¹³⁄₁₆ x 3⁷⁄₁₆ inches (71 x 87 mm)
Ref.: Rewald 87
1976:18-115[17]

77:18 PHILETAS SPEAKING TO DAPHNIS AND CHLOE
Image: 3¹¹⁄₁₆ x 3⅜ inches (94 x 96 mm)
Ref.: Rewald 88
1976:18-115[18]

77:19 THREE GOATS
Image: 2¾ x 2½ inches (70 x 64 mm)
Ref.: Rewald 89
1976:18-115[19]

77:20 DAPHNIS AND CHLOE SITTING CLOSE TOGETHER
Image: 3¹¹⁄₁₆ x 3⅜ inches (94 x 85 mm)
Ref.: Rewald 90
1976:18-115[20]

77:21 DAPHNIS AND CHLOE RUN SMILING TOGETHER
[without border]
Image: 3¹⁵⁄₁₆ x 2⁵⁄₁₆ inches (100 x 58 mm)
Ref.: Rewald 92
1976:18-115[21]

77:22 DAPHNIS AND CHLOE EMBRACE ONE ANOTHER
Image: 2¾ x 3⅜ inches (70 x 85 mm)
Ref.: Rewald 93
1976:18-115[22]

77:23 DAPHNIS AND CHLOE PLAYING [without border]
Image: 4 x 2⅞ inches (102 x 72 mm)
Ref.: Rewald 95
1976:18-115[23]

77:24 METHYMNAEAN CARRYING CHLOE AWAY
Image: 3⁹⁄₁₆ x 3⅜ inches (90 x 85 mm)
Ref.: Rewald 96
1976:18-115[24]

77:25 DAPHNIS RUSHING INTO THE EMBRACES
OF CHLOE
Image: 3¹¹⁄₁₆ x 3¼ inches (93 x 82 mm)
Ref.: Rewald 98
1976:18-115[25]

77:26 DAPHNIS AND CHLOE SACRIFICING A
CROWNED GOAT
Image: 3⅝ x 3⅛ inches (92 x 79 mm)
Ref.: Rewald 99
1976:18-115[26]

(77:30)

(77:35)

(77:33)

77:27 SYRINX DISAPPEARS IN A GROVE OF REEDS
Image: 2¹⁵⁄₁₆ x 3⅜ inches (77 x 85 mm)
Ref.: Rewald 100
1976:18-115[27]

77:28 DAPHNIS DRIVING HOME HIS FLOCK
Image: 3¹⁄₁₆ x 3½ inches (78 x 88 mm)
Ref.: Rewald 102
1976:18-115[28]

77:29 THREE GOATS RESTING
Image: 1⅞ x 3⅜ inches (47 x 86 mm)
Ref.: Rewald 103
1976:18-115[29]

77:30 DAPHNIS AND CHLOE REMEMBER THEIR
SWEET CONVERSATION
Image: 2¾ x 3⅜ inches (69 x 86 mm)
Ref.: Rewald 104
1976:18-115[30]

77:31 DAPHNIS AND CHLOE IN DRYAS' HOUSE
Image: 3⅞ x 3⅜ inches (99 x 85 mm)
Ref.: Rewald 105
1976:18-115[31]

77:32 DAPHNIS LIFTS CHLOE UP
Image: 4⁵⁄₁₆ x 3⁵⁄₁₆ inches (110 x 84 mm)
Ref.: Rewald 106
1976:18-115[32]

77:33 LYCAENIUM TEACHES DAPHNIS THE
SECRETS OF LOVE
Image: 3¼ x 3⅝ inches (82 x 92 mm)
Ref.: Rewald 108
1976:18-115[33]

77:34 THE ECHO, DAUGHTER OF A NYMPH
Image: 4⁹⁄₁₆ x 2⁷⁄₁₆ inches (116 x 62 mm)
Ref.: Rewald 109
1976:18-115[34]

77:35 CHLOE KISSES DAPHNIS
Image: 2⅞ x 2⅜ inches (73 x 60 mm)
Ref.: Rewald 110
1976:18-115[35]

77:36 DAPHNIS PULLS AN APPLE FOR CHLOE
Image: 3⅜ x 3⁷⁄₁₆ inches (86 x 88 mm)
Ref.: Rewald 111
1976:18-115[36]

(77:38)

(77:41)

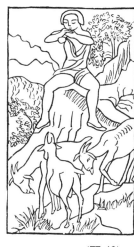

(77:43)

77:37 DAPHNIS PUTS THE APPLE INTO CHLOE'S BOSOM
Image: 3½ x 3⁷⁄₁₆ inches (90 x 88 mm)
Ref.: Rewald 112
1976:18-115[37]

77:38 DAPHNIS PUTS THE APPLE INTO CHLOE'S BOSOM
Image: 3⁵⁄₈ x 3⁵⁄₁₆ inches (92 x 84 mm)
Ref.: Rewald 113
1976:18-115[38]

77:39 THREE GOATS
Image: 3¼ x 3½ inches (83 x 89 mm)
Ref.: Rewald 114
1976:18-115[39]

77:40 DAPHNIS AND CHLOE AT PLAY
Image: 3⁵⁄₈ x 3 inches (92 x 76 mm)
Ref.: Rewald 115
1976:18-115[40]

77:41 CHLOE HELPS DAPHNIS WITH HIS GOATS
Image: 3⁷⁄₁₆ x 3¹¹⁄₁₆ inches (88 x 99 mm)
Ref.: Rewald 117
1976:18-115[41]

77:42 THREE GOATS
Image: 3³⁄₈ x 3¼ inches (86 x 82 mm)
Ref.: Rewald 118
1976:18-115[42]

77:43 DAPHNIS PLAYS TO HIS GOATS
Image: 4¾ x 2¾ inches (121 x 70 mm)
Ref.: Rewald 119
1976:18-115[43]

77:44 LAMPUS RAVISHING CHLOE AWAY
Image: 4⁹⁄₁₆ x 1⁷⁄₈ inches (116 x 47 mm)
Ref.: Rewald 120
1976:18-115[44]

77:45 DAPHNIS AND CHLOE
Image: 4⁵⁄₈ x 2⅛ inches (117 x 53 mm)
Ref.: Rewald 121
1976:18-115[45]

77:46 CHLOE IS GIVEN TO DAPHNIS [without border]
Image: 4⅞ x 1¹⁵⁄₁₆ inches (125 x 49 mm)
Ref.: Rewald 122
1976:18-115[46]

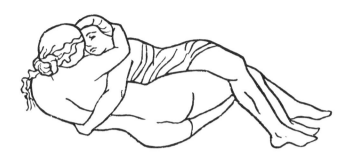

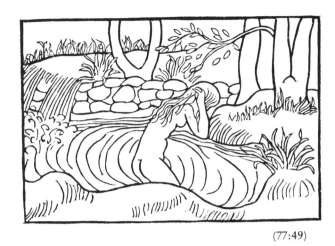

(77:47)

(77:49)

77:47 DAPHNIS AND CHLOE LYING NAKED TOGETHER
Image: 2⅜ x 3⅞ inches (60 x 99 mm)
Ref.: Rewald 124
1976:18-115[47]

77:48 DAPHNIS AND CHLOE LYING NAKED TOGETHER
Image: 1½ x 4¼ inches (38 x 109 mm)
Ref.: Rewald 125
1976:18-115[48]

77:49 CHLOE BATHING IN THE CAVE OF THE NYMPHS
Image: 3⅛ x 4¹¹⁄₁₆ inches (80 x 120 mm)
Ref.: Rewald 126
1976:18-115[49]

Note: This portfolio and no. 78 are sets of the woodcuts Maillol made for Longus Sophista, Daphnis and Chloe *(London, A. Swemmer, 1937). See Garvey,* Artist and the book, *174 (Daphnis and Chloe).*

(78)

DAPHNIS ET CHLOÉ, BOIS ORIGINAUX D'ARISTIDE MAILLOL, ca. 1937
Portfolio of fifty woodcuts printed in red on laid paper
Sheets: 7⅞ x 5⅛ inches (200 x 130 mm)
Printer: Philippe Gonin, Paris

Publisher: Philippe Gonin, Paris
Ref.: Rewald 69-71, 74-90, 92-93, 95-96, 98-100, 102-6, 108-15, 117-22, 124-27
1976:18-116
Note: This portfolio is identical to no. 77 except for the color of ink and the addition of four initials, W, T, B and A (Rewald 127), printed on one sheet.

(79)
DAPHNIS PLAYING HIS PIPE FOR CHLOE, ca. 1937
For the portfolio *Daphnis et Chloé, bois originaux d'Aristide Maillol*
Woodcut printed in red on laid paper
Image: 3⁵⁄₁₆ x 3⁵⁄₁₆ inches (84 x 84 mm)
Sheet: 8½ x 5⅜ inches (216 x 136 mm)
Printer: Philippe Gonin, Paris
Publisher: Philippe Gonin, Paris
Ref.: Rewald 76
1976:18-29
Note: see also nos. 77 and 78

Edouard Manet 1832 – 1883

(80)

CHAPEAU ET GUITARE

Cover for the portfolio *Edouard Manet eaux-fortes*, 1874

Etching and aquatint printed in black on blue wove paper

Plate: 9¹⁄₁₆ x 8⁹⁄₁₆ inches (230 x 217 mm)

Sheet (folded): 18 x 15¾ inches (458 x 400 mm)

Numbered and initialed in ink, ctr.: 22 / EM; dated in the plate, u.l.: 1874; inscribed in the plate, l.l.: A. Cadart, imprimeur, Paris

Publisher: Alfred Cadart, Paris, 1874

Edition: 50 impressions

Ref.: Guérin 62 ii/iii; Harris 39 ii/iii; Wilson 68 ii/vi

1972:50-62

Note: This etching was drawn on the plate in about 1863, but only a few impressions were made at that time. The plate was subsequently cut down and printed as the cover and frontispiece of Manet's 1874 portfolio. The etching was reprinted posthumously in 1890 and again in 1894 and 1905 after the inscriptions had been erased from the plate. See no. 81.

(81)

CHAPEAU ET GUITARE

Etching, aquatint and roulette printed in black on Van Gelder laid paper, proof for posthumous edition

Plate: 9¹⁄₁₆ x 8⁹⁄₁₆ inches (230 x 217 mm)

Sheet: 17⅝ x 12⅜ inches (448 x 314 mm)

Inscribed in pencil, l.l.: Bon à tirer pour . . . [?]

Publisher: M. Dumont, Paris, 1894, or Alfred Strölin, Paris, 1905

Edition: 30 impressions printed in 1894, 100 impressions printed in 1905

Ref.: Guérin 62 iii/iii; Harris 39 iii/iii; Wilson 68 v/vi

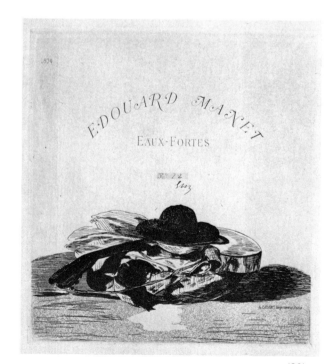

(80)

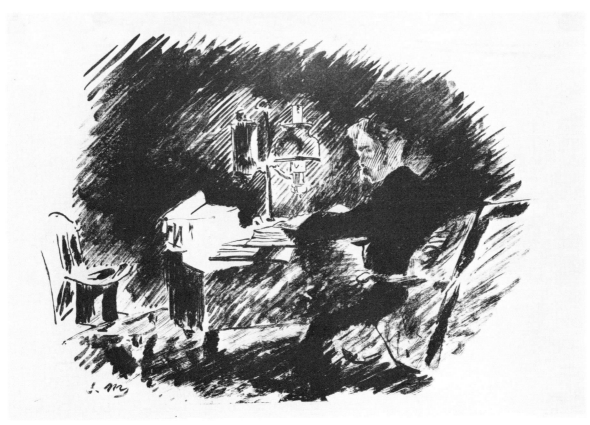

(82)

1972:50-63
Note: See no. 80.

(82)
UNDER THE LAMP, 1875
For Edgar Allan Poe, *Le corbeau; The raven*, Stéphane Mallarmé trans.
Transfer lithograph on zinc printed in black on china paper
Image: 10⅞ x 15 inches (276 x 381 mm)
Sheet: 11¾ x 17½ inches (299 x 445 mm)
Initialed on the stone, l.l.: EM
Printer: Lefman, Paris
Publisher: Richard Lesclide, Paris

Edition: the text edition was issued in an edition of 240 copies with lithographs printed on either china or holland paper; some copies with a double set of lithographs
Ref.: Guérin 86ᵃ; Harris 83ᵇ; Garvey, *Artist and the book*, 178 (*Le corbeau; The raven*)
1972:50-64

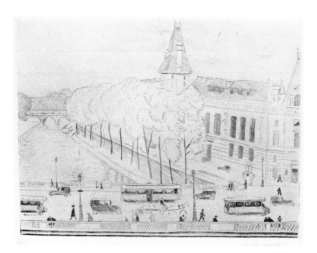

(84)

Pierre-Albert Marquet 1875 – 1947

(83)

NOTRE-DAME

Lithograph printed in black on wove paper
Image: 6¹³⁄₁₆ x 4⅞ inches (173 x 124 mm)
Sheet: 13⅜ x 10⅛ inches (339 x 257 mm)
Signed in pencil, l.r.: Marquet; inscribed in pencil,
l.l.: K/Z
1976:18-32

(84)

PONT SAINT-MICHEL

Etching, drypoint and aquatint printed in black on Rives
wove paper
Plate: 9¹⁄₁₆ x 12 inches (231 x 305 mm)
Sheet: 11⅛ x 15 inches (283 x 381 mm)
Signed in pencil, l.r.: Marquet; numbered in pencil, l.l.:
27/80
Edition: 80 impressions
1976:18-33

Henri Matisse 1869 – 1954

(85)

BUSTE DE FEMME ACCOUDÉE AVEC BRACELETS ET
COLLIER, 1925

Frontispiece for Waldemar George, *Henri Matisse* (Paris,
Editions de Quatre Chemins)

Etching printed in black on mounted china paper, plate
208
Plate: 3½ x 4⅝ inches (90 x 118 mm)
Sheet: 10⁵⁄₁₆ x 8⅜ inches (262 x 213 mm)
Signed and numbered in pencil, l.r.: 14/100 Henri
Matisse; signed and dated in the plate: l.l.: Henri
Matisse 1925
Edition: 100 impressions
Ref.: Fribourg 73 ii/ii
1972: 50-65

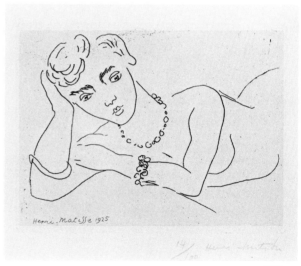

(85)

(86)

DIX DANSEUSES, 1927

Portfolio of ten lithographs printed in black on japan paper with an introduction by Waldemar George

Sheets: 19¾ x 12¾ inches (502 x 324 mm)

Signed and numbered in pencil on each sheet, l.l. or l.r.: 4/15 / Henri Matisse; portfolio numbered in ink on the colophon: 9

Printer: Duchâtel, Paris

Publisher: Galerie d'Art Contemporain, Paris

Edition: 158 numbered copies (1-5 on china paper, 6-20 on japan, 21-150 on Arches wove, I-VIII (or A-H) *hors commerce* on Arches wove). Copy no. 9.

86:1 DANSEUSE AU TABOURET,
plate 90 or 95
Image: 17⅞ x 11 inches (454 x 279 mm)
Ref.: Fribourg 436; Duthuit-Matisse 481
1972:50-66°

86:2 DANSEUSE ASSISE (EN HAUTEUR),
plate 91 or 93
Image: 17 x 10¾ inches (432 x 272 mm)
Ref.: Fribourg 437; Duthuit-Matisse 480
1972:50-66ᵉ

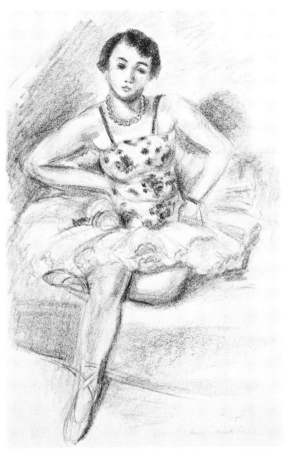

(86:4)

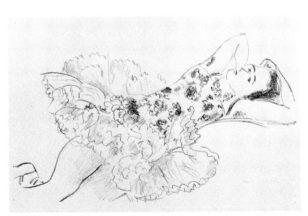

(86:3)

86:3 DANSEUSE ENDORMIE AU DIVAN,
plate 91 or 99
Image: 11 x 18 inches (279 x 459 mm)
Ref.: Fribourg 438; Duthuit-Matisse 485
1972:50-66ᵃ

86:4 DANSEUSE ÉTENDUE AU DIVAN (MAINS À LA NUQUE), plate 93
Image: 11 x 17¹⁵⁄₁₆ inches (279 x 456 mm)
Ref.: Fribourg 439; Duthuit-Matisse 484
1972:50-66ᵍ

86:5 Danseuse au divan, pliée en deux, plate 98
Image: 11⅛ x 18 inches (282 x 458 mm)
Ref.: Fribourg 440; Duthuit-Matisse 489
1972:50-66[i]

86:6 Danseuse au fauteuil en bois, plate 95 or 97
Image: 18⅛ x 10⅛ inches (460 x 269 mm)
Ref.: Fribourg 441; Duthuit-Matisse 483
1972:50-66[f]

86:7 Danseuse étendue, plate 97 or 90
Image: 9⅝ x 16⅜ inches (249 x 416 mm)
Ref.: Fribourg 442; Duthuit-Matisse 488
1972:50-66[m]

86:8 Danseuse allongée, tête accoudée, plate 94
Image: 6⅛ x 16¹⁵⁄₁₆ inches (155 x 415 mm)
Ref.: Fribourg 443; Duthuit-Matisse 486
1972:50-66[k]

86:9 Danseuse couchée, plate 96
Image: 10½ x 18 inches (266 x 258 mm)
Ref.: Fribourg 444; Duthuit-Matisse 487
1972:50-66[c]

86:10 Danseuse debout, accoudée, plate 99 or 91
Image: 18⅛ x 11 inches (461 x 279 mm)
Ref.: Fribourg 445; Duthuit-Matisse 482
1972:50-66[q]

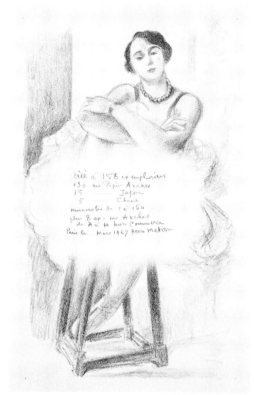

(87) (87)

Eight cancelled plates from *Dix danseuses*, 1927
Lithographs printed in black on Arches wove paper
Sheets: 19⅞ x 12¹⁵⁄₁₆ inches (505 x 329 mm)
Inscribed and signed on the stones, ctr.: tiré à 158 exemplaires / 130 sur papier Arches / 15 - Japon / 5 - Chine / numerotés de 1 á 150 / plus 8 sur Arches de A á H / hors commerce / Paris le mars 1927 Henri Matisse
Ref.: cancelled Matisse-Duthuit 481-2, 484-9
1972: 50-66[b,d,h,j,l,n,p,r]

Note: These eight impressions were acquired with the portfolio Dix danseuses *(no. 87). The center of each image has been erased and the* justification *of the edition inscribed by Matisse on this area of the stone.*

(88)

(88)

Tête de femme se reposant sur bras croisés, 1929

Etching printed in black on mounted china paper, plate 176

Plate: 4 x 5¾ inches (101 x 147 mm)

Sheet: 11⅛ x 14¹⁵⁄₁₆ inches (282 x 380 mm)

Signed and numbered in pencil, l.r.: 3/25 / Henri Matisse

Edition: 25 impressions plus 3 trial proofs

Ref.: Fribourg 193; Duthuit-Matisse 168 (*Jeune femme le visage enfoui dans les bras*)

1972:50-67

(89)

Jeune fille se coiffant, 1934/35

Etching printed in black on mounted china paper, plate 217

Plate: 4 x 5⁹⁄₁₆ inches (145 x 109 mm)

Sheet: 14¹³⁄₁₆ x 11 inches (361 x 279 mm)

Signed and numbered in pencil, l.r.: 14/25 Henri Matisse

Edition: 25 signed and numbered impressions plus 5 trial proofs

Ref.: Fribourg 230; Duthuit-Matisse 242 (*Jeune fille arrangeant ses cheveux*)

1972:50-68

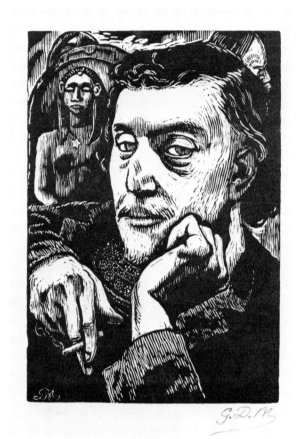

(91)

After Henri Matisse

(90)

PETIT INTÉRIEUR BLEU, ca. 1952

Aquatint printed in six colors on Arches wove paper

Plate: 20 x 16¾ inches (508 x 427 mm)

Sheet: 28⅛ x 22⅛ inches (714 x 562 mm)

Numbered in pencil, l.l.: 140/200

Printer: Roger Lacourière, Paris

Publisher: Maeght, Paris

Edition: 200 impressions

Ref.: Duthuit-Matisse IV

1984:10-72

Georges Daniel Monfried
1856 – 1929

(91)

PORTRAIT OF PAUL GAUGUIN

Wood engraving printed in black on japan paper

Image: 6⅞ x 4¹³⁄₁₆ inches (174 x 123 mm)

Sheet: 11 x 8¾ inches (279 x 222 mm)

Monogrammed in block, l.l.; initialed in ink, l.r.:

G.D.M.; numbered in pencil, l.l.: 27/100

Edition: 100 impressions

1975:24-1

Ernest de Montfort

(92)

MONSIEUR ECARTELANCE

Etching printed in black on wove paper with notations in pencil, proof

Plate: 12⅜ x 8¾ inches (314 x 222 mm)

Sheet: 13 x 10⅛ inches (330 x 257 mm)

Signed in the plate, l.ctr.: E. Montfort; titled in the plate, u.ctr. (in reverse): Monsieur Ecartelance; inscribed in the plate, l.l.: 88

1976:18-34

(93)

COPPER PLATE FOR MONSIEUR ECARTELANCE

12½ x 8⅞ inches (317 x 225 mm)

1976:18-35

Edvard Munch 1863 – 1944

(94)

Christiania-Bohême i, 1895

Etching and drypoint printed in black on wove paper

Plate: 8⅝ x 11¾ inches (219 x 299 mm)

Sheet: 12¼ x 16¼ inches (310 x 413 mm)

Signed in pencil, l.r.: Edv. Munch

Printer: O. Felsing, Berlin

Ref.: Schiefler 10 iid/iid; Willoch 9 iii/iii

1972:50-69

(95)

Zwei Menschen (Die Einsamen), 1895

Drypoint and roulette printed in black on wove paper, proof

Plate: 6⅝ x 8¹⁵⁄₁₆ inches (168 x 227 mm)

Sheet: 9½ x 12⅞ inches (241 x 327 mm)

Signed and annotated in pencil, l.r.: E Munch / Probe-druck

Printer: Sabo and Angerer, Berlin

Ref.: Schiefler 20 i/v; Willoch 19 i/v

1972:50-70

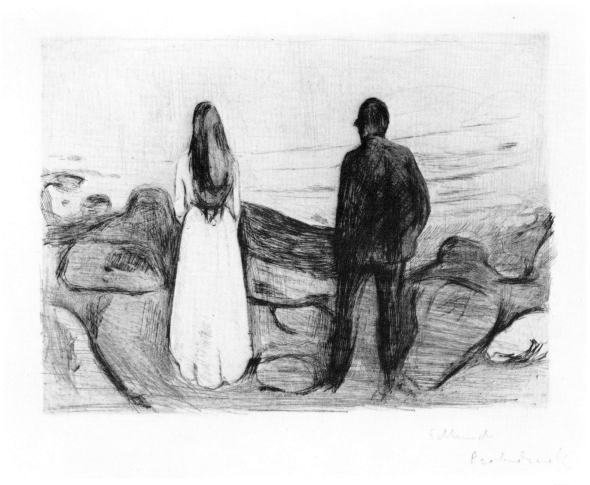

(95)

(96)

Begegnung in Weltall, 1899
Woodcut printed in three colors, from one block cut
into three pieces, on china paper
Image: 5⁵⁄₁₆ x 8¼ inches (151 x 210 mm)
Sheet: 8¹¹⁄₁₆ x 11¼ inches (221 x 285 mm)
Ref.: Schiefler 135
1972:50-71

(97)

Kinderkopf, 1905
Drypoint printed in black on Van Gelder wove paper
Plate: 4 x 4⅛ inches (101 x 109 mm)
Sheet: 13¹¹⁄₁₆ x 9¹¹⁄₁₆ inches (348 x 246 mm)
Printer: O. Felsing, Berlin
Ref.: Schiefler 220; Willoch 113 *(Portrait of Herbert
Esche's daughter)*
1972:50-72

(98)

Männerkopf, 1906
Drypoint printed in black on wove paper
Plate: 4⅝ x 3⅜ inches (118 x 86 mm)
Sheet: 10⅛ x 7⅛ inches (260 x 184 mm)
Printer: O. Felsing, Berlin
Ref.: Schiefler 243; Willoch 128
1972:50-73

(99)

Norwegische Landschaft, 1908-9
Drypoint printed in black on laid paper
Plate: 4 x 5⅞ inches (103 x 150 mm)
Sheet: 7⅛ x 8¹⁵⁄₁₆ inches (182 x 228 mm)
Ref.: Schiefler 268 ii/ii; Willoch 268 iii/iii
1984:10-73

(100)

Schatten, 1908-9
For the suite *Alpha og Omega*
Lithograph printed in black on wove paper
Image: 9⅞ x 19⁵⁄₁₆ inches (225 x 491 mm)
Sheet: 11³⁄₁₆ x 21⁵⁄₁₆ inches (284 x 541 mm)
Ref.: Schiefler 313
1972:50-74

(101)

Mädchenporträt, 1912
Woodcut printed in black on brown wove paper, proof
Image: 21¾ x 13¾ inches (552 x 350 mm)
Sheet: 26⅛ x 17¼ inches (663 x 438 mm)
Signed and annotated in pencil, l.r.: E. Munch / Probe-
druck T---[?]--- Tryk [?]
Ref.: Schiefler 388[a/b]
1972:50-75

(102)

Der Löwenbändiger, 1916
Lithograph printed in black on wove paper
Image: 19½ x 26 inches (495 x 665 mm)
Sheet: 22⅞ x 29⅝ inches (581 x 750 mm)
Signed in pencil, l.r.: Edv Munch
Ref.: Schiefler 456[b/c]
1978:1-17

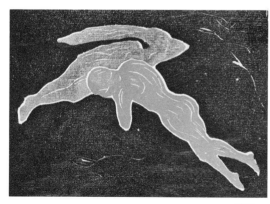

(96)

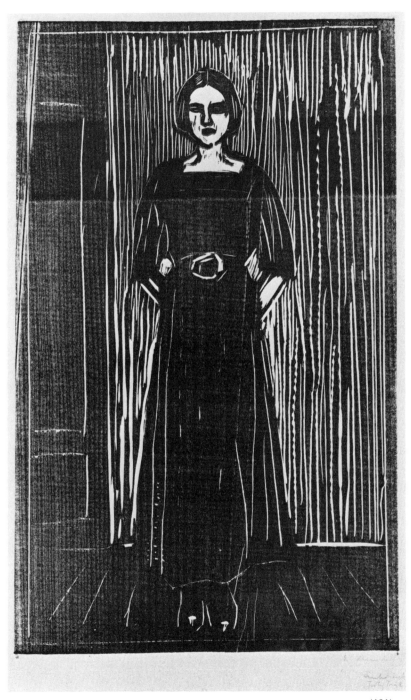

(101)

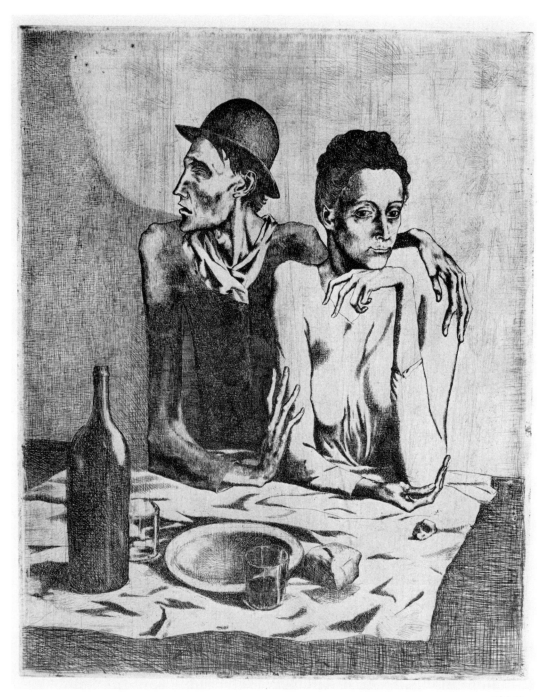

(104:1)

After Edvard Munch

(103)

17 VIGNETTES, 1928

For Gustav Schiefler, *Edvard Munch, Das Graphische Werk, 1906-1926*

Linecuts printed in black on one sheet of japan paper
Image: 13⅞ x 9¾ inches (357 x 247 mm)
Sheet: 22¾ x 15⅞ inches (578 x 403 mm)
1972:50-76

Pablo Picasso 1881 – 1973

(104)

SALTIMBANQUES, 1913

Suite of fourteen etchings and drypoints printed in black on Van Gelder wove paper from steel-faced plates
Printer: Louis Fort, Paris
Publisher: Ambroise Vollard, Paris
Edition: 279 impressions (250 on Van Gelder wove paper; 29 on old japan paper)

104:1 LE REPAS FRUGAL, ca. 1904
Etching printed in black on Van Gelder wove paper
Plate: 18¼ x 14⅞ inches (463 x 378 mm)
Sheet: 26 x 20 inches (660 x 508 mm)
Ref.: Geiser 2 iib/iib; Bloch 1
1970:18-2

104:2 TÊTE DE FEMME, ca. 1904
Etching printed in black on Van Gelder wove paper
Plate: 4¹¹⁄₁₆ x 3⅜ inches (119 x 87 mm)
Sheet: 19½ x 12¹³⁄₁₆ inches (495 x 326 mm)
Ref.: Geiser 3b; Bloch 2
1970:18-1

104:3 LES PAUVRES, ca. 1904
Etching printed in black on Van Gelder wove paper
Plate: 9¼ x 7 inches (235 x 179 mm)
Sheet: 19¾ x 11 inches (505 x 330 mm)
Ref.: Geiser 4 iib/iib; Bloch 3
1970:18-3

104:4 L' ABREUVOIR, ca. 1904
Drypoint printed in black on Van Gelder wove paper
Plate: 4¹³⁄₁₆ x 3⁷⁄₁₆ inches (122 x 187 mm)
Sheet: 12⅞ x 19¹⁵⁄₁₆ inches (328 x 507 mm)
Ref.: Geiser 10b; Bloch 8
1970:18-7

104:5 AU CIRQUE, ca. 1904
Drypoint printed in black on Van Gelder wove paper
Plate: 8⅝ x 5½ inches (220 x 140 mm)
Sheet: 19⁵⁄₁₆ x 12⅞ inches (492 x 328 mm)
Ref.: Geiser 11b; Bloch 9
1970:18-8

104:6 LE SALTIMBANQUE AU REPOS, ca. 1904
Drypoint printed in black on Van Gelder wove paper
Plate: 4¾ x 3½ inches (120 x 89 mm)
Sheet: 19⅜ x 12¾ inches (492 x 323 mm)
Ref.: Geiser 12b; Bloch 10
1970:18-9

104:7 LA TOILETTE DE LA MÈRE, ca. 1904
Etching printed in black on Van Gelder wove paper
Plate: 9¼ x 7 inches (235 x 178 mm)
Sheet: 20 x 13 inches (508 x 330 mm)
Ref.: Geiser 15b; Bloch 13
1970:18-12

104:8 BUSTE D'HOMME, 1905
Drypoint printed in black on Van Gelder wove paper
Plate: 4¾ x 3¹¹⁄₁₆ inches (120 x 93 mm)
Sheet: 19⁷⁄₁₆ x 12⅞ inches (493 x 327 mm)
Signed and dated in the plate, u.l.: Picasso / 2-05
Ref.: Geiser 5b; Bloch 4
1970:18-4

104:9 LES DEUX SALTIMBANQUES, 1905
Drypoint printed in black on Van Gelder wove paper
Plate: 4¾ x 3⅝ inches (126 x 92 mm)
Sheet: 19¾ x 13 inches (501 x 330 mm)
Signed in the plate, u.l.: Picasso; initialed and dated in
the plate in vertical arrow, u.l.: P 1905
Ref.: Geiser 6[b]; Bloch 5
1970:18-5

104:10 TÊTE DE FEMME, DE PROFIL, 1905
Drypoint printed in black on Van Gelder wove paper
Plate: 11½ x 9⅞ inches (293 x 250 mm)
Sheet: 26 x 19⅞ inches (660 x 505 mm)
Ref.: Geiser 7[b]; Bloch 6
1970:18-15

104:11 LES SALTIMBANQUES, 1905
Drypoint printed in black on Van Gelder wove paper
Plate: 11⅜ x 12⅞ inches (288 x 328 mm)
Sheet: 19⅞ x 25¹¹⁄₁₆ inches (505 x 652 mm)
Signed and dated in the plate, l.r.: Picasso / 1905
Ref.: Geiser 9[b]; Bloch 7
1970:18-6

104:12 LE BAIN, 1905
Drypoint printed in black on Van Gelder wove paper
Plate: 13½ x 11⁵⁄₁₆ inches (343 x 287 mm)
Sheet: 25⅞ x 19¹¹⁄₁₆ inches (657 x 500 mm)
Signed and dated in the plate, u.r.: Picasso / 1905
Ref.: Geiser 14[b]; Bloch 12
1970:18-11

104:13 SALOMÉ, 1905
Drypoint printed in black on Van Gelder wove paper
Plate: 17⅞ x 13¹¹⁄₁₆ inches (405 x 347 mm)
Sheet: 26 x 19⅞ inches (660 x 505 mm)
Signed and dated in the plate, u.r.: Picasso / 1905
Ref.: Geiser 17[b]; Bloch 14
1970:18-13

104:14 LA DANSE, 1905
Drypoint printed in black on Van Gelder wove paper
Plate: 7¼ x 9⅛ inches (184 x 232 mm)
Sheet: 12¹⁵⁄₁₆ x 19⅞ inches (329 x 505 mm)
Ref.: Geiser 18[b]; Bloch 15
1970:18-14

Note: Vollard acquired fifteen Saltimbanque *plates in 1913 and turned them over to Fort for steel-facing and printing. During the process of steel-facing, one of the plates was damaged (no. 105), reducing the suite to fourteen images. Before Vollard acquired the plates, Auguste Delâtre had printed thirty impressions of* Le repas frugal *and a few proofs of the other plates.*

(105)

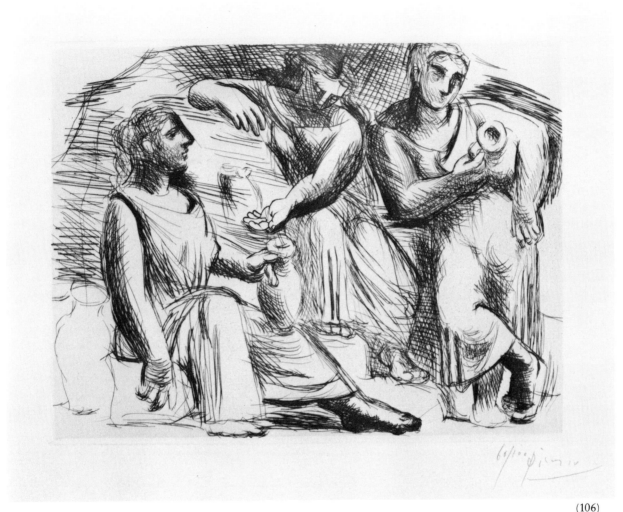

(106)

(105)

LA FAMILLE DE SALTIMBANQUES AU MACAQUE, 1905

Drypoint printed in black on Van Gelder wove paper from the steel-faced plate

Plate: 9¼ x 7 1/16 inches (236 x 179 mm)

Sheet: 20 x 13 inches (158 x 331 mm)

Printer: Louis Fort, Paris, 1913

Ref.: Geiser 13[b]; Bloch 11

1970:18-10

Note: This print was to have been included in the suite,

Saltimbanques, *but imperfect oxidation of the plate during steel-facing caused Vollard to destroy the greater number of the impressions printed.*

(106)

LA SOURCE, 1921

Drypoint and engraving on laid paper

Plate: 7 1/16 x 9⅜ inches (179 x 238 mm)

Sheet: 13⅜ x 17¾ inches (340 x 451 mm)

Signed and numbered in pencil, l.r.: 60/100 Picasso

Printer: Leblanc & Trautmann, Paris
Publisher: Marcel Guiot, Paris
Edition: 100 impressions printed in 1929
Ref.: Geiser 61 ii/ii; Bloch 45
1972:50-77

(107)

MATERNITÉ, 1924
Etching printed in black on Arches wove paper
Plate: 19⅝ x 19¹¹⁄₁₆ inches (498 x 500 mm)
Sheet: 22⅝ x 30⅛ inches (567 x 765 mm)
Signed in pencil, l.r.: Picasso; numbered in pencil, l.l.:
19/50
Edition: 50 impressions printed in 1955
Ref.: Geiser 111bis; Bloch 70
1978:1-18

(108)

EAUX-FORTES ORIGINALES POUR LE CHEF-D'OEUVRE
INCONNU D'HONORÉ DE BALZAC, 1931
Suite of thirteen etchings printed in black on Van Gelder
wove paper from the steel-faced plates
Sheets: 15⅛ x 19¾ inches (384 x 502 mm)
Printer: Louis Fort, Paris
Publisher: Ambroise Vollard, Paris
Edition: 117 impressions (1-99 on Van Gelder wove
paper, A-H hors commerce)
Ref.: Garvey, Artist and the book, 225 (Chef-d'oeuvre
inconnu); Goeppert 20 (Chef-d'oeuvre inconnu)

108:1 SCULPTEUR DEVANT SA SCULPTURE, 1927
Plate: 7¹¹⁄₁₆ x 11 inches (195 x 279 mm)
Signed in ink, l.l.: Picasso; numbered in ink, l.l.: 39/99
Ref.: Geiser 123b; Bloch 82
1970:18-28

108:2 PEINTRE ENTRE DEUX MODÈLES, 1927
Plate: 7¹¹⁄₁₆ x 10¹⁵⁄₁₆ inches (195 x 278 mm)
Signed in ink, l.r.: Picasso; numbered in ink, l.l.: 2/99

Ref.: Geiser 124b; Bloch 83
1970:18-27

108:3 TAUREAU ET CHEVAL, 1927
Plate: 7⅝ x 10¹⁵⁄₁₆ inches (194 x 277 mm)
Signed in ink, l.r.: Picasso; numbered in ink, l.l.: 39/99
Ref.: Geiser 125b; Bloch 84
1970:18-26

108:4 PEINTRE ET MODÈLE TRICOTANT, 1927
Plate: 7¾ x 10¹⁵⁄₁₆ inches (196 x 278 mm)
Signed in ink, l.r.: Picasso; numbered in ink, l.l.: 39/99
Ref.: Geiser 126b; Bloch 85
1970:18-25

108:5 SCULPTEUR MODÈLANT, 1927
Plate: 7⅝ x 10¹⁵⁄₁₆ inches (194 x 277 mm)
Signed in ink, l.r.: Picasso; numbered in pencil, l.l.:
39/99
Ref.: Geiser 127b; Bloch 86
1970:18-24

108:6 PEINTRE CHAUVE DEVANT SON CHEVALET, 1927
Plate: 7¾ x 10¹⁵⁄₁₆ inches (196 x 277 mm)
Signed in ink, l.r.: Picasso; numbered in ink, l.l.: 39/99
Ref.: Geiser 128b; Bloch 87
1970:18-23

108:7 PEINTRE RAMASSANT SON PINCEAU, 1927
Plate: 7¾ x 10¹⁵⁄₁₆ inches (196 x 278 mm)
Signed in ink, l.r.: Picasso; numbered in ink, l.l.: 39/99
Ref.: Geiser 129b; Bloch 88
1970:18-22

108:8 PEINTRE TRAVAILLANT, 1927
Plate: 7⅝ x 10¹⁵⁄₁₆ inches (195 x 277 mm)
Signed in ink, l.r.: Picasso; numbered in ink, l.l.: 39/99
Ref.: Geiser 130b; Bloch 89
1970:18-21

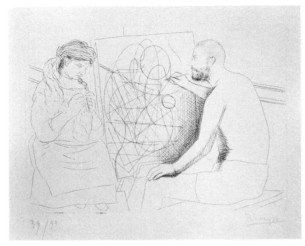

(108:4)

108:9　Trois nus debout, 1927
Plate: 7¹¹⁄₁₆ x 10¹⁵⁄₁₆ inches (195 x 277 mm)
Signed in ink, l.r.: Picasso; numbered in ink, l.l.: 2/99
Ref.: Geiser 131ᵇ; Bloch 90
1970:18-20

108:10　Nu assis entouré d'esquisses de bêtes et hommes, 1927
Plate: 7¹¹⁄₁₆ x 11 inches (195 x 278 mm)
Signed in ink, l.r.: Picasso; numbered in ink, l.l.: 39/99
Ref.: Geiser 132ᵇ; Bloch 91
1970:18-19

108:11　Peintre devant son tableau, 1927
Plate: 10¹⁵⁄₁₆ x 7¹¹⁄₁₆ inches (278 x 195 mm)
Signed in ink, l.r.: Picasso; numbered in ink, l.l.: 2/99
Ref.: Geiser 133ᵇ; Bloch 92
1970:18-18

108:12　Peintre devant son chevalet, 1927
Plate: 7¹¹⁄₁₆ x 10¹⁵⁄₁₆ inches (195 x 278 mm)
Signed in ink, l.r.: Picasso; numbered in ink, l.l.: 39/99
Ref.: Geiser 134ᵇ; Bloch 93
1970:18-17

108:13　Table des eaux-fortes, 1931
Plate: 14¾ x 11¾ inches (375 x 299 mm)
Signed in ink, l.r.: Picasso; numbered in ink, l.l.: 39/99
Ref.: Geiser 135ᵇ; Bloch 94
1970:18-16

(109)
Le cheval, 1936
For *Eaux-fortes originales pour textes de Buffon*
Aquatint and drypoint printed in black on wove paper
Image: 10¾ x 8½ inches (273 x 216 mm)
Sheet: 14⅜ x 11³⁄₁₆ inches (364 x 283 mm)
Printer: Roger Lacourière, Paris
Publisher: Martin Fabiani, Paris, 1942
Ref.: Bloch 328
1978:1-19

Note: The collection includes eighteen of Picasso's thirty-two prints inspired by the Comte de Buffon's Histoire naturelle. *Picasso received the commission from Ambroise Vollard in 1931 and completed the plates in 1936. The suite was still unpublished, however, at the time of Vollard's death in 1939. Martin Fabiani, one of Vollard's associates, finally published Picasso's prints in 1942 in book form with excerpts from the* Histoire naturelle. *The book was issued in an edition of 226 copies (five on japan super-nacré with an extra suite of etchings on china paper; 30 on japan imperial with an extra suite of etchings on china paper; 55 on Montval wove paper; 135 on Vidalon wove paper; and one suite of etchings on blue-tinted paper). In the published edition, the images were printed on paper smaller than the copper plates. Before 1942, however, and presumably even before 1939, proofs were pulled on large sheets of paper, with plate marks and full margins. There are four of these early proofs in this collection (nos. 110, 111, 119, and 126). See Garvey,* Artist and the book, *231 (Eaux-fortes originales);* Goeppert 37 *(Histoire naturelle).*

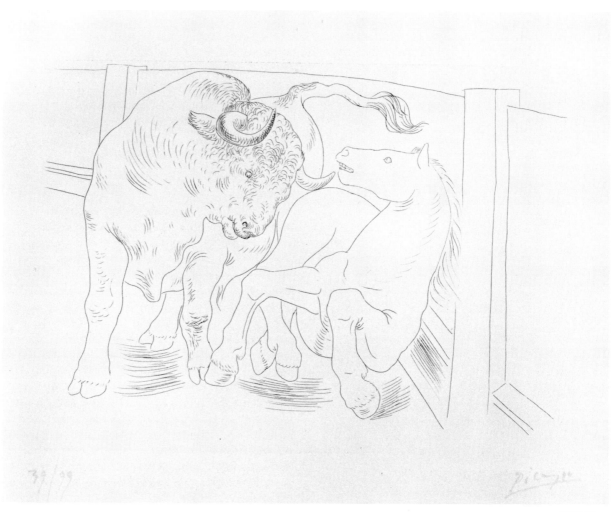

39/99 Picasso

(108:3)

(110)

L' Ane, 1936

For *Eaux-fortes originales pour textes de Buffon*

Aquatint and drypoint printed in black on Montval laid
paper

Plate: 16⁷⁄₁₆ x 12½ inches (418 x 317 mm)

Sheet: 17⁵⁄₁₆ x 13 inches (440 x 330 mm)

Signed in pencil, l.r.: Picasso; titled in the plate, l.ctr.:
L' ANE; dated in the plate, l.r. (in reverse): fevrier
XXXVI

Printer: Roger Lacourière, Paris

Edition: see no. 109

Ref.: Bloch 329

1978:1-20

(111)

Le taureau, 1936

For *Eaux-fortes originales pour textes de Buffon*

Aquatint and drypoint printed in black on Montval laid
paper

Plate: 15⁵⁄₈ x 10⁹⁄₁₆ inches (397 x 268 mm)

Sheet: 17¼ x 13⅛ inches (439 x 334 mm)

Signed in pencil, l.r.: Picasso; titled in the plate, l.ctr.:
LE TAUREAU

Printer: Roger Lacourière, Paris

Edition: see no. 109

Ref.: Bloch 330

1978:1-21

(112)

Le bélier, 1936

For *Eaux-fortes originales pour textes de Buffon*

Aquatint and drypoint printed in black on Vidalon wove
paper

Image: 10¹¹⁄₁₆ x 8⅛ inches (271 x 207 mm)

Sheet: 14⅜ x 11⅛ inches (365 x 282 mm)

Signed in pencil, l.r.: Picasso

Printer: Roger Lacourière, Paris

Publisher: Martin Fabiani, Paris, 1942

Edition: see no. 109

Ref.: Bloch 332

1978:1-22

(113)

Le chat, 1936

For *Eaux-fortes originales pour textes de Buffon*

Aquatint and drypoint printed in black on Vidalon wove
paper

Image: 10⁵⁄₈ x 8⅜ inches (270 x 213 mm)

Sheet: 14½ x 11 inches (369 x 280 mm)

Printer: Roger Lacourière, Paris

Publisher: Martin Fabiani, Paris, 1942

Edition: see no. 109

Ref.: Bloch 333

1978:1-23

(114)

Le chien, 1936

For *Eaux-fortes originales pour textes de Buffon*

Aquatint and drypoint printed in black on Vidalon wove
paper

Image: 10¾ x 8½ inches (272 x 217 mm)

Sheet: 14½ x 11 inches (370 x 280 mm)

Printer: Roger Lacourière, Paris

Publisher: Martin Fabiani, Paris, 1942

Edition: see no. 109

Ref.: Bloch 334

1978:1-24

(115)

Le singe, 1936

For *Eaux-fortes originales pour textes de Buffon*

Aquatint, drypoint and roulette printed in black on
Vidalon wove paper

Image: 11¼ x 8⅞ inches (285 x 225 mm)

Sheet: 14⁹⁄₁₆ x 11 inches (371 x 279 mm)

Printer: Roger Lacourière, Paris

Publisher: Martin Fabiani, Paris, 1942

Edition: see no. 109

Ref.: Bloch 339

1978:1-25

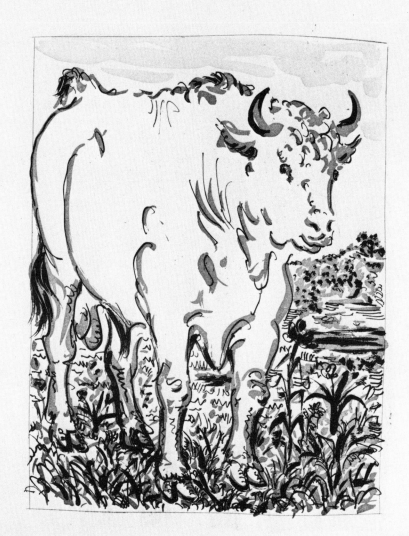

LE TAVREAV

Picasso

(111)

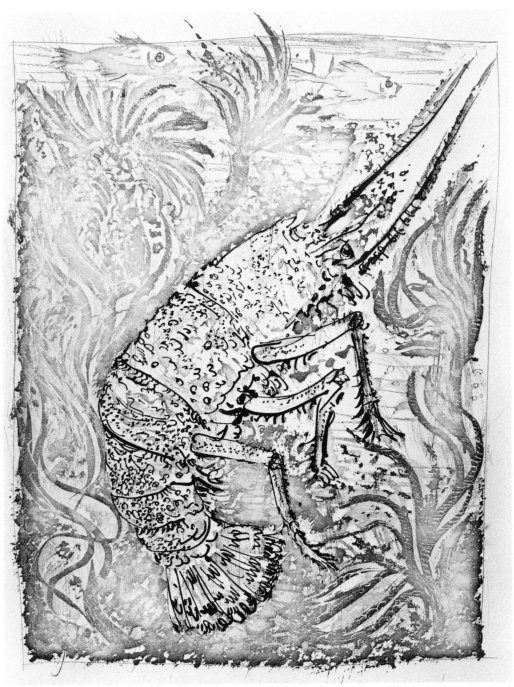

(122)

(116)

L' EPERVIER, 1936

For *Eaux-fortes originales pour textes de Buffon*

Aquatint and drypoint printed in black on Vidalon wove paper

Image: 11⁷⁄₁₆ x 8½ inches (290 x 216 mm)

Sheet: 14⅝ x 11¹⁄₁₆ inches (371 x 281 mm)

Printer: Roger Lacourière, Paris

Publisher: Martin Fabiani, Paris, 1942

Edition: see no. 109

Ref.: Bloch 342

1978:1-26

(117)

L' AUTRUCHE, 1936

For *Eaux-fortes originales pour textes de Buffon*

Aquatint and drypoint printed in black on Vidalon wove paper

Image: 10⅝ x 8⁷⁄₁₆ inches (270 x 215 mm)

Sheet: 14¾ x 11 inches (374 x 280 mm)

Signed in pencil, l.r.: Picasso

Printer: Roger Lacourière, Paris

Publisher: Martin Fabiani, Paris, 1942

Edition: see no. 109

Ref.: Bloch 343

1978:1-27

(118)

LA MÈRE POULE, 1936

For *Eaux-fortes originales pour textes de Buffon*

Aquatint and drypoint printed in black on Vidalon wove paper

Image: 11¼ x 9¾ inches (285 x 247 mm)

Sheet: 14⅜ x 11 inches (366 x 280 mm)

Printer: Roger Lacourière, Paris

Publisher: Martin Fabiani, Paris, 1942

Edition: see no. 109

Ref.: Bloch 345

1978:1-28

(119)

L' ABEILLE, 1936

For *Eaux-fortes originales pour textes de Buffon*

Aquatint, drypoint and roulette printed in black on Montval laid paper

Plate: 16⁷⁄₁₆ x 12⁷⁄₁₆ inches (418 x 316 mm)

Sheet: 17⅜ x 13⅛ inches (441 x 333 mm)

Titled in the plate, l.ctr.: L' AVEILLE [*sic*]

Printer: Roger Lacourière, Paris

Edition: see no. 109

Ref.: Bloch 349

1978:1-29

(120)

LE PAPILLON, 1936

For *Eaux-fortes originales pour textes de Buffon*

Aquatint and drypoint printed in black on Vidalon wove paper

Image: 10⅝ x 8³⁄₁₆ inches (270 x 208 mm)

Sheet: 14⅜ x 11 inches (366 x 280 mm)

Printer: Roger Lacourière, Paris

Publisher: Martin Fabiani, Paris, 1942

Edition: see no. 109

Ref.: Bloch 350

1978:1-30

(121)

LA GUÊPE, 1936

For *Eaux-fortes originales pour textes de Buffon*

Aquatint and drypoint on china paper

Image: 11⅝ x 8½ inches (296 x 216 mm)

Sheet: 14⁵⁄₁₆ x 11¹⁄₁₆ inches (364 x 280 mm)

Signed in pencil, l.r.: Picasso; titled in the plate, l.ctr.: La guepe

Printer: Roger Lacourière, Paris

Publisher: Martin Fabiani, Paris, 1942

Edition: see no. 109

Ref.: Bloch 351

1978:1-31

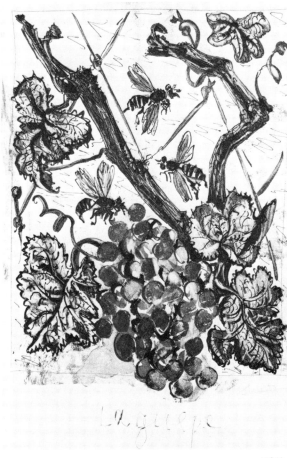

(121)

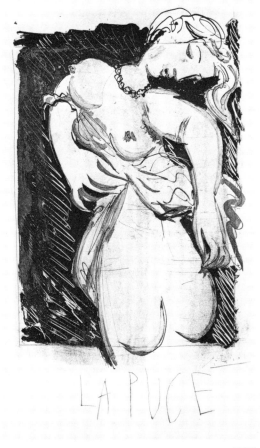

(126)

(122)

LA LANGOUSTE, 1936

For *Eaux-fortes originales pour textes de Buffon*

Aquatint and drypoint printed in black on Vidalon wove
paper

Image: 11⅞ x 9⁵⁄₁₆ inches (290 x 212 mm)

Sheet: 14½ x 11⅛ inches (369 x 283 mm)

Printer: Roger Lacourière, Paris

Publisher: Martin Fabiani, Paris, 1942

Edition: see no. 109

Ref.: Bloch 352

1978:1-32

(123)

L' ARAIGNÉE, 1936

For *Eaux-fortes originales pour textes de Buffon*

Aquatint and drypoint printed in black on Vidalon wove
paper

Image: 10⅝ x 8³⁄₁₆ inches (270 x 208 mm)

Sheet: 14⁹⁄₁₆ x 11 inches (370 x 280 mm)

Printer: Roger Lacourière, Paris

Publisher: Martin Fabiani, Paris, 1942

Edition: see no. 109

Ref.: Bloch 353

1978:1-33

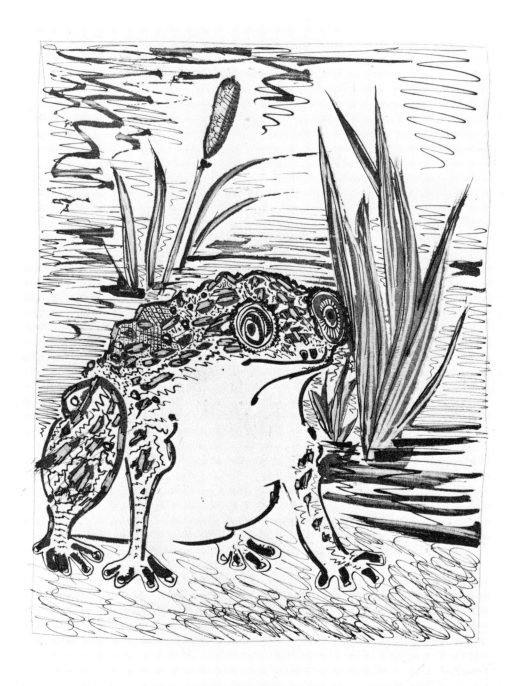

(124)

LA LIBELLULE, 1936

For *Eaux-fortes originales pour textes de Buffon*

Aquatint and drypoint printed in black on china paper

Image: 10⅝ x 8³⁄₁₆ inches (270 x 208 mm)

Sheet: 14⅜ x 10⅞ inches (364 x 276 mm)

Signed in pencil, l.r.: Picasso; titled in the plate, l.ctr.:

LA LIBELULE [*sic*]

Printer: Roger Lacourière, Paris

Publisher: Martin Fabiani, Paris, 1942

Edition: see no. 109

Ref.: Bloch 354

1978:1-34

(125)

LE CRAPAUD, 1936

For *Eaux-fortes originales pour textes de Buffon*

Aquatint and etching printed in black on Vidalon wove paper

Image: 10⅝ x 8³⁄₁₆ inches (270 x 208 mm)

Sheet: 14⁵⁄₁₆ x 11⅛ inches (364 x 283 mm)

Signed in pencil, l.r.: Picasso

Printer: Roger Lacourière, Paris

Publisher: Martin Fabiani, Paris, 1942

Edition: see no. 109

Ref.: Bloch 356

1978:1-35

(126)

LA PUCE, 1936

For *Eaux-fortes originales pour textes de Buffon*

Aquatint and drypoint printed in black on wove paper

Plate: 16⅜ x 12⁷⁄₁₆ inches (416 x 316 mm)

Sheet: 17½ x 13⅛ inches (444 x 332 mm)

Signed in pencil, l.r.: Picasso; titled in the plate, l.ctr.:

LA PUCE

Printer: Roger Lacourière, Paris

Edition: see no. 109

Ref.: Bloch 359

1978:1-36

Note: No text was found for La puce; *consequently the print was published only in the suites which accompanied the text edition.*

(127)

DORMEUSE, 1947

Lithograph printed in black on Arches wove paper

Sheet (image printed to edge of sheet): 19¾ x 25¾ inches (502 x 655 mm)

Signed in blue pencil, l.l.: Picasso; numbered in blue pencil, l.r.: 38/50; dated in the plate, l.l.: Dimanche 23.3.47

Printer: Mourlot Frères, Paris

Edition: 50 impressions

Ref.: Bloch 435; Mourlot 81

1978:1-37

(128)

BUSTE DE FEMME, 1955

Aquatint and drypoint printed in black on Arches wove paper

Plate: 25½ x 19⁹⁄₁₆ inches (648 x 497 mm)

Sheet: 30¹⁄₁₆ x 22½ inches (763 x 571 mm)

Signed in pencil, l.r.: Picasso; numbered in pencil, l.l.: 22/50; dated in the plate, u.r. (in reverse): 19.3.55

Printer: Roger Lacourière, Paris

Edition: 50 impressions

Ref.: Bloch 771

1978:1-38

(129)

CHEVAUX DE MINUIT, 1956

Seven of twelve drypoints for Roch Grey, *Chevaux de minuit,* the suite

Drypoints printed in black on japan tissue

Sheets (folded): 16½ x 10⅝ inches (420 x 270 mm)

Plates (except for Bloch 810): 8¼ x 6 inches (209 x 154 mm); Bloch 810: 9¹⁄₁₆ x 6 inches (321 x 153 mm)

Numbered in pencil, l.l.: 4/6; inscribed in pencil, l.l.,

with the monogram of the book's designer, Iliazd
Printer: Roger Lacourière, Paris (Robert Dutrou, pressman)
Publisher: Degré Quarante et Un, Cannes and Paris
Edition: 6 suites of prints; the text edition was issued in 68 copies (52 on japan paper, 16 *hors commerce* on china paper)
Ref.: Bloch 810-13, 819, 820; Garvey, *Artist and the book*, 237 *(Chevaux de minuit);* Goeppert 73 *(Chevaux de minuit)*
1975:24-2a-g

(130)

RELAIS DE LA JEUNESSE, 1950
Lithograph printed in black on wove paper, image trimmed from the poster for the youth rally, Nice, August 1950
Image: 19¾ x 25⁹⁄₁₆ inches (502 x 650 mm)
Sheet: 21³⁄₁₆ x 27⅜ inches (538 x 695 mm)
Signed on the stone, l.r.: Picasso
Printer: Mourlot Frères, Paris
Publisher: Comité National d'Initiative, Paris
Edition: 500 impressions
Ref.: Mourlot 188; Czwiklitzer 6
1984:10-74

After Pablo Picasso

(131)

UNTITLED, 1955
Illustration for André Suarès, *Hélène chez Archimède,* opposite page 192
Wood engraving printed in black on japan paper
Image: 11⅛ x 8⁹⁄₁₆ inches (282 x 218 mm)
Sheet: 17⅛ x 10⅜ inches (440 x 268 mm)
Block cutter: Georges Aubert
Publisher: Nouveau Cercle Parisien du Livre, Paris
1975:24-4
Note: see no. 266

(132)

UNTITLED
Unpublished illustration for André Suarès, *Hélène chez Archimède* (Paris, Nouveau Cercle Parisien du Livre, 1955)
Wood engraving printed in black on wove paper
Image: 6½ x 7¾ inches (165 x 197 mm)
Sheet: 12¹⁄₁₆ x 13¾ inches (306 x 349 mm)
Block cutter: Georges Aubert
1975:24-3b
Note: see no. 266

(133)

WOODBLOCK
For no. 132, unpublished illustration for André Suarès, *Hélène chez Archimède* (Paris, Nouveau Cercle Parisien du Livre, 1955)
6⅜ x 7¾ x ¹⁵⁄₁₆ inches (163 x 198 x 24 mm)
Block cutter: Georges Aubert
1975:24-3a
Note: see no. 267

Camille Pissarro 1830 – 1903

(134)

RUE DE L' EPICERIE, À ROUEN, 1886
Drypoint printed in black on laid paper
Plate: 6¹¹⁄₁₆ x 5⅞ inches (169 x 151 mm)
Sheet: 12 x 8⅞ inches (305 x 219 mm)
Signed in ink, l.r.: C. Pissarro; inscribed in ink, l.l.: no 2-1er etat / Rue de l'epicerie a Rouen (encore)
Provenance: Marcel Louis Guérin (Lugt, *Suppl.,* 1872b)
Edition: 2 signed and numbered proofs of first state
Ref.: Delteil 64 i/ii
1972:50-78

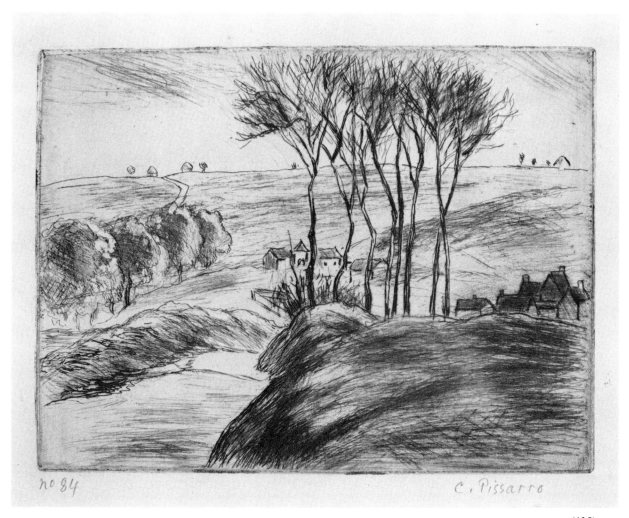

no 84

C. Pissarro

(135)

(135)
PAYSAGE À OSNY, 1887
For *L'Estampe originale,* album no. V, 1894
Etching and drypoint printed in black on laid paper
Plate: 4⁹⁄₁₆ x 6³⁄₁₆ inches (116 x 157 mm)
Sheet: 10¼ x 11³⁄₈ inches (260 x 289 mm)

Signed in pencil, l.r.: C. Pissarro; numbered in pencil,
l.l.: no 84
Publisher: André Marty, Paris
Edition: 100 signed and numbered impressions
Ref.: Delteil 70 i/ii
1976:18-38

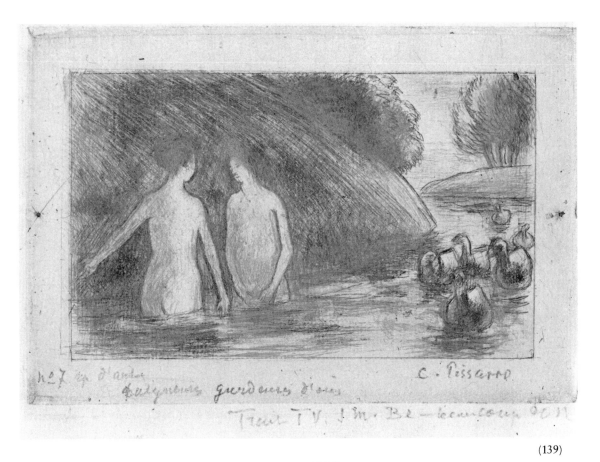

(139)

(136)

LA BONNE FAISANT SON MARCHÉ, 1888

For the journal *La revue indépendante*, no. 16,
1 February 1888

Drypoint printed in black on laid paper
Sheet (trimmed to platemark): 7⅞ x 5½ inches
(200 x 140 mm)

Titled in pencil, l.r.: Bonne faisant son marché

Edition: 80 impressions

Ref.: Delteil 74 i/iv

1972:50-79

(137)

BAIGNEUSES À L'OMBRE DES BERGES BOISÉES, 1894

For *L'Estampe originale*, album no. IX, 1895

Lithograph on zinc printed in black on mounted china
paper, proof

Image: 6 x 8½ inches (153 x 216 mm)
Sheet: 10⅞ x 14¾ inches (276 x 375 mm)

Initialed on the plate, l.r.: C.P.; signed in pencil, l.r.:
C. Pissarro; annotated in pencil, l.l.: Ep definitive no 2 /
Baigneuses à l'ombre des berges boisées

Printer: Tailliardat, Paris

Edition: 12 proofs and an edition of 100 impressions

Ref.: Delteil 142 ii/ii

1972:50-82

(138)

LES DEUX BAIGNEUSES, 1895

Etching and drypoint printed in black on laid paper, posthumous impression

Plate: 7¹⁄₁₆ x 5 inches (180 x 128 mm)

Sheet: 10⁷⁄₁₆ x 7¼ inches (264 x 181 mm)

Stamped in dark gray, l.l.: C.P. (Lugt, *Suppl.*, 613ᵉ); numbered in pencil, l.r.: 23/49

Edition: 49 impressions printed posthumously in 1922, 1923 or 1930

Ref.: Delteil 116 ix/ix

1972:50-80

(139)

BAIGNEUSES GARDEUSES D'OIES, 1895

Etching printed in four colors (orange, yellow, blue, black) on light blue paper

Plate: 4⁵⁄₈ x 7 inches (117 x 178 mm)

Sheet: 6¹⁄₁₆ x 10⁵⁄₁₆ inches (154 x 264 mm)

Signed in pencil, l.r.: C. Pissarro; annotated in pencil, l.l.: no 7 ep d'art / baigneuses gardeuses d'oies / Trait TV. JM. Be -- beaucoup OCN [?]

Edition: 12 impressions

Ref.: Delteil 119 ix/ix

1972:50-81

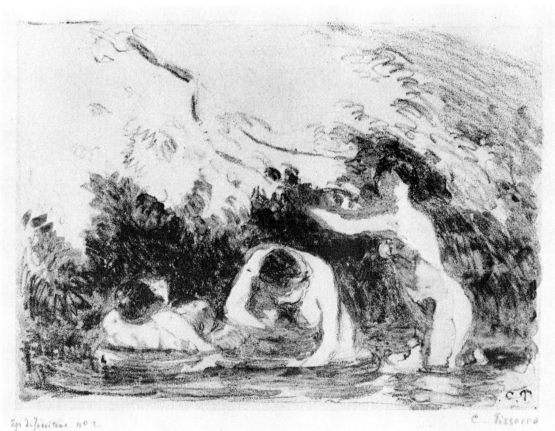

(137)

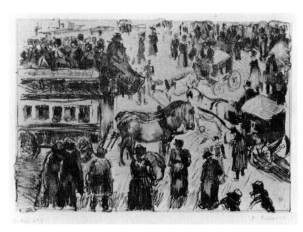

(141)

(140)

LES TRIMARDEURS, 1896

For the journal *Les temps nouveaux*

Lithograph printed in black on mounted china paper

Image: 9⁵⁄₁₈ x 11¹³⁄₁₆ inches (245 x 301 mm)

Sheet: 16½ x 19⅞ inches (418 x 504 mm)

Signed on the stone, l.l.: C. Pissarro; stamped in black on the verso, l.r.: J. Grave. imp. edit. 140 Rue Mouffetard, Paris

Printer: Tailliardat, Paris

Publisher: Jean Grave, Paris

Ref.: Delteil 154 v/v

1972:50-83

(141)

PLACE DU HAVRE, À PARIS, 1897

Lithograph on zinc printed in black on light purple wove paper mounted on white

Image: 5⁵⁄₈ x 8⅜ inches (142 x 212 mm)

Sheet: 10¹³⁄₁₆ x 14⅜ inches (275 x 365 mm)

Signed in pencil, l.r.: C. Pissarro; annotated in pencil, l.l.: Ep defi no 5 place du Havre

Provenance: Mme. de Poles (Lugt, *Suppl.*, 172[b])

Printer: Tailliardat, Paris

Edition: 12 signed and numbered impressions plus 2 or 3 unsigned impressions

Ref.: Delteil 185 ii/ii

1972:50-84

(142)

GROUPE DE PAYSANS, ca. 1899

Lithograph on zinc printed in black on mauve paper mounted on white wove

Image: 5⅛ x 4⅛ inches (130 x 105 mm)

Sheet: 10⅝ x 7⅛ inches (269 x 181 mm)

Signed in pencil, l.l.: C. Pissarro; annotated in pencil, l.l.: no 7 Groupe de paysans (Variante)

Provenance: Arthur B. Spingarn (Lugt, *Suppl.*, 83[b])

Printer: Tailliardat, Paris

Edition: 14 or 15 signed and numbered impressions

Ref.: Delteil 189

1976:18-36

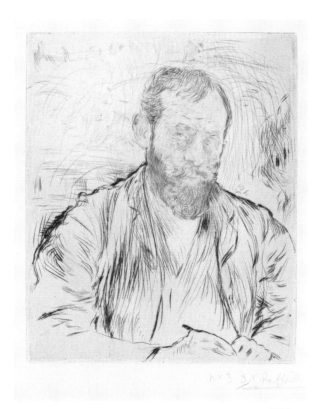

(144)

(143)

VACHÈRE, ca. 1899

Lithograph on zinc printed in black on tan paper
mounted on white wove

Image: 5⅛ x 4⁷⁄₁₆ inches (130 x 113 mm)

Sheet: 10⅝ x 7⅛ inches (269 x 181 mm)

Signed in pencil, l.r.: C. Pissarro; annotated in pencil,
l.l.: no 7/Vachere

Provenance: Arthur B. Spingarn (Lugt, *Suppl.*, 83[b])

Printer: Tailliardat, Paris

Edition: 14 signed and numbered impressions

Ref.: Delteil 190

1976:18-37

Jean-François Raffaëlli 1850 – 1924

(144)

SELF-PORTRAIT, 1893

For *L'Estampe originale,* album no. II, 1893

Drypoint printed in four colors on laid paper

Plate: 7⅜ x 6³⁄₁₆ (187 x 157 mm)

Sheet: 23⅝ x 16⅝ inches (599 x 423 mm)

Signed and numbered in pencil, l.r.: no 3 J.F. Raffaëlli

Publisher: André Marty, Paris

Edition: 100 impressions

Ref.: Delteil 7

1976:18-39

Odilon Redon 1840 – 1916

(145)

PERVERSITÉ, 1891

Etching and drypoint printed in black on laid paper

Plate: 8⁵⁄₁₆ x 6⅛ inches (211 x 156 mm)

Sheet: 13⅞ x 10¾ inches (352 x 273 mm)

Signed in pencil, l.l.: Odilon Redon

Publisher: Ambroise Vollard, Paris

Edition: 30 impressions

Ref.: Mellerio 20; Harrison 23 c/c

1972:50-85

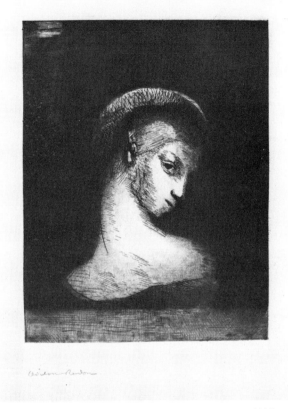

(145)

(146)

LA SULAMITE, 1897

Lithograph printed in three colors on china paper

Image: 9¹³⁄₁₆ x 7⁹⁄₁₆ inches (249 x 192 mm)

Sheet: 12¹⁄₁₆ x 8⅝ inches (307 x 219 mm)

Signed in pencil, l.l.: Odilon Redon

Printer: Auguste Clot, Paris

Edition: 50 impressions

Ref.: Mellerio 167

1978:1-39

(147)

BÉATRICE, 1897

For *L'Album d'estampes originales de la Galerie Vollard*

Lithograph printed in three colors (yellow, gray-green and blue) on china paper mounted on wove, proof
Image: 13³⁄₁₆ x 11⅝ inches (335 x 296 mm)
Sheet: 22¼ x 16¼ inches (564 x 412 mm)
Initialed on the stone, u.r.: OR

Printer: Auguste Clot, Paris
Publisher: Ambroise Vollard, Paris

Edition: unknown number of trial proofs with color variations; 100 impressions printed in five colors

Ref.: Mellerio 168

1978:1-40

(148)

APOCALYPSE DE SAINT-JEAN, 1899

Suite of twelve lithographs printed in black on china paper mounted on wove, plus a frontispiece/cover
Sheets: 22¼ x 16½ inches (513 x 420 mm)

Printer: Blanchard, Paris
Publisher: Ambroise Vollard, Paris

Edition: 100 impressions

148:1 FRONTISPIECE/COVER

Lithograph printed in black on heavy japan paper
Image: 10⅜ x 9³⁄₁₆ inches (263 x 233 mm)
Sheet (folded): 24¹³⁄₁₆ x 17⁹⁄₁₆ inches (630 x 444 mm)
Initialed in blue crayon, verso, l.l.: O.R.

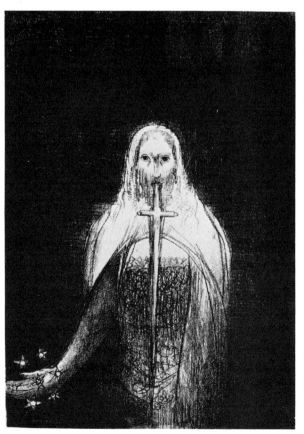

(148:2)

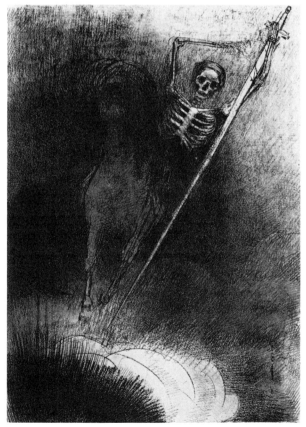

(148:4)

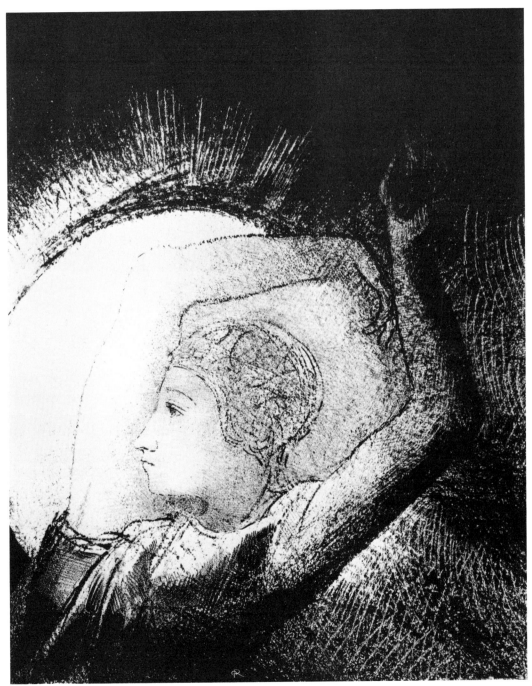

(148:7)

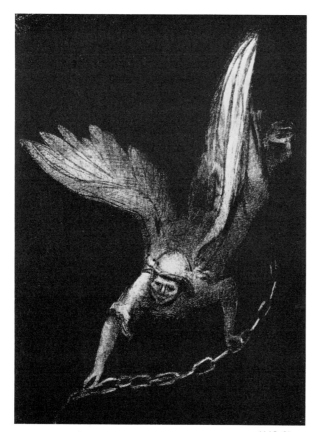

(148:9)

Ref.: Mellerio 173
1976:18-40

148:2 "... ET IL AVAIT EN SA MAIN DROITE SEPT
ÉTOILES, ET DE SA BOUCHE SORTAIT UNE ÉPÉE AIGÜE À
DEUX TRANCHANTS"
Image: 11 7/16 x 8 5/16 inches (290 x 211 mm)
Signed on the stone, l.l.: ODILON REDON
Ref.: Mellerio 174
1976:18-41

148:3 "... PUIS JE VIS, DANS LA MAIN DROITE DE
CELUI QUI ÉTAIT ASSIS SUR LE TRÔNE, UN LIVRE ÉCRIT
DEDANS ET DEHORS, SCELLÉ DE SEPT SCEAUX"

Image: 12 3/4 x 9 9/16 inches (323 x 242 mm)
Signed on the stone, l.l.: ODILON REDON
Ref.: Mellerio 175
1976:18-42

148:4 "... ET CELUI QUI ÉTAIT MONTÉ DESSUS SE
NOMMAIT LA MORT"
Image: 12 5/16 x 8 15/16 inches (312 x 226 mm)
Signed on the stone vertically, l.r.: ODILON REDON
Ref.: Mellerio 176
1976:18-43

148:5 "... PUIS L'ANGE PRIT L'ENCENSOIR"
Image: 12 5/16 x 8 9/16 inches (313 x 217 mm)
Signed and initaled on the stone, l.ctr.:
OR ODILON REDON
Ref.: Mellerio 177
1976:18-44

148:6 "ET IL TOMBE DU CIEL UNE GRANDE ÉTOILE,
ARDENTE COMME UN FLAMBEAU"
Image: 12 1/8 x 9 3/16 inches (308 x 233 mm)
Initialed on the stone, l.l.: OR
Ref.: Mellerio 178
1976:18-45

148:7 "... UNE FEMME REVÊTUE DU SOLEIL"
Image: 11 5/16 x 9 1/16 inches (287 x 230 mm)
Initialed on the stone, l.ctr.: OR
Ref.: Mellerio 179
1976:18-46

148:8 "ET UN AUTRE ANGE SORTIT DU TEMPLE QUI EST
AU CIEL, AYANT LUI AUSSI UNE FAUCILLE TRANCHANTE"
Image: 12 5/16 x 8 7/16 inches (312 x 214 mm)
Initialed on the stone (scratched in), l.r.: OR
Ref.: Mellerio 180
1976:18-47

148:9 "Après cela, je vis descendre du ciel un ange qui avait la chef de l'abîme, et une grande chaîne en sa main"
Image: 12 1/16 x 9 5/16 inches (306 x 236 mm)
Initialed on the stone (scratched in), l.ctr.: OR
Ref.: Mellerio 181
1978:18-48

148:10 ". . . Et le lia pour mille ans"
Image: 11 7/8 x 8 5/16 inches (302 x 212 mm)
Ref.: Mellerio 182
1976:18-49

148:11 ". . . Et le diable qui les séduisait, fût jeté dans l'étang de feu et de soufre, où est la bête et le faux prophète"
Image: 10 13/16 x 9 7/16 inches (275 x 239 mm)
Signed on the stone, l.ctr.: Odilon Redon
Ref.: Mellerio 183
1976:18-50

148:12 "Et moi, Jean, je vis la sainte cité, la nouvelle Jérusalem, qui descendait du ciel, d'auprès de Dieu"
Image: 11 3/4 x 9 1/4 inches (299 x 236 mm)
Ref.: Mellerio 184
1976:18-51

148:13 "C'est moi, Jean, qui ai vu et qui ai ouï ces choses"
Image: 10 x 7 5/16 inches (255 x 186 mm)
Initialed on the stone (reversed), l.r.: OR
Ref.: Mellerio 185
1976:18-52

(149)
Three unpublished lithographs, ca. 1900
For Stéphane Mallarmé, *Un coup de dés jamais n'abolira le hazard*

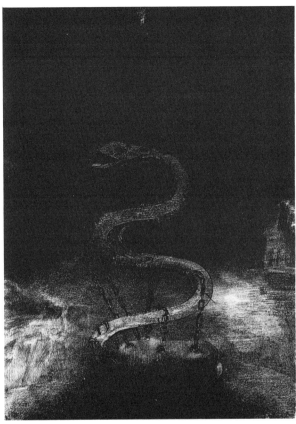

(148:10)

Lithographs printed in black on china paper mounted on wove
Ref.: Garvey, *Artist and the book*, 257 (*Un coup de dés jamais . . .*)

149:1 Femme de profil vers la gauche coiffée d'un hennin
Image: 11 3/4 x 9 7/16 inches (299 x 240 mm)
Sheet: 13 1/2 x 10 11/16 inches (342 x 271 mm)
Initialed on the stone, l.r.: OR
Ref.: Mellerio 186
1972:50-86

149:2 Tête d'enfant, de face, avec au-dessus un arc-en-ciel
Image: 4⅛ x 2¹³⁄₁₆ inches (105 x 72 mm)
Sheet: 9¹⁵⁄₁₆ x 7³⁄₁₆ inches (227 x 182 mm)
Initialed on the stone, l.r.: OR
Ref.: Mellerio 187
1972:50-87

149:3 Femme coiffée d'une toque et rejetant le buste en arrière
Image: 9⁷⁄₁₆ x 9³⁄₁₆ inches (240 x 233 mm)
Sheet: 14¹⁵⁄₁₆ x 11¾ inches (363 x 298 mm)
Ref.: Mellerio 188
1972:50-88

(150)
Edouard Vuillard, 1900
Lithograph printed in black on china paper
Image: 7¹¹⁄₁₆ x 5⅞ inches (194 x 149 mm)
Sheet: 12¹⁵⁄₁₆ x 8¹¹⁄₁₆ inches (329 x 221 mm)
Dated on the stone, l.r.: 1900
Printer: Blanchard, Paris
Edition: 12 impressions
Ref.: Mellerio 190
1972:50-89

(151)
Pierre Bonnard, 1902
Lithograph printed in black on china paper
Image: 5¾ x 4¹³⁄₁₆ inches (146 x 123 mm)
Sheet: 8¾ x 14⅝ inches (221 x 371 mm)
Printer: Blanchard, Paris
Edition: 12 impressions
Ref.: Mellerio 191
1972:50-90

(152)
Paul Sérusier, 1903
Lithograph printed in black on china paper
Image: 6⁷⁄₁₆ x 5⅜ inches (163 x 136 mm)

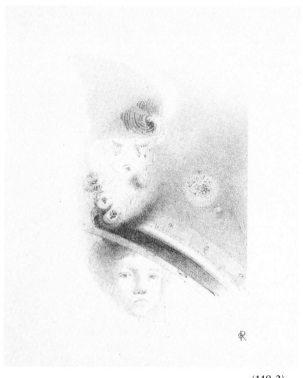

(149:2)

Sheet: 14¹¹⁄₁₆ x 9⁹⁄₁₆ inches (373 x 242 mm)
Dated on the stone, l.l.: 1903
Printer: Blanchard, Paris
Edition: 12 impressions
Ref.: Mellerio 192
1972:50-91

(153)
Maurice Denis, 1903
Lithograph printed in black on china paper
Image: 5¹³⁄₁₆ x 5⅝ inches (148 x 143 mm)
Sheet: 15 x 8¹³⁄₁₆ inches (381 x 224 mm)
Dated on the stone, l.r.: 1903
Printer: Blanchard, Paris
Edition: 25 impressions
Ref.: Mellerio 193
1972:50-92

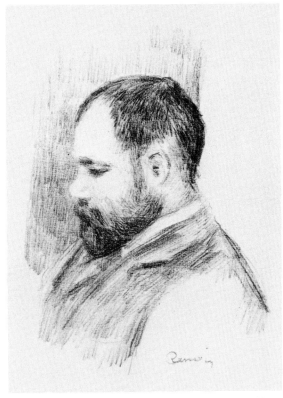

(157:3)

Pierre-Auguste Renoir 1841 – 1919

(154)

LES DEUX BAIGNEUSES, 1895

For *L'Estampe originale,* album no. IX, 1895

Etching printed in black on wove paper

Plate: 10³⁄₁₆ x 9⁷⁄₁₆ inches (261 x 240 mm)

Sheet: 15½ x 12 inches (394 x 305 mm)

Numbered and initialed in black crayon, l.r.: 83 R; signed in the plate, l.r.: Renoir

Publisher: André Marty, Paris

Edition: 100 signed and numbered impressions plus an unknown number of trial proofs

Ref.: Delteil 9; Stella 9

1972:50-93

(155)

MÈRE ET ENFANT (MME RENOIR ET JEAN), 1896

For *L'Album des peintres-gravures*

Drypoint printed in three colors on laid paper

Plate: 9¾ x 7⅞ inches (247 x 200 mm)

Sheet: 16 x 11⅛ inches (406 x 282 mm)

Provenance: Otto Gerstenberg (Lugt 2785)

Printer: Auguste Clot, Paris

Publisher: Ambroise Vollard, Paris

Edition: 100 impressions

Ref.: Delteil 10; Stella 10

1972:50-94

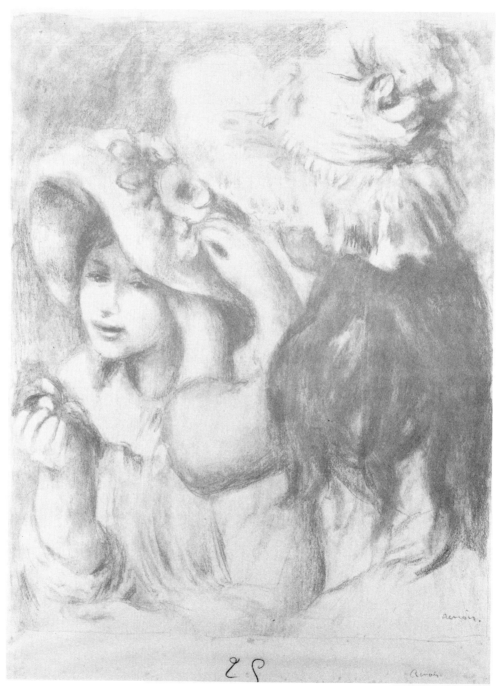

(156)

(156)

LE CHAPEAU ÉPINGLÉ (2nd plate), 1898

Lithograph printed in gray on china paper, proof
Image: 24 x 19¼ inches (610 x 490 mm)
Sheet: 28¹/₁₆ x 20⁹/₁₆ inches (713 x 522 mm)
Signed in chalk, l.r.: Renoir; signed on the stone, l.r.:
Renoir
Printer: Auguste Clot, Paris
Publisher: Ambroise Vollard, Paris
Edition: 200 impressions
Ref.: Delteil 30; Roger-Marx 5 *bis;* Stella 30
1978:1-41

(157)

DOUZE LITHOGRAPHIES ORIGINALES DE PIERRE-
AUGUSTE RENOIR, 1919

Twelve transfer lithographs plus title page and photo-
lithographed table of contents on Arches wove paper
Sheets: 13 x 10 inches (330 x 255 mm)
Signed on the stone, l.r. or l.l.: Renoir
Printer: Auguste Clot, Paris
Publisher: Ambroise Vollard, Paris
Edition: 1000 (nos. 1-50 on antique japan paper;
nos. 51-1000 on wove paper); copy no. 185
*Note: The album was completed in 1904 but Vollard
did not publish it until 1919 when he also issued his
biographical study,* La vie et l'oeuvre de Pierre-Auguste
Renoir.

157:1 TITLE PAGE

Lithograph printed in black with typeset text on wove
paper
Image: 3½ x 2¼ inches (89 x 57 mm)
1975:24-5[a]

157:2 TABLE OF CONTENTS

Photolithograph printed in black on wove paper
Image: 12¹/₁₆ x 7½ inches (307 x 190 mm)
1975:24-5[b]

157:3 AMBROISE VOLLARD, 1904

Image: 9½ x 6⅞ inches (241 x 175 mm)
Ref.: Delteil 37; Roger-Marx 12; Stella 37
1975:24-5[c]

157:4 LOUIS VALTAT, 1904

Image: 11¾ x 9⅜ inches (298 x 238 mm)
Ref.: Delteil 38; Roger-Marx 13; Stella 38
1975:24-5[d]

157:5 CLAUDE RENOIR, LA TÊTE BAISÉE, 1904

Image: 7¹¹/₁₆ x 7⅝ inches (195 x 193 mm)
Ref.: Delteil 39 ii/ii; Roger-Marx 14; Stella 39
1975:24-5[e]

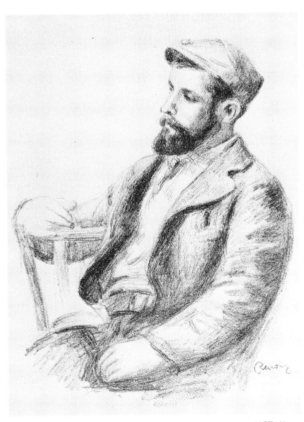

(157:4)

157:6　CLAUDE RENOIR, TOURNÉ À GAUCHE, 1904
Image: 4¹⁵⁄₁₆ x 4⅝ inches (125 x 118 mm)
Ref.: Delteil 40; Roger-Marx 15; Stella 40
1975:24-5ᶠ

157:7　LA PIERRE AUX TROIS CROQUIS, 1904
Image: 9 x 11⅜ inches (229 x 289 mm)
Ref.: Delteil 41 ii/ii; Roger-Marx 16; Stella 41
1975:24-5ᵍ

157:8　ETUDE DE FEMME NUE, ASSISE, 1904
Image: 7⅝ x 6⅜ inches (193 x 162 mm)
Ref.: Delteil 42; Roger-Marx 17; Stella 42
1975:24-5ʰ

157:9　ETUDE DE FEMME NUE, ASSISE, VARIANTE, 1904
Image: 6¼ x 6¼ inches (159 x 159 mm)
Ref.: Delteil 43 ii/ii; Roger-Marx 18; Stella 43
1975:24-5ⁱ

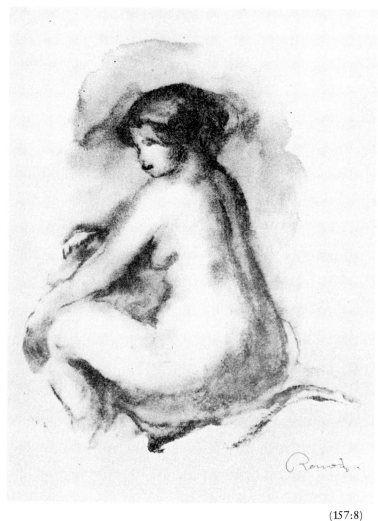

(157:8)

157:10 FEMME AU CEP DE VIGNE, 1904
Image: 7 x 4½ inches (178 x 114 mm)
Ref.: Delteil 44; Roger-Marx 19; Stella 44
1975:24-5[j]

157:11 FEMME AU CEP DE VIGNE, 1[RE] VARIANTE, 1904
Image: 6⅞ x 4⅝ inches (175 x 118 mm)
Ref.: Delteil 45; Roger-Marx 20; Stella 45
1975:24-5[k]

157:12 FEMME AU CEP DE VIGNE, 2[E] VARIANTE, 1904
Image: 4⅝ x 3⅜ inches (117 x 85 mm)
Ref.: Delteil 46; Roger-Marx 21; Stella 46
1975:24-5[l]

157:13 FEMME AU CEP DE VIGNE, 3[E] VARIANTE, 1904
Image: 6½ x 4 inches (165 x 102 mm)
Ref.: Delteil 47; Roger-Marx 22; Stella 47
1975:24-5[m]

157:14 FEMME AU CEP DE VIGNE, 4[E] VARIANTE, 1904
Image: 5½ x 3⅞ inches (140 x 98 mm)
Ref.: Delteil 48; Roger-Marx 23; Stella 48
1975:24-5[n]

Diego Rivera 1886 – 1957

(158)

BOY WITH A DOG, 1932
Lithograph printed in black on Rives wove paper
Image: 16½ x 12 inches (420 x 305 mm)
Sheet: 22⅝ x 15⅞ inches (575 x 403 mm)
Signed and inscribed in pencil, l.l.: Epreuve d'artiste.
Diego Rivera; initialed and dated on the stone, l.r.
(in reverse): DR 32
Edition: 100 impressions
1972:50-96

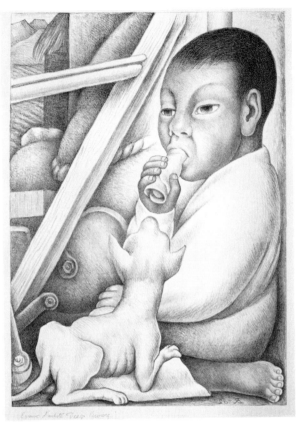

(158)

(159)

OPEN AIR SCHOOL, 1932
Lithograph printed in black on Rives wove paper
Image: 12⁹⁄₁₆ x 16⅜ inches (319 x 416 mm)
Sheet: 15⅝ x 21¹⁄₁₆ inches (396 x 536 mm)
Signed and numbered in pencil, l.l.: 53/100 Diego
Rivera; dated in pencil, l.r.: 1932; initialed and dated on
the stone, l.r.: DR 32
Edition: 100 impressions
1972:50-95

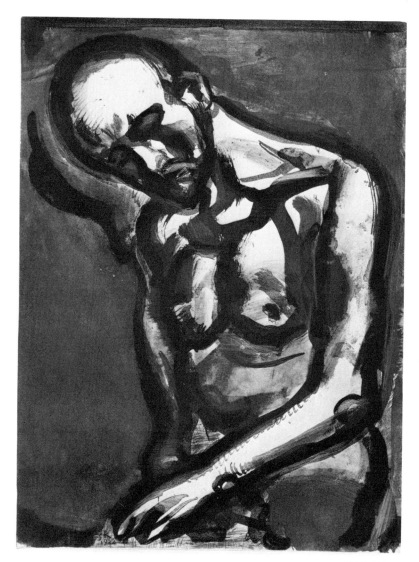

(161:12)

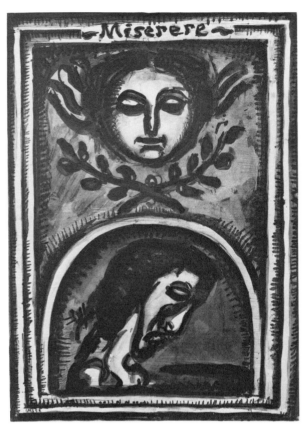

(161:1)

japan imperial paper, 25 *hors commerce*)
Ref.: Wofsy 61; Chapon-Rouault 342 iii/iii
1976:18-65

(161)
MISERERE, 1948 [1922-27]
1 f., [9] p., plus 58 photogravures with etching, aquatint, drypoint, roulette, scraping and burnishing printed in black on Arches laid paper
Sheets: 25¾ x 19⅞ inches (655 x 505 mm); mounted in folder with titles in letterpress
Signed in the plates: GR or G Rouault; dated in the plates 1922 to 1927
Printer: Jacquemin, Paris
Publisher: Editions de L'Etoile Filante, Paris, 1948
Edition: 450 numbered copies (1-425 for the trade, I-XXV *hors commerce*); copy no. 229

Georges Rouault 1871 – 1958

(160)
SELF-PORTRAIT II, 1926
For Georges Charensol, *Rouault*
Lithograph printed in black on japan imperial paper
Image: 9 1/16 x 6¾ inches (230 x 171 mm)
Sheet: 10 5/16 x 8¼ inches (261 x 210 mm)
Signed and numbered in pencil, l.r.: 3/100 Georges Rouault
Printer: Duchâtel, Paris
Publisher: Editions des Quatre Chemins, Paris
Edition: 125 impressions (100 signed and numbered on

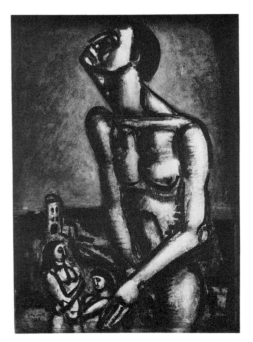

(161:6)

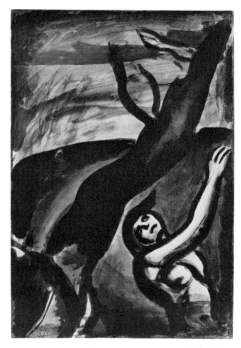

(161:11)

161:1 MISERERE MEI, DEUS, SECUNDUM MAGNAM MISERICORDIAM TUAM, 1923
Plate: 22¹³/₁₆ x 16⅝ inches (579 x 423 mm)
Ref.: Wofsy 108; Chapon-Rouault 54$^{e/e}$
1969:80-1

161:2 JÉSUS HONNI . . . , 1922
Plate: 21⅝ x 15¹³/₁₆ inches (549 x 401 mm)
Ref.: Wofsy 109b; Chapon-Rouault 55$^{d/d}$
1969:80-2

161:3 TOUJOURS FLAGELLÉ . . . , 1922
Plate: 19³/₁₆ x 14⁷/₁₆ inches (487 x 367 mm)
Ref.: Wofsy 110; Chapon-Rouault 56$^{c/c}$
1969:80-3

161:4 SE RÉFUGIE EN TON COEUR, VA-NU-PIEDS DE MALHEUR, 1922
Plate: 19⅛ x 14¹¹/₁₆ inches (486 x 372 mm)

Ref.: Wofsy 111; Chapon-Rouault 57$^{g/g}$
1969:80-4

161:5 SOLITAIRE, EN CETTE VIE D'EMBÛCHES ET DE MALICES, 1922
Plate: 22¹³/₁₆ x 16⁷/₁₆ inches (579 x 417 mm)
Ref.: Wofsy 112b; Chapon-Rouault 58$^{e/e}$
1969:80-5

161:6 NE SOMMES-NOUS PAS FORÇATS? 1926
Plate: 23⅜ x 17³/₁₆ inches (594 x 437 mm)
Ref.: Wofsy 113; Chapon-Rouault 59$^{d/d}$
1969:80-6

161:7 NOUS CROYANT ROIS, 1923
Plate: 23³/₁₆ x 16⁹/₁₆ inches (589 x 421 mm)

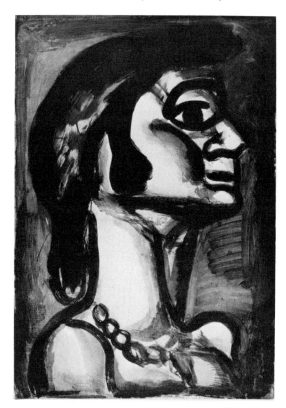

(161:15)

Ref.: Wofsy 114; Chapon-Rouault 60[e/e]
1969:80-7

161:8 QUI NE SE GRIME PAS? 1922
Plate: 22⁵/₁₆ x 16⁷/₈ inches (567 x 429 mm)
Ref.: Wofsy 115; Chapon-Rouault 61[c/c]
1969:80-8

161:9 IL ARRIVE PARFOIS QUE LA ROUTE SOIT
BELLE . . . , 1922
Plate: 14¹¹/₁₆ x 19¹⁵/₁₆ inches (372 x 507 mm)
Ref.: Wofsy 116; Chapon-Rouault 62[d/d]
1969:80-9

161:10 AU VIEUX FAUBOURG DES LONGUES
PEINES, 1923
Plate: 22¼ x 16½ inches (565 x 419 mm)
Ref.: Wofsy 117[b]; Chapon-Rouault 63[d/d]
1969:80-10

161:11 DEMAIN SERA BEAU, DISAIT LE
NAUFRAGÉ, 1922
Plate: 19¹³/₁₆ x 14 inches (504 x 356 mm)
Ref.: Wofsy 118[b]; Chapon-Rouault 64[d/d]
1969:80-11

161:12 LE DUR MÉTIER DE VIVRE . . . , 1922
Plate: 18⁷/₈ x 14³/₁₆ inches (479 x 361 mm)
Ref.: Wofsy 119; Chapon-Rouault 65[c/c]
1969:80-12

161:13 IL SERAIT SI DOUX D'AIMER, 1923
Plate: 22⁵/₈ x 16¼ inches (574 x 413 mm)
Ref.: Wofsy 120; Chapon-Rouault 66[d/d]
1969:80-13

161:14 FILLE DITE DE JOIE, 1922
Plate: 20 x 14³/₈ inches (508 x 365 mm)
Ref.: Wofsy 121; Chapon-Rouault 67[d/d]
1969:80-14

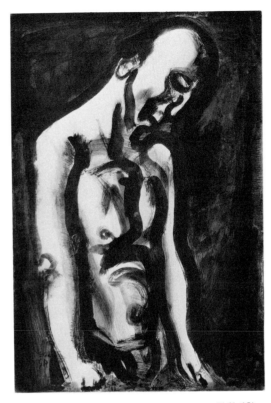

(161:18)

161:15 EN BOUCHE QUI FUT FRAICHE, GOÛT
DE FIEL, 1922
Plate: 19⁷/₈ x 13¹⁵/₁₆ inches (505 x 354 mm)
Ref.: Wofsy 122; Chapon-Rouault 68[d/d]
1969:80-15

161:16 DAME DU HAUT-QUARTIER CROIT PRENDRE
POUR LE CIEL PLACE RÉSERVÉE, 1922
Plate: 22⁵/₈ x 16¼ inches (574 x 413 mm)
Ref.: Wofsy 123; Chapon-Rouault 69[b/b]
1969:80-16

161:17 FEMME AFFRANCHIE, À QUATORZE HEURES,
CHANTE MIDI, 1923
Plate: 22 x 16¹⁵/₁₆ inches (599 x 431 mm)

Ref.: Wofsy 124; Chapon-Rouault 70[c/c]
1969:80-17

161:18 LE CONDAMNÉ S'EN EST ALLÉ . . . , 1922
Plate: 19¹⁵⁄₁₆ x 13⁵⁄₈ inches (507 x 346 mm)
Ref.: Wofsy 125; Chapon-Rouault 71[d/d]
1969:80-18

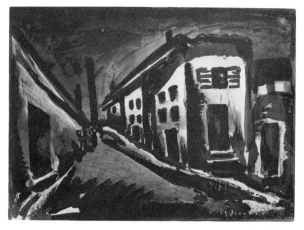

161:19 SON AVOCAT, EN PHRASES CREUSES, CLAME SA
TOTALE INCONSCIENCE . . . , 1922
Plate: 21¼ x 16¹⁄₁₆ inches (537 x 408 mm)
Ref.: Wofsy 126[b]; Chapon-Rouault 72[c/c]
1969:80-19

161:20 SOUS UN JÉSUS EN CROIX OUBLIÉ LÀ, 1926
Plate: 22⅞ x 16½ inches (581 x 420 mm)
Ref.: Wofsy 127; Chapon-Rouault 73[e/e]
1969:80-20

161:21 "IL A ÉTÉ MALTRAITÉ ET OPPRIMÉ ET IL N'A PAS
OUVERT LA BOUCHE," 1923
Plate: 22⅞ x 16¼ inches (581 x 413 mm)
Ref.: Wofsy 128; Chapon-Rouault 74[c/c]
1969:80-21

161:22 EN TANT D'ORDRES DIVERS, LE BEAU MÉTIER
D'ENSEMENCER UNE TERRE HOSTILE, 1926
Plate: 23¼ x 17 inches (591 x 432 mm)
Ref.: Wofsy 129; Chapon-Rouault 75[c/c]
1969:80-22

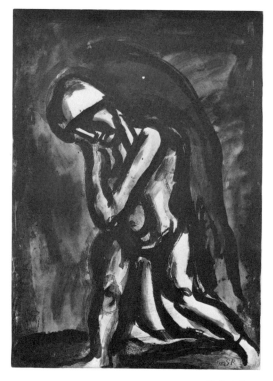

(161:23)

(161:24)

161:23 RUE DES SOLITAIRES, 1922
Plate: 14⅜ x 19¹⁵⁄₁₆ inches (364 x 507 mm)
Ref.: Wofsy 130[b]; Chapon-Rouault 76[e/e]
1969:80-23

161:24 "HIVER LÈPRE DE LA TERRE," 1922
Plate: 20⅜ x 14½ inches (517 x 369 mm)
Ref.: Wofsy 131; Chapon-Rouault 77[f/f]
1969:80-24

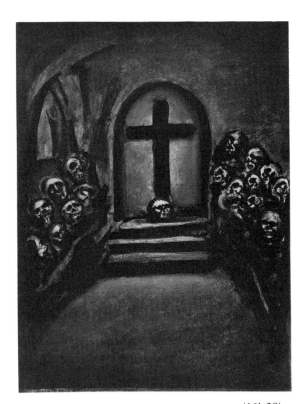

(161:28)

161:28　"CELUI QUI CROIT EN MOI, FÛT-IL MORT, VIVRA," 1923
Plate: 22¾ x 17³⁄₁₆ inches (579 x 437 mm)
Ref.: Wofsy 135; Chapon-Rouault 81[e/e]
1969:80-28

161:29　CHANTEZ MATINES, LE JOUR RENAIT, 1922
Plate: 20¼ x 14⁷⁄₁₆ inches (513 x 367 mm)
Ref.: Wofsy 136; Chapon-Rouault 82[d/d]
1969:80-29

161:30　"NOUS . . . C'EST EN SA MORT QUE NOUS AVONS ÉTÉ BAPTISÉS," 1921
Plate: 21⅝ x 16⅝ inches (549 x 422 mm)
Ref.: Wofsy 137; Chapon-Rouault 84[e/e]
1969:20-30

161:25　JEAN-FRANÇOIS JAMAIS NE CHANTE ALLÉLUIA . . . , 1923
Plate: 23¼ x 16¹¹⁄₁₆ inches (589 x 424 mm)
Ref.: Wofsy 132; Chapon-Rouault 78[f/f]
1969:80-25

161:26　AU PAYS DE LA SOIF ET DE LA PEUR . . . , 1923
Plate: 16⅝ x 22¹⁵⁄₁₆ inches (414 x 583 mm)
Ref.: Wofsy 133[b]; Chapon-Rouault 79[c/c]
1969:80-26

161:27　SUNT LACRYMAE RERUM . . . , 1926
Plate: 22¹³⁄₁₆ x 16⅜ inches (580 x 417 mm)
Ref.: Wofsy 134; Chapon-Rouault 80[e/e]
1969:80-27

(161:27)

161:31 "AIMEZ-VOUS LES UNS LES AUTRES," 1923
Plate: 23 5/16 x 16 3/4 inches (592 x 426 mm)
Ref.: Wofsy 138; Chapon-Rouault 84[e/e]
1969:80-31

161:32 SEIGNEUR, C'EST VOUS, JE VOUS
RECONNAIS, 1927
Plate: 22 5/8 x 17 5/8 inches (574 x 448 mm)
Ref.: Wofsy 139; Chapon-Rouault 85[d/d]
1969:20-32

161:33 ET VÉRONIQUE AU TENDRE LIN, PASSE ENCORE
SUR LE CHEMIN . . . , 1922
Plate: 17 3/16 x 16 7/8 inches (437 x 429 mm)
Ref.: Wofsy 140; Chapon-Rouault 86[d/d]
1969:80-33

161:34 "LES RUINES ELLES-MÊMES ONT PÉRI," 1926
Plate: 23 x 17 11/16 inches (585 x 450 mm)
Ref.: Wofsy 141; Chapon-Rouault 87[c/c]
1969:80-34

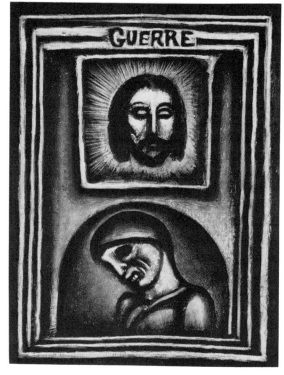

(161:34)

161:35 "JÉSUS SERA EN AGONIE JUSQU'À LA FIN DU
MONDE . . . ," 1922
Plate: 23 1/16 x 16 5/16 inches (586 x 414 mm)
Ref.: Wofsy 142; Chapon-Rouault 88[e/e]
1969:80-35

161:36 CE SERA LA DERNIÈRE, PETIT PÈRE! 1927
Plate: 23 5/16 x 17 inches (592 x 432 mm)
Ref.: Wofsy 143; Chapon-Rouault 89[d/d]
1969:80-36

161:37 HOMO HOMINI LUPUS, 1926
Plate: 23 x 16 9/16 inches (584 x 420 mm)
Ref.: Wofsy 144; Chapon-Rouault 90[f/f]
1969:80-37

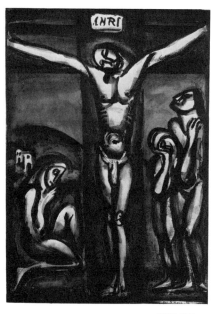

(161:31)

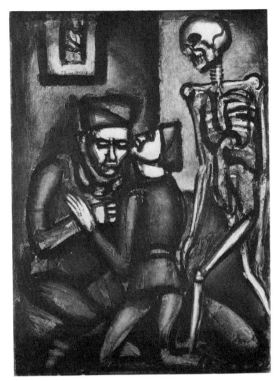

(161:36)

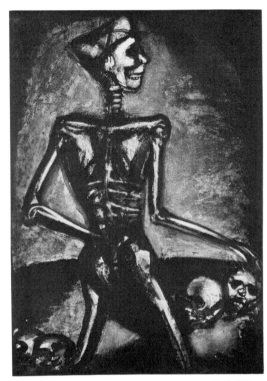

(161:37)

161:38 LE CHINOIS INVENTA, DIT-ON, LA POUDRE À CANON, NOUS EN FIT DON, 1926
Plate: 22⁵⁄₈ x 16³⁄₈ inches (574 x 417 mm)
Ref.: Wofsy 145; Chapon-Rouault 91[b/b]
1969:80-38

161:39 NOUS SOMMES FOUS, 1922
Plate: 22³⁄₈ x 16⁵⁄₁₆ inches (569 x 415 mm)
Ref.: Wofsy 146; Chapon-Rouault 92[d/d]
1969:80-39

161:40 FACE À FACE, 1926
Plate: 22¹¹⁄₁₆ x 17¼ inches (577 x 438 mm)
Ref.: Wofsy 147; Chapon-Rouault 93[c/c]
1969:80-40

161:41 AUGURES, 1923
Plate: 20⅛ x 17⁵⁄₁₆ inches (511 x 440 mm)
Ref.: Wofsy 148; Chapon-Rouault 94[c/c]
1969:80-41

161:42 BELLA MATRIBUS DETESTATA, 1927
Plate: 23³⁄₁₆ x 17⅝ inches (589 x 447 mm)
Ref.: Wofsy 149; Chapon-Rouault 95[e/e]
1969:80-42

161:43 "NOUS DEVONS MOURIR, NOUS ET TOUT CE QUI EST NÔTRE," 1922
Plate: 20⅜ x 14⅜ inches (517 x366 mm)
Ref.: Wofsy 150; Chapon-Rouault 96[c/c]
1969:80-43

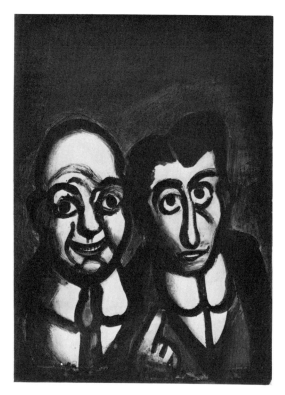

(161:39)

161:44 MON DOUX PAYS, OÙ ÊTES-VOUS? 1927
Plate: 16¹¹/₁₆ x 23⁹/₁₆ inches (424 x 599 mm)
Ref.: Wofsy 151; Chapon-Rouault 97[d/d]
1969:80-44

161:45 LA MORT L'A PRIS COMME IL SORTAIT DU LIT
D'ORTIES, 1922
Plate: 21¼ x 13³/₁₆ inches (540 x 335 mm)
Ref.: Wofsy 152[b]; Chapon-Rouault 98[f/f]
1969:80-45

161:46 "LE JUSTE, COMME LE BOIS DE SANTAL,
PARFUME LA HACHE QUI LE FRAPPE," 1926
Plate: 23³/₁₆ x 16¹¹/₁₆ inches (589 x 424 mm)
Ref.: Wofsy 153; Chapon-Rouault 99[e/e]
1969:80-46

161:47 DE PROFUNDIS . . . , 1927
Plate: 17¹/₈ x 23¾ inches (434 x 603 mm)
Ref.: Wofsy 154; Chapon-Rouault 100[e/e]
1969:80-47

161:48 AU PRESSOIR, LE RAISIN FUT FOULÉ, 1922
Plate: 15⁵/₈ x 19¹/₈ inches (397 x 486 mm)
Ref.: Wofsy 155; Chapon-Rouault 101[d/d]
1969:80-48

161:49 "PLUS LE COEUR EST NOBLE, MOINS LE COL
EST ROIDE," 1926
Plate: 23¹/₈ x 16¾ inches (587 x 426 mm)
Ref.: Wofsy 156; Chapon-Rouault 102[c/c]
1969:80-49

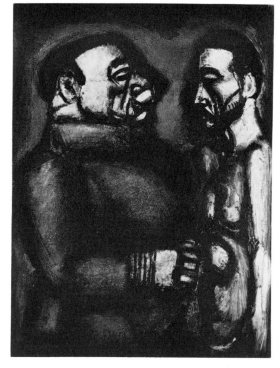

(161:40)

161:50 "DES ONGLES ET DU BEC," 1926
Plate: 22¾ x 17⁹⁄₁₆ inches (578 x 446 mm)
Ref.: Wofsy 157; Chapon-Rouault 103[b/b]
1969:80-50

161:51 LOIN DU SOURIRE DE REIMS, 1922
Plate: 20³⁄₁₆ x 15¹⁄₁₆ inches (512 x 383 mm)
Ref.: Wofsy 158; Chapon-Rouault 104[g/g]
1969:80-51

161:52 DURA LEX SED LEX, 1926
Plate: 22¹¹⁄₁₆ x 17⅛ inches (576 x 436 mm)
Ref.: Wofsy 159; Chapon-Rouault 105[e/e]
1969:80-52

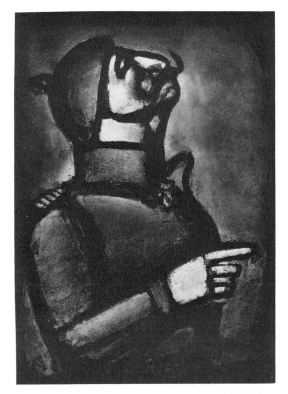

(161:49)

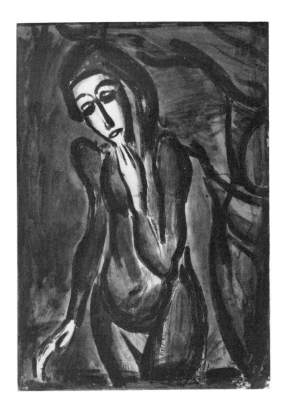

(161:43)

161:53 VIERGE AUX SEPT GLAIVES, 1926
Plate: 23⅛ x 16¼ inches (586 x 412 mm)
Ref.: Wofsy 160[b]; Chapon-Rouault 106[c/c]
1969:80-53

161:54 "DEBOUT LES MORTS!" 1927
Plate: 23¼ x 17⁹⁄₁₆ inches (590 x 447 mm)
Ref.: Wofsy 161; Chapon-Rouault 107[b/b]
1969:80-54

161:55 L'AVEUGLE PARFOIS A CONSOLÉ LE
VOYANT, 1926
Plate: 23⅛ x 17¼ inches (588 x 438 mm)
Ref.: Wofsy 162; Chapon-Rouault 108[d/d]
1969:80-55

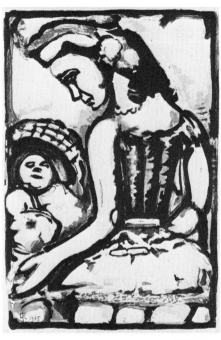

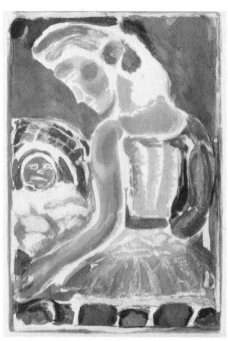

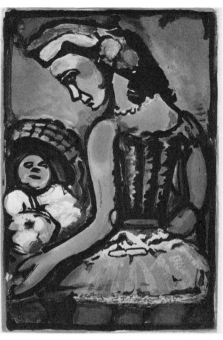

(165:1) (165:4) (164)

161:56 En ces temps noirs de jactance et
d'incroyance, Notre-Dame de la Fin des Terres
vigilante, 1927
Plate: 23³⁄₁₆ x 17³⁄₁₆ inches (592 x 437 mm)
Ref.: Wofsy 163; Chapon-Rouault 109$^{c/c}$
1969:80-56

161:57 "Obéissant jusqu'à la mort et à la mort
de la croix," 1926
Plate: 23⅛ x 16¾ inches (586 x 426 mm)
Ref.: Wofsy 164; Chapon-Rouault 110$^{b/b}$
1969:80-57

161:58 "C'est par ses meurtrissures que nous
sommes guéris," 1922
Plate: 22¹⁵⁄₁₆ x 18⅝ inches (583 x 473 mm)
Ref.: Wofsy 165; Chapon-Rouault 111$^{b/b}$
1969:80-58

(162)

Incantation, 1928
For Ambroise Vollard, *Réincarnations du Père Ubu*
Photogravure, etching, aquatint and roulette printed in
black on japan *nacré*
Plate: 11¾ x 7¹³⁄₁₆ inches (298 x 198 mm)
Sheet: 17¼ x 13¹⁄₁₆ inches (438 x 332 mm)
Signed in ink, l.r.: Georges Rouault; signed and dated in
the plate, l.ctr.: 1928 GR
Printer: Aux Deux Ours, Paris (Henri Jourde, pressman)
Publisher: Ambroise Vollard, Paris, 1932
Edition: 225 albums of the 22 etchings (50 on japan
nacré, 175 on Van Gelder paper); the text edition was
issued in 335 numbered copies (1-55 on Montval paper
with a double suite of etchings on Arches and Rives
papers, 56-305 on Vidalon paper with a suite of etch-
ings, I-XXX copies *hors commerce*)
Ref.: Wofsy 298 *(Paysage au palmier);* Chapon-Rouault

17[e/e]; Garvey, *Artist and the book*, 270 *(Réincarnations du Père Ubu)*
1976:18-64

(163)
IMPASSE, 1929
For the suite *La petite banlieue*
Lithograph printed in black on Rives wove paper
Image: 12⁷⁄₈ x 8¹³⁄₁₆ inches (327 x 224 mm)
Sheet: 17⁵⁄₈ x 12³⁄₈ inches (448 x 313 mm)
Signed in pencil, l.r.: G Rouault; numbered in pencil, l.l.: 34/100; initialed and dated on the stone, l.l.: GR 1929
Publisher: Editions des Quatre Chemins, Paris
Edition: 100 impressions
Ref.: Wofsy 72 *(Attente);* Chapon-Rouault 347
1976:18-66

(164)
DORS, MON AMOUR, 1935
For G. Rouault, *Cirque de l'étoile filante*, plate 17
Aquatint, etching, and roulette printed in at least seven colors on Montval laid paper
Plate: 12³⁄₁₆ x 8⁵⁄₁₆ inches (308 x 212 mm)
Sheet: 17⁹⁄₁₆ x 13⁷⁄₁₆ inches (447 x 342 mm)
Initialed and dated in the plate, l.l.: GR 1935
Printer: Roger Lacourière, Paris
Publisher: Ambroise Vollard, Paris, 1938
Edition: the book was issued in 280 copies (215 on Montval laid paper, 35 on japan imperial with a suite of prints in black, and 30 *hors commerce* incl. 5 on japan imperial and 25 on Montval laid paper)
Ref.: Wofsy 335; Chapon-Rouault 256[b/b]; Garvey, *Artist and the book*, 271 *(Cirque de l'étoile filante)*
1976:18-54
Note: see SCMA, Modern illustrated books, *32 (Cirque de l'étoile filante)*

(165)
DORS, MON AMOUR, 1935
Four proofs for G. Rouault, *Cirque de l'étoile filante* (Paris, Ambroise Vollard, 1938), plate XVII
Plates: 12⁷⁄₁₆ x 8⁵⁄₈ inches (315 x 219 mm)
Sheets: 17³⁄₈ x 12³⁄₄ inches (442 x 323 mm)
Printer: Roger Lacourière, Paris

165:1 DORS, MON AMOUR
Aquatint, etching and roulette printed in black on china paper mounted on japan paper
Ref.: Chapon-Rouault 256[a/b]
1976:18-55

165:2 DORS, MON AMOUR
Aquatint and roulette printed from one plate in at least five colors (yellow, green, red, blue, brown) on china paper mounted on japan paper, color proof
1976:18-56

165:3 DORS, MON AMOUR
Etching and aquatint printed from one plate in at least five colors (yellow, red, brown, gray, mauve) on china paper mounted on japan paper, color proof
1976:18-57

165:4 DORS, MON AMOUR
Aquatint, etching and roulette printed from two plates in at least seven colors (yellow, red, green, blue, brown, gray, mauve) on china paper mounted on japan paper, color proof
1976:18-58
Note: see no. 164

(166)

CHRIST DEVANT LA VILLE, 1935

For André Suarès, *Passion*

Etching, drypoint, roulette and aquatint printed in black
on Montval laid paper

Plate: 12 1/16 x 8 7/16 inches (306 x 215 mm)

Sheet: 17 5/16 x 13 5/16 inches (440 x 337 mm)

Initialed and dated in the plate, l.l.: GR 1935

Printer: Roger Lacourière, Paris

Publisher: Ambroise Vollard, Paris, 1939

Edition: the book was issued in 270 numbered copies
(1-245 on Montval laid paper, 1-40 with an extra suite
of prints printed in black; I-XXV *hors commerce* on
Montval laid paper)

Ref.: Wofsy 337; Chapon-Rouault 257[a/b]; Garvey, *Artist
and the book,* 272 (*Passion*)

1976:18-61

After Georges Rouault

(167)

WOODBLOCK

Possibly for unused illustration to Ambroise Vollard,
Réincarnations du Père Ubu (Paris, Ambroise Vollard,
1932)

11 3/4 x 8 x 15/16 inches (298 x 203 x 24 mm)

Block cutter: Georges Aubert, Paris

1984:10-82

Note: see no. 163

(168)

MIOUSIC

For G. Rouault, *Cirque de l'étoile filante* (Paris,
Ambroise Vollard, 1938), page 42

Wood engraving printed in black on china paper tabbed
on laid paper, page proof

Image: 11 13/16 x 7 15/16 inches (299 x 201 mm)

Sheet: 15 3/8 x 10 5/8 inches (390 x 270 mm)

Inscribed and initialed in ink, l.r.: Bon à tirer Remonter
les noirs aux fleches / surtout les bases GR.; inscribed in
pencil, l.r.: fait

Block cutter: Georges Aubert, Paris

Printer: Aux Deux Ours (Henri Jourde, pressman), Paris

Edition: see no. 164

1976:18-63

(169)

TANT DE BONS GARÇONS

For G. Rouault, *Cirque de l'étoile filante* (Paris,
Ambroise Vollard, 1938), page 61

Wood engraving printed in black on china paper tabbed
onto Rives laid paper, page proof

Image: 6 1/16 x 7 15/16 inches (155 x 201 mm)

Sheet: 9 1/4 x 11 13/16 inches (232 x 300 mm)

Inscribed and initialed in ink, l.r.: Bon a tirer / GR; in-
scribed in pencil, l.r.: fait; l.l.: 68 26

Block cutter: Georges Aubert, Paris

Printer: Aux Deux Ours (Henri Jourde, pressman), Paris

Edition: see no. 164

1976:18-67

(170)

DOUCE AMÈRE

For G. Rouault, *Cirque de l'étoile filante* (Paris,
Ambroise Vollard, 1938)

Wood engraving printed in black on china paper, proof
for table of plates

Image: 2 3/8 x 7 1/16 inches (59 x 37 mm)

Sheet: 4 1/4 x 3 1/2 inches (108 x 89 mm)

Inscribed in pencil below image: Douce amere-; Bon a
tirer / GR; page 100

Block cutter: Georges Aubert, Paris

Printer: Aux Deux Ours (Henri Jourde, pressman), Paris

Edition: see no. 164

1976:18-59

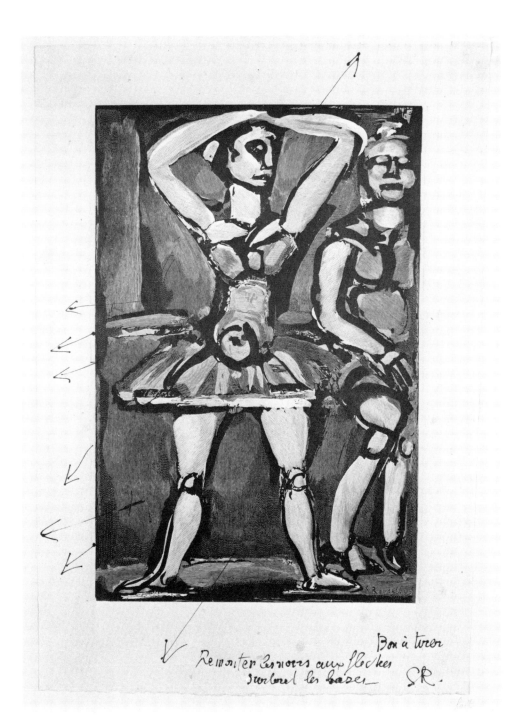

(171)

WOODBLOCK FOR *DOUCE AMÈRE*

2½ x 1⅝ x ⅝ inches (63 x 42 x 22 mm)

Block cutter: Georges Aubert, Paris

1976:18-60

Note: see no. 170

(172)

UNTITLED LANDSCAPE

For G. Rouault, *Cirque de l'étoile filante* (Paris, Ambroise Vollard, 1938) page 157

Wood engraving printed in black on china paper tabbed onto Montval laid paper, page proof

Image: 1¼ x 7¹⁵⁄₁₆ inches (32 x 202 mm)

Sheet (china): 4⅛ x 11⅜ inches (104 x 288 mm)

Inscribed in ink, l.r.: Bon a tirer GR; inscribed in pencil, l.r.: fait; l.l.: 56

Block cutter: Georges Aubert, Paris

Printer: Aux Deux Ours (Henri Jourde, pressman), Paris

Edition: see no. 164

1976:18-62

(173)

LA PETITE ÉCUYÈRE

For G. Rouault, *Cirque de l'étoile filante* (Paris, Ambroise Vollard, 1938)

Wood engraving printed in black on china paper, proof for table of plates

Image: 3⁷⁄₁₆ x 4⁹⁄₁₆ inches (86 x 116 mm)

Sheet: 9¹⁵⁄₁₆ x 10¹³⁄₁₆ inches (252 x 273 mm)

Inscribed and initaled in pencil, l.r.: Bon à tirer / GR

Block cutter: Georges Aubert, Paris

Printer: Aux Deux Ours (Henri Jourde, pressman), Paris

Edition: see no. 164

1976:18-53

(174)

DÉPART POUR AILLEURS

For André Suarès, *Passion* (Paris, Ambroise Vollard, 1939)

Wood engraving printed in black on laid paper

Image: 11¹⁵⁄₁₆ x 8¹⁄₁₆ inches (303 x 204 mm)

Sheet: 16⅛ x 12⅛ inches (409 x 307 mm)

Block cutter: Georges Aubert, Paris

Printer: Henri Jourde, Paris

Edition: see no. 166

1972:50-97

Paul Signac 1863 – 1935

(175)

LES BATEAUX, 1895

Lithograph printed in four colors on wove paper

Image: 9¼ x 15⅝ inches (235 x 397 mm)

Sheet: 15⅜ x 20⅞ inches (391 x 531 mm)

Numbered in pencil, l.r.: 26/40

Publisher: Gustave Pellet, Paris

Edition: 40 impressions

Ref.: Kornfeld-Wick 13

1972:50-98

Alfred Sisley 1839 – 1899

(176)

BORDS DU LOING: LA CHARRETTE, 1890

Etching printed in black on laid paper

Plate: 8¹³⁄₁₆ x 5¾ inches (224 x 146 mm)

Sheet: 11⅛ x 7⅞ inches (282 x 200 mm)

Inscribed in the plate, l.l. to l.r.: Sisley del. et sc.; Paysage; Gazette des Beaux-Arts

Publisher: Gazette des Beaux-Arts, Paris, 1899

Ref.: Delteil 1 iii/iv

1978:1-66

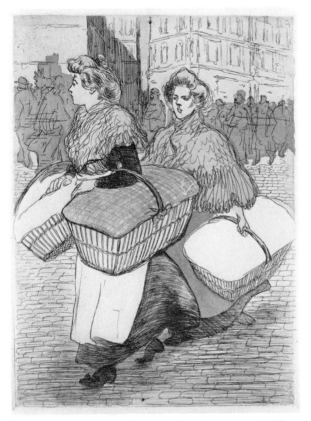

(177)

Théophile-Alexandre Steinlen
1859 – 1932

(177)

BLANCHISSEUSES REPORTANT L'OUVRAGE, 1898

Etching and drypoint printed in five colors on wove paper

Plate: 14½ x 10⅝ inches (359 x 269 mm)

Sheet: 19¹³/₁₆ x 12¹³/₁₆ inches (503 x 326 mm)

Ref.: Crauzat 22 iii/iii

1976:18-68

(178)

PAYSAGE NORVÈGE, 1902

Etching and drypoint on zinc printed in five colors on Arches laid paper

Plate: 6⅞ x 11¹⁵/₁₆ inches (174 x 303 mm)

Sheet: 11¹¹/₁₆ x 16 inches (297 x 406 mm)

Signed in pencil, l.r.: Steinlen; blind stamp, l.r.: Ed SAGOT / Editeur / PARIS [Lugt 2254]

Publisher: Edmond-Honoré Sagot, Paris

Ref.: Crauzat 60

1984:10-75

(182)

(179)

SÉPARATION

Song sheet cover, lyrics by Georges Herbert, music by Alfred Bert

Lithograph printed in black on mounted china paper

Image: 10⁷/₁₆ x 6½ inches (265 x 165 mm)

Sheet: 15⅛ x 10⅞ inches (358 x 275 mm)

Signed on the stone, l.l.: Steinlen

Publisher: G. Onet, Paris

Ref.: Crauzat 410 ii/ii

1976:18-70

(180)

LA COMÈTE

Lithograph printed in black on mounted china paper

Image: 9³/₁₆ x 6½ inches (234 x 155 mm)

Sheet: 13¾ x 10¹⁵/₁₆ inches (352 x 273 mm)

Signed on the stone, l.l.: Steinlen

Ref.: not in Crauzat

1976:18-69

Jan Toorop 1858 – 1929

(181)

VENISE SAUVÉE, 1895

Program for Théâtre de l'Oeuvre production of the play by Thomas Otway

Lithgraph printed in black on wove paper

Image: 17⁹/₁₆ x 11 inches (446 x 280 mm)

Sheet: 19¹³/₁₆ x 13 inches (503 x 330 mm)

Signed on the stone (in reverse), l.l.: JAN / TOOROP

Ref.: Pollak 88

1976:18-71

Henri de Toulouse-Lautrec 1864-1901

(182)

MISS LOIE FULLER, 1892

Lithograph printed in four colors on wove paper

Image: 14¹⁵/₁₆ x 10¼ inches (364 x 260 mm)

Sheet: 15 x 11⅛ inches (381 x 282 mm)

Publisher: L'Estampe originale (André Marty), Paris

Edition: 50 impressions

Ref.: Delteil 39; Adhémar 8; Adriani-Wittrock 8 iii/iii

1978:1-45

(183)

L'ESTAMPE ORIGINALE, 1893

Cover for album no. I

Lithograph printed in green on wove paper, proof

Image: 22¾ x 25¾ inches (578 x 644 mm)

Sheet: 22⅜ x 31⅛ inches (594 x 790 mm)

Signed and dated on the stone, u.r.: T-Lautrec 93; monogrammed on the stone, l.r.

Printer: Edw. Ancourt, Paris

Publisher: André Marty, Paris

Ref.: Delteil 17; Adhémar 10; Adriani-Wittrock 10 i/ii

1978:1-42

(184)

L'ESTAMPE ORIGINALE, 1893

Cover for album no. I

Lithograph printed in seven colors on wove paper

Image: 22¼ x 25⅜ inches (565 x 644 mm)

Sheet: 23 x 31⅜ inches (584 x 796 mm)

Signed and numbered in pencil, l.l.: T-Lautrec 3; signed and dated on the stone, u.r.: T-Lautrec 93; monogrammed on the stone, l.r.

Printer: Edw. Ancourt, Paris

Publisher: André Marty, Paris

Edition: 100 impressions

Ref.: Delteil 17; Adhémar 10; Adriani-Wittrock 10 ii/ii

1978:1-43

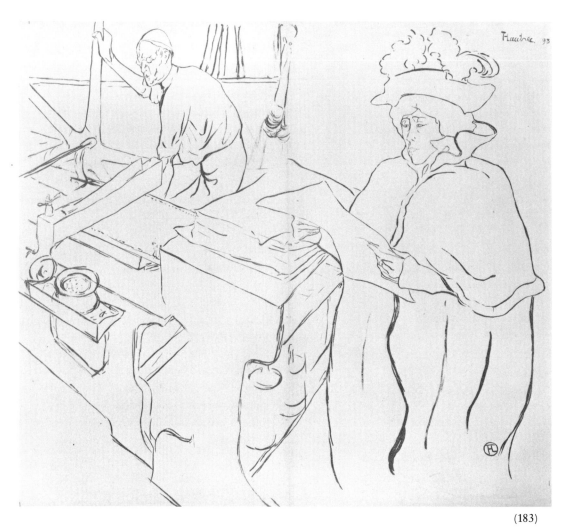

(183)

(185)

LA MODISTE (RENÉE VERT), 1893

Lithograph printed in two colors on wove paper
Image: 16½ x 11⅜ inches (420 x 290 mm)
Sheet: 20⁹⁄₁₆ x 12¹⁵⁄₁₆ inches (521 x 329 mm)
Initialed on the stone (in reverse), l.ctr.: T-L; monogram-
med on the stone, l.l.; monogram stamped in red, l.r.
(Lugt 1338)

Edition: 150 impressions

Ref.: Delteil 13 i/ii; Adhémar 17 *(La modiste dressant
un chapeau)*; Adriani-Wittrock 16 i/ii

1972:50-99

*Note: This image, with lettering, was used as a menu
for the 23 June 1893 dinner given by the Société des
Indépendants.*

(186)

PAUVRE PIERREUSE, 1893

Lithograph printed in green with stenciled color on wove paper, proof for song sheet cover

Image: 9 15/16 x 6¾ inches (236 x 170 mm)

Sheet: 13⅞ x 10⅝ inches (352 x 270 mm)

Signed and numbered in pencil, l.l.: No 89 / T-Lautrec; monogrammed on the stone, l.r.; blind stamp, l.l.: ED KLEINMANN / PARIS / 8 Rue de la Victoire (variant of Lugt 1573)

Publisher: Edouard Kleinmann, Paris

Edition: 100 impressions

Ref.: Delteil 26 i/ii; Adhémar 27; Adriani-Wittrock 36 i/iv

1972:50-101

(187)

LE PETIT TROTTIN, 1893

Lithograph printed in black on japan paper, proof for song sheet cover

Image: 11 x 7¼ inches (280 x 185 mm)

Sheet: 12 7/16 x 9⅞ inches (315 x 251 mm)

Signed in pencil, l.l.: T-Lautrec; monogrammed on the stone, l.l.

Publisher: A. Fouquet, Paris

Ref.: Delteil 27 i/ii; Adhémar 18; Adriani-Wittrock 37 i/iii

1972:50-102

(188)

LE COIFFEUR, 1893

Program for Théâtre Libre production of *Une faillite, Le poète et le financier* by Björnstjerne Björnson and Maurice Vaucaire

Lithograph printed in three colors on wove paper

Image: 12⅝ x 9 7/16 inches (320 x 240 mm)

Sheet: 12¾ x 9½ inches (233 x 241 mm)

Monogrammed on the stone, l.r.

Printer: Eugène Verneau, Paris

Ref.: Delteil 14 ii/ii; Adhémar 40; Adriani-Wittrock 38 ii/iii

1972:50-100

(189)

AUX VARIÉTÉS: MLLE LENDER ET BRASSEUR, 1893

For the journal *L'Escarmouche*

Lithograph printed in black on wove paper

Image: 13 3/16 x 10¼ inches (335 x 260 mm)

Sheet: 15 1/16 x 11⅛ inches (381 x 282 mm)

Signed and numbered in pencil, l.l.: N° 95 / T-Lautrec; monogrammed on the stone, l.l.

Printer: Eugène Verneau, Paris

Publisher: Georges Darien, Paris

Edition: 100 impressions; reproduced in *L'Escarmouche*, no. 2, 19 November 1893

Ref.: Delteil 41 ii/iii; Adhémar 44; Adriani-Wittrock 43 ii/iii

1978:1-46

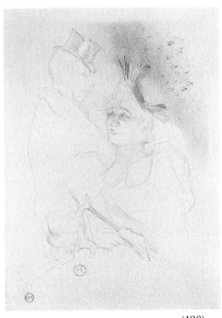

(190)

(190)

MLLE LENDER ET BARON, 1893
For the journal *L'Escarmouche*
Lithograph printed in green-brown ink on wove paper
Image: 12⅝ x 9⅛ inches (320 x 232 mm)
Sheet: 15 x 11 inches (381 x 279 mm)
Numbered in pencil, l.l.: N° 6; monogrammed on the
stone, l.l.; monogram stamped in red, l.l. (Lugt 1338)
Printer: Eugène Verneau, Paris
Publisher: Georges Darien, Paris
Edition: 100 impressions; reproduced in *L'Escar-
mouche,* no. 4, 3 December 1893
Ref.: Delteil 43; Adhémar 46; Adriani-Wittrock 45 i/ii
1978:1-47

(191)

AU MOULIN-ROUGE, L'UNION FRANCO-RUSSE, 1894
For the journal *L'Escarmouche*
Lithograph printd in black on wove paper
Image: 13⅛ x 9⁹⁄₁₆ inches (333 x 244 mm)
Sheet: 15 x 11¹⁄₁₆ inches (380 x 281 mm)
Numbered in pencil, l.r.: 59; monogrammed on the
stone, l.r.; monogram stamped in red, l.r. (Lugt 1338)
Printer: Eugène Verneau, Paris
Publisher: Georges Darien, Paris
Edition: 100 impressions; reproduced in *L'Escar-
mouche,* no. 1 (second year), 7 January 1894
Ref.: Delteil 50; Adhémar 53; Adriani-Wittrock 52
1972:50-103

(192)

AU THÉÂTRE LIBRE: ANTOINE DANS *INQUIÉTUDE,* 1894
For the journal *L'Escarmouche*
Lithograph printed in black on wove paper
Image: 14⁹⁄₁₆ x 10⅜ inches (370 x 263 mm)
Sheet: 15 x 11 inches (381 x 279 mm)
Numbered in pencil, l.l.: 55; monogrammed on the
stone, l.r.; monogram stamped in red, l.l. (Lugt 1338)
Printer: Eugène Verneau, Paris
Publisher: Georges Darien, Paris

(193:1)

Edition: 100 impressions; reproduced in *L'Escar-
mouche,* no. 2 (second year), 14 January 1894
Ref.: Delteil 51, Adhémar 55, Adriani-Wittrock 53
1978:1-48

(193)

AUX AMBASSADEURS, 1894
Three color proofs
Ref.: Delteil 68; Adhémar 73; Adriani-Wittrock 72

193:1 AUX AMBASSADEURS
Lithograph printed in yellow on wove paper, proof
Image: 5½ x 9⁷⁄₁₆ inches (140 x 240 mm)
Sheet: 23½ x 17 inches (597 x 432 mm)
1972:50-104

(193:2)

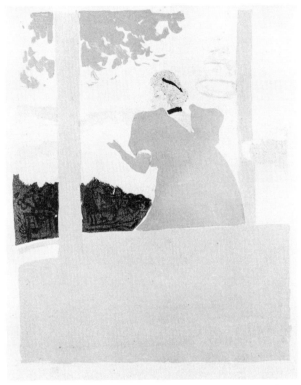

(193:3)

193:2 AUX AMBASSADEURS
Lithograph printed in yellow and beige on wove paper, proof
Image: 11 $^{15}/_{16}$ x 9 $^{9}/_{16}$ inches (303 x 240 mm)
Sheet: 23½ x 17 inches (597 x 432 mm)
1972:50-105

193:3 AUX AMBASSADEURS
Lithograph printed in yellow, beige, pink and black on wove paper, proof
Image: 11 $^{15}/_{16}$ x 9 $^{5}/_{8}$ inches (303 x 245 mm)
Sheet: 23½ x 17 inches (597 x 432 mm)
1972:50-106

(194)
LES VIEUX MESSIEURS, 1894
Song sheet with lithographed cover, complete with fold

sheet and monologue written by Maurice Donnay for Yvette Guilbert
Lithograph printed in black on wove paper
Image: 9¾ x 6¼ inches (248 x 159 mm)
Sheet (folded): 10¾ x 6⅞ inches (273 x 175 mm)
Monogrammed on the stone, l.l.
Publisher: Société d'Editions Musicales, Paris
Ref.: Delteil 75 ii/iii; Adhémar 80; Adriani-Wittrock 95 ii/iii
1972:50-107

(195)
LE CHARIOT DE TERRE CUITE, 1895
Program for Théâtre de l'Oeuvre production of the play by Victor Barrucand, adapted from the Sanskrit drama *Mric'Chakatika*

(197)

Lithograph printed in blue on salmon-colored wove paper
Image and sheet: 17¼ x 11 inches (439 x 279 mm)
Monogrammed on the stone, l.ctr.
Ref.: Delteil 77 ii/ii; Adhémar 109; Adriani-Wittrock 105 ii/ii
1972:50-108
Note: Toulouse-Lautrec designed the set for this play as well as the program.

(196)
YVETTE GUILBERT, 1894
For *Yvette Guilbert*, plate 1
Lithograph printed in green on wove paper, proof before text
Image: 10¾ x 7⅛ inches (272 x 181 mm)
Sheet: 17¹⁄₁₆ x 12⁷⁄₁₆ inches (434 x 316 mm)
Monogrammed on the stone, ctr.
Printer: Edw. Ancourt, Paris
Publisher: L'Estampe originale (André Marty), Paris
Ref.: Delteil 80 i/ii; Adhémar 86; Adriani-Wittrock 78 i/ii; Garvey, *Artist and the book*, 301 *(Yvette Guilbert)*
1972:50-110
Note: see nos. 197 and 267.

(197)
YVETTE GUILBERT, 1894
For *Yvette Guilbert*, plate 5
Lithograph printed in green on wove paper, proof before text
Image: 12 x 7¼ inches (305 x 184 mm)
Sheet: 14¹⁵⁄₁₆ x 11⅛ inches (379 x 282 mm)
Signed in pencil, l.l.: T-Lautrec; monogrammed on the stone, ctr.; blind stamp, l.r.: LIBRERIA/PRAND/REGGIO/E.
Printer: Edw. Ancourt, Paris
Publisher: L'Estampe originale (André Marty), Paris
Ref.: Delteil 84 i/ii; Adhémar 90; Adriani-Wittrock

82 i/ii; Garvey, *Artist and the book*, 301 *(Yvette Guilbert)*

1972:50-111

Note: see nos. 196 and 267

(198)

ANNA HELD DANS *TOUTES CES DAMES AU THÉÂTRE*, 1894

Lithograph printed in black on wove paper

Image: 13 x 8⅜ inches (331 x 213 mm)

Sheet: 20⅜ x 14⅛ inches (518 x 360 mm)

Signed in crayon, l.l.: T-Lautrec; numbered in pencil, l.l.: n°9; monogrammed on the stone, l.l.

Ref.: Delteil 100 i/iii; Adhémar 112; Adriani-Wittrock 103 i/ii

1978:1-49

(199)

INVITATION ALEXANDRE NATANSON, 1895

Lithograph printed in black on wove paper

Image: 10¹⁵⁄₁₆ x 6⅛ inches (278 x 156 mm)

Sheet: 13½ x 7¹⁄₁₆ inches (343 x 180 mm)

Monogrammed on the stone, l.r.

Ref.: Delteil 101 ii/ii; Adhémar 123; Adriani-Wittrock 110 ii/ii

1972:50-112

(200)

YAHNE ET ANTOINE DANS *L'AGE DIFFICILE*, 1895

Lithograph printed in black on wove paper

Image: 13¾ x 10 inches (350 x 254 mm)

Sheet: 23 x 15⅞ inches (584 x 404 mm)

Numbered in red crayon, l.l.: No 10; momogrammed on the stone, u.r.; monogram stamped in red, l.r. (Lugt 1338); blind stamp, l.l.: ED. KLEINMANN / PARIS / 8 Rue de la Victoire (variant of Lugt 1573)

Provenance: Max Blach (Lugt, *Suppl.,* 261ᵉ)

Publisher: Edouard Kleinmann, Paris

Edition: 25 impressions

Ref.: Delteil 112; Adhémar 117; Adriani-Wittrock 128

1972:50-113

(201)

AU RIDEAU, 1895

Cover for *L'Estampe originale,* album no. X, 1895

Lithograph printed in two colors on wove paper

Image and sheet: 23¼ x 32½ inches (589 x 826 mm)

Signed in pencil, l.l.ctr.: T-Lautrec; monogrammed on the stone u.ctr.

Printer: Edw. Ancourt, Paris

Publisher: André Marty, Paris

Ref.: Delteil 127; Adhémar 111; Adriani-Wittrock 107 iii/iii

1978:1-44

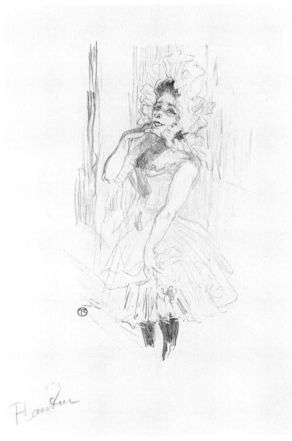

(198)

(202)

LENDER ET LAVALLIÈRE DANS *LES FILS D'ARÉTIN*, 1895

Lithograph printed in black on wove paper
Image: 18 x 14⅜ inches (457 x 365 mm)
Sheet: 23¾ x 16¾ inches (603 x 426 mm)
Signed and dedicated in pencil, l.r.: à Gallimond [?] /
T-Lautrec; monogrammed on the stone, l.r.
Edition: 20 impressions
Ref.: Delteil 164 i/ii; Adhémar 133; Adriani-Wittrock
121 i/ii
1972:50-116

(203)

LA CHÂTELAINE (LE TOCSIN), 1895

Lithograph printed in two colors on wove paper
Image: 21¼ x 15½ inches (540 x 394 mm)
Sheet: 22⅜ x 17½ inches (568 x 445 mm)
Monogrammed and dated on the stone, l.l.: [monogram] / 95
Printer: Cassan fils, Toulouse
Ref.: Delteil 357 ii/ii; Adhémar 147; Adriani-Wittrock
140 ii/ii
1972:50-128

(204)

LA PASSAGÈRE DU 54 (PROMENADE EN YACHT), 1895

Lithograph printed in green on japan imperial paper
Image: 23½ x 16 inches (596 x 406 mm)
Sheet: 25⁵⁄₁₆ x 19⅜ inches (643 x 492 mm)
Signed in black crayon, l.l.: T-Lautrec; numbered in
pencil, l.l.: n°7; monogram stamped in red, l.l.
(Lugt 1338)
Printer: Bourgerie et cie, Paris
Edition: 50 impressions
Ref.: Delteil 366 i/ii; Adhémar 188; Adriani-Wittrock
145 i/iii
1972:50-129

(205)

LA PASSAGÈRE DU 54 (PROMENADE EN YACHT), 1895

Poster for the Salon des Cent, Exposition internationale
d'affiches
Lithograph printed in six colors on wove paper
Image: 23¾ x 15⁹⁄₁₆ inches (603 x 396 mm)
Sheet: 24 x 16¹⁄₁₆ inches (610 x 408 mm)
Monogrammed on the stone, l.r.; dated within the
monogram: 95
Printer: Bourgerie et cie, Paris
Publisher: La plumel
Ref.: Delteil 366 iii/iii; Adhémar 188; Adriani-Wittrock
145 iii/iii
1984:10-76

(206)

LES PAPILLONS, 1895

Song sheet cover, music by Désiré Dihau for poem by
Jean Richepin
Lithograph printed in black on wove paper
Image: 10 x 7½ inches (254 x 190 mm)
Sheet: 13¹³⁄₁₆ x 10¹⁵⁄₁₆ inches (351 x 278 mm)
Monogrammed on the stone, l.l.
Publisher: C. Jourbert, Paris
Ref.: Delteil 133 ii/ii; Adhémar 154; Adriani-Wittrock
151 ii/ii
1976:18-73

(207)

LES HIRONDELLES DE MER, 1895

Song sheet with lithographed cover, complete with fold
sheet and music by Désiré Dihau, poem by Jean
Richepin
Lithograph printed in black on wove paper
Image: 8¹⁄₁₆ x 7⅞ inches (205 x 200 mm)
Sheet (folded): 13¹³⁄₁₆ x 10⅝ inches (351 x 270 mm)
Monogrammed on the stone, l.l.
Publisher: C. Jourbert, Paris
Ref.: Delteil 138 ii/ii; Adhémar 156; Adriani-Wittrock
156 ii/ii
1976:18-72

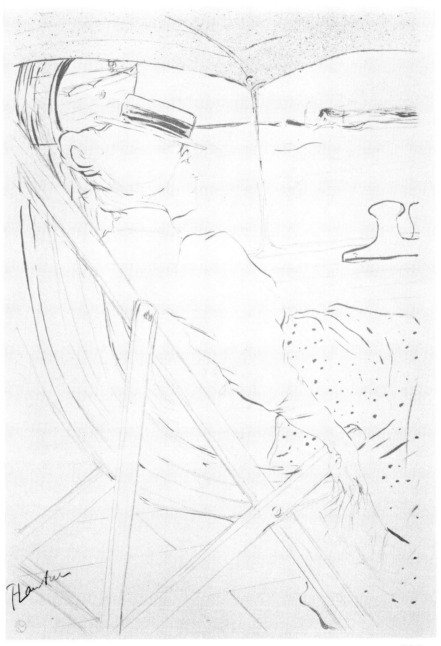

(204)

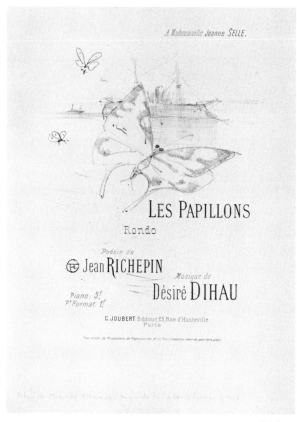

(206)

(208)
Q̲UATORZE LITHOGRAPHIES ORIGINALES DE TOULOUSE-
LAUTREC POUR ILLUSTRER DES CHANSONS [ca. 1920]
Portfolio of fourteen song sheet covers, music by Désiré
Dihau for lyrics by Jean Richepin
Lithographs printed in black on wove paper
Sheets: 12¾ x 9⅞ inches (323 x 251 mm)
Printer: H. Lefèbre, Paris
Publisher: A. Richard, Paris (originally published by C.
Joubert, Paris, 1895, as *Mélodies de Désiré Dihau, de
l'Opéra*)
Edition: 120 numbered copies (1-100 on wove paper,
I-XX on china paper); copy no. 83

208:1 A̲DIEU, 1895
Image: 9½ x 7¾ inches (242 x 197 mm)
Ref.: Delteil 129 ii/ii; Adhémar 158 ii/ii;
Adriani-Wittrock 147 ii/ii
1976:18-142[a]

208:2 B̲ALLADE DE N̲OËL, 1895
Image: 9⁷⁄₁₆ x 7⁹⁄₁₆ inches (240 x 192 mm)
Ref.: Delteil 130 ii/ii; Adhémar 159 ii/ii;
Adriani-Wittrock 148 ii/ii
1976:18-142[b]

208:3 C̲E QUE DIT LA PLUIE, 1895
Image: 6¹¹⁄₁₆ x 7¹¹⁄₁₆ inches (170 x 195 mm)
Ref.: Delteil 131 ii/ii; Adhémar 153 ii/ii;
Adriani-Wittrock 149 ii/ii
1976:18-142[c]

208:4 L̲E FOU, 1895
Image: 8⅜ x 5¾ inches (213 x 146 mm)
Ref.: Delteil 132 ii/ii; Adhémar 163 ii/ii;
Adriani-Wittrock 150 ii/ii
1976:18-142[d]

208:5 L̲ES PAPILLONS, 1895
Image: 8⅝ x 7⅜ inches (213 x 187 mm)
Ref.: Delteil 133 ii/ii; Adhémar 154 ii/ii;
Adriani-Wittrock 151 ii/ii
1976:18-142[e]

208:6 L'H̲ARENG SAUR, 1895
Image: 9⅛ x 8¼ inches (232 x 210 mm)
Ref.: Delteil 134 ii/ii; Adhémar 155 ii/ii;
Adriani-Wittrock 152 ii/ii
1976:18-142[f]

208:7 L̲E SECRET, 1895
Image: 9¼ x 7⅜ inches (235 x 187 mm)
Ref.: Delteil 135 ii/ii; Adhémar 151 ii/ii;

Adriani-Wittrock 153 ii/ii
1976:18-142[g]

208:8 ETOILES FILANTES, 1895
Image: 10⅝ x 8¼ inches (261 x 206 mm)
Ref.: Delteil 136 ii/ii; Adhémar 161 ii/ii;
Adriani-Wittrock 154 ii/ii
1976:18-142[h]

208:9 OCEANO NOX, 1895
Image: 10¼ x 8⅛ inches (260 x 207 mm)
Ref.: Delteil 137 ii/ii; Adhémar 157 ii/ii;
Adriani-Wittrock 155 ii/ii
1976:18-142[i]

208:10 LES HIRONDELLES DE MER, 1895
Image: 8 x 8 inches (203 x 203 mm)
Ref.: Delteil 138 ii/ii; Adhémar 156 ii/ii;
Adriani-Wittrock 156 ii/ii
1976:18-142[j]

208:11 FLORÉAL, 1895
Image: 9⅛ x 7½ inches (232 x 191 mm)
Ref.: Delteil 139 ii/ii; Adhémar 164 ii/ii;
Adriani-Wittrock 157 ii/ii
1976:18-142[k]

208:12 ACHETEZ MES BELLES VIOLETTES, 1895
Image: 9¼ x 6¾ inches (236 x 171 mm)
Ref.: Delteil 140 ii/ii; Adhémar 165 ii/ii;
Adriani-Wittrock 158 ii/ii
1976:18-142[l]

208:13 BERCEUSE, 1895
Image: 9½ x 7⅞ inches (241 x 200 mm)
Ref.: Delteil 141 ii/ii; Adhémar 152 ii/ii;
Adriani-Wittrock 159 ii/ii
1976:18-142[m]

208:14 LES VIEUX PAPILLONS, 1895
Image: 8⅞ x 7⅝ inches (226 x 194 mm)
Ref.: Delteil 142 ii/ii; Adhémar 162 ii/ii;
Adriani-Wittrock 160 ii/ii
1976:18-142[n]

(209)
SOUPER À LONDRES, 1896
For the album *Etudes de femmes*
Lithograph printed in black on wove paper
Image: 12¼ x 14¼ inches (313 x 362 mm)
Sheet: 13⅝ x 18¹¹⁄₁₆ inches (346 x 475 mm)
Signed in pencil, l.l.: T-Lautrec; signed and dated on the
stone (in reverse), u.l.: Lautrec / [monogram] / 96
Printer: Lemercier et Cie., Paris
Publisher: L'Estampe originale (André Marty), Paris
Edition: 100 impressions
Ref.: Delteil 167; Adhémar 190; Adriani-Wittrock 166
1972:50-117

(210)
L'OEUVRE, 1896
Prospectus for the 1895-96 season of Théâtre de
l'Oeuvre with lithographed cover
Lithograph on brown wove paper
Image: 8⅜ x 13½ inches (213 x 343 mm)
Sheet (folded): 9⅝ x 14⅜ inches (245 x 365 mm)
Monogrammed on the stone, ctr.l.
Printer: E. Robert, Paris
Ref.: Delteil 149 ii/ii; Adhémar 183; Adriani-Wittrock
168 ii/ii
1976:18-74

*Note: This is the complete prospectus including texts in
French, English and Dutch, illustrated with lithographs
and woodcuts by Dondelet, Maurice Denis, Edouard
Vuillard, A. de la Gandara and Félix Vallotton.*

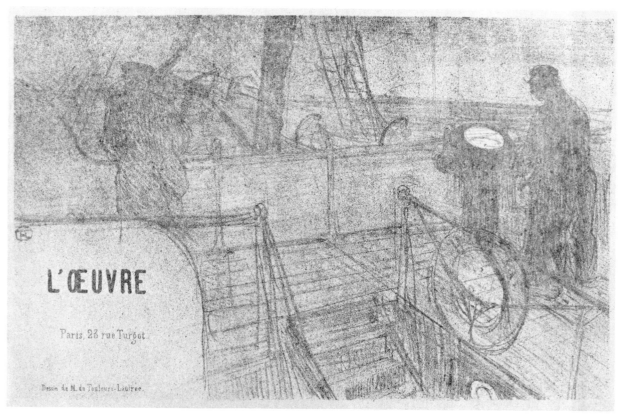

L'ŒUVRE

Paris, 23 rue Turgot.

Dessin de M. de Toulouse-Lautrec.

(210)

(211)

OSCAR WILDE ET ROMAIN COOLUS, 1896
Program for Théâtre de l'Oeuvre production of *Salomé* by O. Wilde and *Raphael* by R. Coolus
Lithograph printed in black on wove paper
Image: 11¹⁵/₁₆ x 19³/₈ inches (303 x 492 mm)
Sheet: 12¹⁵/₁₆ x 19³/₄ inches (327 x 502 mm)
Monogrammed on the stone, u.r.
Ref.: Delteil 195 iv/iv; Adhémar 186; Adriani-Wittrock 167 iv/iv
1978:1-50

(212)

PROCÈS ARTON: DÉPOSITION ARTON, 1896
Lithograph printed in black on wove paper
Image: 13³/₄ x 18¹/₂ inches (350 x 470 mm)
Sheet: 18³/₁₆ x 24³/₈ inches (462 x 619 mm)
Monogrammed and dated on the stone, l.l.:
[monogram] / 96
Ref.: Delteil 191; Adhémar 192; Adriani-Wittrock 170
1972:50-120

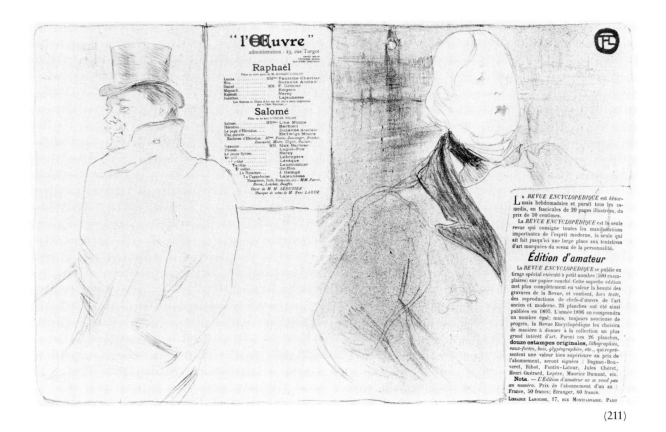

(211)

(213)

PROCÈS ARTON: DÉPOSITION RIBOT, 1896

Lithograph printed in black on wove paper

Image: 17⅝ x 22 inches (448 x 595 mm)

Sheet: 18⅛ x 24½ inches (461 x 622 mm)

Monogrammed and dated on the stone, l.r.:
[monogram] / 96

Ref.: Delteil 192; Adhémar 194; Adriani-Wittrock 171

1972:50-121

(214)

PROCÈS ARTON: DÉPOSITION SOUDAIS, 1896

Lithograph printed in black on wove paper

Image: 16⅞ x 21½ inches (429 x 546 mm)

Sheet: 18¼ x 24⅜ inches (464 x 620 mm)

Monogrammed and dated on the stone, l.l.:
[monogram] / 96

Ref.: Delteil 193, Adhémar 194, Adriani-Wittrock 172

1972:50-122

(215)

LA LÉPREUSE, 1896

Program for Théâtre de l'Oeuvre production of the play by Henry Bataille

Lithograph printed in orange on wove paper
Sheet and image: 19½ x 12¾ inches (495 x 324 mm)
Monogrammed and dated on the stone, u.l.: [monogram] / 96

Ref.: Delteil 196 ii/ii; Adhémar 185; Adriani-Wittrock 173 ii/ii

1972:50-123

(216)

FEMME COUCHÉE (RÉVEIL), 1896

For the suite *Elles*

Lithograph printed in green on wove paper
Sheet and image: 15⅞ x 20½ inches (405 x 521 mm)
Monogrammed on the stone, l.r.; numbered and in-itialed in ink by G. Pellet, l.r.: Serie n° 59 GP (Lugt 1194)

Publisher: Gustave Pellet, Paris

Edition: 100 impressions

Ref.: Delteil 182; Adhémar 203; Adriani-Wittrock 180

1972:50-118

Note: acquired with Elles. . .faksimilie-reproduktion; *see no. 227.*

(217)

FEMME À GLACE (LA GLACE À MAIN), 1896

For the suite *Elles*

Lithograph printed in three colors on wove paper
Sheet and image: 20½ x 15¾ inches (520 x 400 mm)
Monogrammed on the stone, l.r.; numbered and in-itialed in ink by G. Pellet, l.r.: Serie n° 59 GP (Lugt 1194)

Publisher: Gustave Pellet, Paris

Edition: 100 impressions

Ref.: Delteil 185; Adhémar 206; Adriani-Wittrock 183

1972:50-119

(218)

AU PIED DU SINAÏ, 1897

Cover for the book by Georges Clémenceau (Paris, Henri Floury, 1898)

Lithograph printed in four colors on tan wove paper
Image: 10⅜ x 16¼ inches (263 x 412 mm)
Sheet: 14¹⁵⁄₁₆ x 22³⁄₁₆ inches (380 x 564 mm)
Monogrammed on the stone, l.r.

Printer: Chamerot and Renouard, Paris

Edition: 380 impressions

Ref.: Delteil 235 ii/ii, Adhémar 240, Adriani-Wittrock 217 ii/ii

1972:50-125

(219)

HOMMAGE À MOLIÈRE, 1897

Program for Théâtre Antoine production of *Le bien d'autrui* and *Hors les lois* by Emile Fabre, Louis Marsolleau and Arthur Byl

Lithograph printed in green, text in blue, on wove paper
Image: 9 x 8¼ inches (229 x 210 mm)
Sheet: 12½ x 9⅝ inches (317 x 245 mm)
Monogrammed on the stone, ctr.r.

Ref.: Delteil 220 ii/iii; Adhémar 272; Adriani-Wittrock 240 iii/iii

1972:50-124

(220)

YVETTE GUILBERT, 1898

Frontispiece for the portfolio *Yvette Guilbert* with intro-duction by Arthur Byl

Lithograph printed in black on laid paper
Image: 11¾ x 9¾ inches (298 x 248 mm)
Sheet: 19⅝ x 14¾ inches (499 x 375 mm)
Signed in pencil, l.l.: T-Lautrec; signed on the stone, l.r.: T-Lautrec; monogrammed on the stone, l.l.; titled on the stone, u.l.: Yvette Guilbert

Publisher: Bliss and Sands, London

Ref.: Delteil 251, Adhémar 307, Adriani-Wittrock 256

1972:50-126

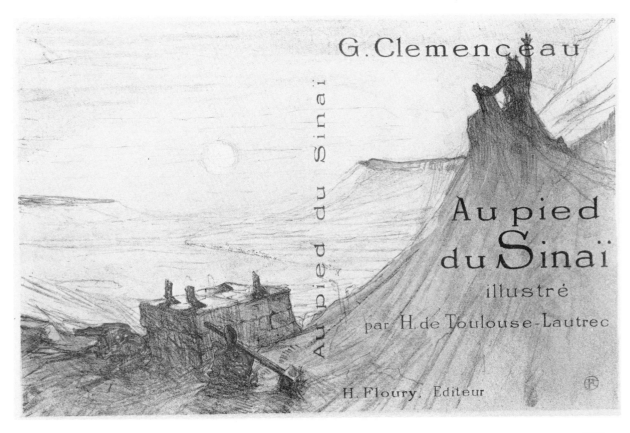

(218)

(221)

CLÉO DE MÉRODE, 1898

For the suite *Treize lithographies*, thirteen portraits of actors and actresses

Lithograph printed in black on japan paper

Image: 11 3/8 x 9 1/2 inches (289 x 241 mm)

Sheet: 15 3/8 x 12 1/2 inches (391 x 318 mm)

Monogrammed on the stone, l.l.

Ref.: Delteil 152; Adhémar 174; Adriani-Wittrock 268

1972:50-114

(222)

LUCIEN GUITRY, 1898

For the suite *Treize lithographies*, thirteen portraits of actors and actresses

Lithograph printed in black on china paper

Image: 11 1/4 x 9 inches (286 x 229 mm)

Sheet: 15 3/8 x 12 7/16 inches (391 x 316 mm)

Monogrammed on the stone, l.l.

Ref.: Delteil 155; Adhémar 177; Adriani-Wittrock 271

1972:50-115

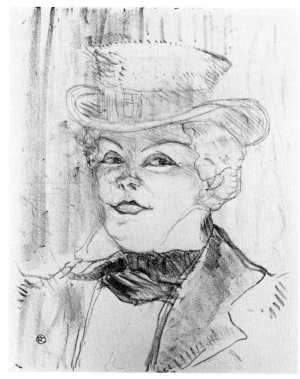

(223)

(223)

MME RÉJANE, 1898
Lithograph printed in black on wove paper
Image: 11⅝ x 9¼ inches (296 x 236 mm)
Sheet: 17 x 12¹⁵/₁₆ inches (432 x 327 mm)
Monogrammed on the stone, l.l.
Ref.: Delteil 266, Adhémar 57, Adriani-Wittrock 285
1972:50-127

(224)

AU HANNETON, 1898
Lithograph printed in black on wove paper
Image: 13¹⁵/₁₆ x 10⅛ inches (352 x 257 mm)
Sheet: 15½ x 11⁷/₁₆ inches (394 x 290 mm)
Signed in pencil, l.r.: T-Lautrec; monogrammed on the

stone, l.r.; number stamped in black ink, l.r.: 92
Publisher: Boussod, Manzi and Joyant, Paris
Edition: 100 impressions
Ref.: Delteil 272; Adhémar 290; Adriani-Wittrock 310
1978:1-51

(225)

MME LE MARGOUIN, MODISTE, 1899-1900
Lithograph printed in black on wove paper
Image: 12⁷/₁₆ x 9⁹/₁₆ inches (316 x 243 mm)
Sheet: 18⅛ x 13¼ inches (461 x 336 mm)
Monogrammed on the stone, u.l.
Edition: 40 impressions
Ref.: Delteil 325; Adhémar 370; Adriani-Wittrock 362
1978:1-52

(226)

YVETTE GUILBERT, 1930
Portfolio of nine lithographs printed in color on wove
paper, printed from the stones drawn in 1898
Sheets: 19 x 14 inches (482 x 351 mm)
Signed and numbered on the verso of title page in ink:
54 Yvette Guilbert
Publisher: Ernest, Brown & Phillips, London
Edition: 82 impressions

226:1 SUR LA SCÈNE, 1898
Lithograph printed in red
Image: 11¾ x 9½ inches (298 x 241 mm)
Ref.: Delteil 252; Adhémar 308; Adriani-Wittrock
257 iii/iii
1972:50-131[a]

226:2 LA GLU, 1898
Lithograph printed in red
Image: 11⁹/₁₆ x 9⁹/₁₆ inches (294 x 242 mm)
Ref.: Delteil 253; Adhémar 309; Adriani-Wittrock
258 iii/iii
1972:50-131[b]

226:3 PESSIMA, 1898
Lithograph printed in purple
Image: 11 11/16 x 9 1/2 inches (296 x 241 mm)
Ref.: Delteil 254; Adhémar 310; Adriani-Wittrock
259 iii/iii
1972:50-131[c]

226:4 A MÉNILMONTANT, DE BRUANT, 1898
Lithograph printed in red
Image: 11 11/16 x 9 1/2 inches (296 x 241 mm)
Ref.: Delteil 255; Adhémar 311; Adriani-Wittrock
260 iii/iii
1972:50-131[d]

226:5 CHANSON ANCIENNE, 1898
Lithograph printed in green
Image: 11 11/16 x 9 1/2 inches (296 x 241 mm)
Ref.: Delteil 257; Adhémar 313; Adriani-Wittrock
261 iii/iii
1972:50-131[e]

226:6 SOÛLARDE, 1898
Lithograph printed in green
Image: 11 5/8 x 9 1/2 inches (295 x 241 mm)
Ref.: Delteil 258; Adhémar 314; Adriani-Wittrock
262 iii/iii
1972:50-131[f]

226:7 LINGER, LONGER, LOO, 1898
Lithograph printed in purple
Image: 11 3/4 x 9 9/16 inches (298 x 242 mm)
Ref.: Delteil 259; Adhémar 315; Adriani-Wittrock
263 iii/iii
1972:50-131[g]

226:8 SALUANT LE PUBLIC, 1898
Lithograph printed in green
Image: 11 11/16 x 9 1/2 inches (296 x 241 mm)

Ref.: Delteil 260; Adhémar 316; Adriani-Wittrock
264 iii/iii
1972:50-131[h]

226:9 A LA RAMPE, 1898
Lithograph printed in purple
Image: 11 11/16 x 9 5/8 inches (296 x 244 mm)
Ref.: Delteil 251; (Frontispiece); Adhémar 307;
Adriani-Wittrock 256 iii/iii
1972:50-131[i]

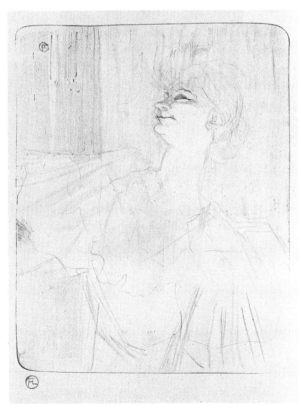

(226:4)

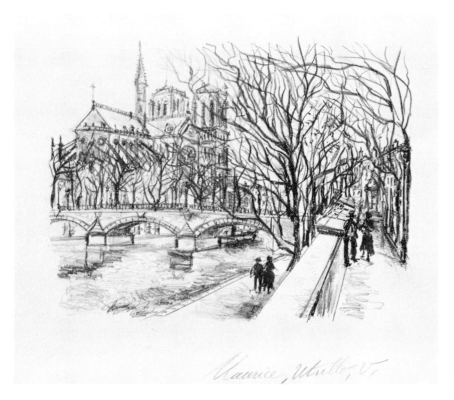

(228)

After Henri de Toulouse-Lautrec

(227)

ELLES. ELF FARBIGE LITHOGRAPHIEN IN FAKSIMILE-REPRODUKTION

Portfolio of eleven photographic reproductions printed in color on wove paper

Sheets: 23¼ x 18⅛ inches (590 x 460 mm)

Publisher: R. Piper & Co., Munich and Leipzig

Edition: 311 (12 copies (A-L) issued with one original lithograph, 50 copies on japan paper issued with two original drawings, 250 copies on holland paper); copy no. B

1972:50-130[a-k]

Note: Femme couchée *was acquired with this volume; see no. 216.*

Maurice Utrillo 1883-1955

(228)

NOTRE-DAME, PARIS, 1924

For *Album Utrillo* in the series *Maîtres et petits-maîtres d'aujourd'hui*

Lithograph printed in black on china paper, proof

Image: 6¾ x 8⅞ inches (171 x 225 mm)

Sheet: 12¾ x 9½ inches (324 x 495 mm)

Signed in pencil, l.r.: Maurice, Utrillo, V; stamped in black, l.l., indicating proof of first state (Lugt, *Suppl.,* 2921[c] and 2921[b])

Publisher: Galerie des Peintres-Graveurs (Edmond Frapier), Paris

Edition: 125 impressions (deluxe edition of 25, ordinary edition of 100)

1972:50-132

Suzanne Valadon 1867-1938

(229)

FEMMES NUES SOUS LES ARBRES, 1904
Soft-ground etching printed in brown on wove paper
Plate: 9⁷⁄₁₆ x 8⁷⁄₈ inches (240 x 226 mm)
Sheet: 13½ x 12³⁄₁₆ inches (343 x 310 mm)
Signed and dated in pencil, l.r.: Suzanne Valadon; signed
and dated in the plate (in reverse), l.r.: S. Valadon / 1904
Ref.: Pétridès E9
1972:50-134

(230)

FEMMES NUES SOUS LES ARBRES, 1904
Soft-ground etching printed in black on Rives wove
paper
Plate: 9⁷⁄₁₆ x 9 inches (240 x 229 mm)
Sheet: 18⅛ x 14¼ inches (461 x 362 mm)
Signed in pencil, l.r.: Suzanne Valadon; signed and dated
in the plate (in reverse), l.r.: S. Valadon / 1904
Printer: Jean-Gabriel Daragnès, Paris, 1932
Ref.: Pétridès E9
1972:50-135

(231)

GRAND-MÈRE ET LOUISE NUE ASSISE PAR TERRE, 1910
Aquatint and drypoint printed in black on Rives wove
paper
Plate: 10¹³⁄₁₆ x 9⅜ inches (274 x 239 mm)
Sheet: 18¹⁄₁₆ x 14½ inches (459 x 369 mm)
Signed in pencil, l.r.: Suzanne Valadon; signed and dated
in the plate (in reverse), l.r.: Suzanne Valadon 1910
Printer: Jean-Gabriel Daragnès, Paris, 1932
Ref.: Pétridès E17
1972:50-136

(232)

TOILETTE DES ENFANTS DANS LE JARDIN, 1910
Aquatint and drypoint printed in black on Rives wove
paper

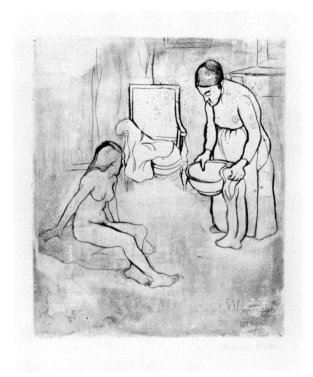

(231)

Plate: 13¹¹⁄₁₆ x 15⁷⁄₁₆ inches (348 x 392 mm)
Sheet: 17⅜ x 21⅜ inches (442 x 542 mm)
Signed in pencil, l.r.: Suzanne Valadon; signed and dated
in the plate (in reverse), l.r.: Suzanne Valadon / 1910
Printer: Jean-Gabriel Daragnès, Paris, 1932
Ref.: Pétridès E19
1976:18-76

(233)

PORTRAIT DE MAURICE UTRILLO, 1928
Lithograph printed in two colors on china paper
Image: 8⁷⁄₈ x 7 inches (225 x 178 mm)
Sheet: 12½ x 9½ inches (317 x 242 mm)
Signed and dated on the stone, l.l.: Suzanne Valadon /
1928
Ref.: Pétridès E26
1976:18-75

Jacques Villon 1875-1963

(234)

LE CAKE-WALK DES PETITES FILLES, 1904

Aquatint and drypoint printed in at least five colors on wove paper

Plate: 12 x 16½ inches (305 x 420 mm)

Sheet: 16⅝ x 23⅜ inches (422 x 594 mm)

Signed in pencil, l.r.: Jacques Villon; numbered in pencil,

l.l.: no 6; blind stamp, l.r.: ED SAGOT / Editeur / PARIS (Lugt 2254)

Publisher: Edmond-Honoré Sagot, Paris

Edition: 30 impressions

Ref.: Auberty-Perrussaux 56 ii/ii; Ginestet-Pouillon E102 iv/iv

1972:50-137

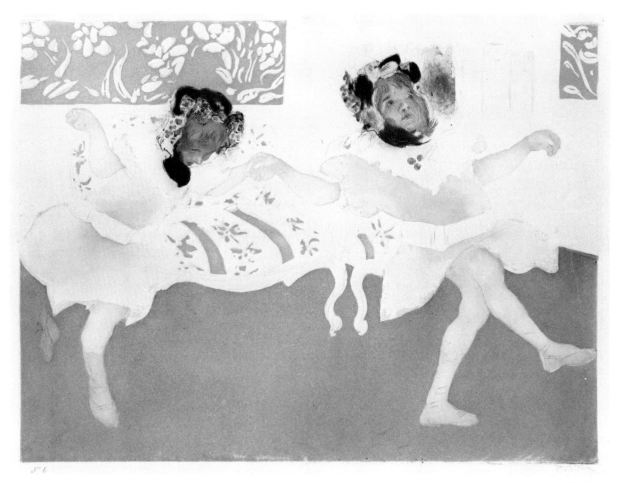

(234)

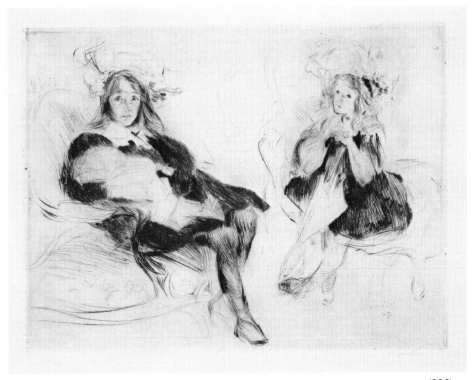

(235)

(235)

EN VISITE, 1905

Drypoint printed in black on wove paper, proof before color

Plate: 11⅞ x 15¹³⁄₁₆ inches (301 x 402 mm)

Sheet: 15⅞ x 23¼ inches (403 x 591 mm)

Signed in pencil, l.r.: Jacques Villon; numbered in pencil, l.l.: no. 11; signed and dated in the plate, l.r.: Jacques Villon / 05

Ref.: Auberty-Perrussaux 68 i/ii; Ginestet-Pouillon E131 ii/iii

1975:50-138

(236)

JEUNE FILLE, VUE DE DOS, 1906

Etching and aquatint printed in green on laid paper

Plate: 6½ x 4¼ inches (165 x 109 mm)

Sheet: 14¼ x 10¹⁵⁄₁₆ inches (361 x 279 mm)

Signed in pencil, l.r.: Jacques Villon; signed and dated in the plate, l.l.: Jacques Villon / 06; blind stamp, l.r.: ED SAGOT / Editeur / PARIS (Lugt 2254)

Publisher: Edmond-Honoré Sagot, Paris

Edition: 50 impressions

Ref.: Auberty-Perrussaux 99 ii/ii; Ginestet-Pouillon E155 vi/vi

1972:50-139

(237)

LES FEMMES DE THRACE, 1907

Etching printed in black on laid paper

Plate: 8⁹⁄₁₆ x 6⁹⁄₁₆ inches (218 x 167 mm)

Sheet: 10 1/16 x 8 3/4 inches (256 x 222 mm)
Signed in pencil, l.r.: Jacques Villon; numbered in pencil,
l.l.: 20/30; signed in the plate, l.l.: Jacques Villon
Edition: 30 impressions
Ref.: Auberty-Perrussaux 119; Ginestet-Pouillon
E205 ii/ii
1972:50-140

(238)
PORTRAIT OF E.D., 1913
Etching and drypoint printed in black on laid paper
Plate: 9 1/4 x 6 15/16 inches (235 x 161 mm)
Sheet: 12 3/4 x 9 3/4 inches (323 x 247 mm)
Signed in pencil, l.r.: Jacques Villon; numbered in pencil
and black crayon, l.l.: 19/25; inscribed in pencil, not in
the artist's hand, l.ctr.: . . . [?] Earl L. Cushman
Edition: 25 impressions
Ref.: Auberty-Perrussaux 191; Ginestet-Pouillon E277
1972:50:141

(239)
UNTITLED, 1953
For Virgil, *Les bucoliques,* plate 2
Two lithographs printed in seven colors on one sheet of
Arches wove paper
Image (left): 3 11/16 x 4 1/8 inches (94 x 105 mm)
Image (right): 7 13/16 x 6 11/16 inches (198 x 170 mm)
Sheet: 15 1/16 x 22 3/8 inches (382 x 569 mm)
Signed in pencil, l.r.: Jacques Villon
Printer: Mourlot Frères (Jean Célestin), Paris
Publisher: Scripta & Picta, Paris
Edition: the book was issued in 269 copies (245 on
Arches wove paper; 24 on japan *nacré* with a suite of
lithographs printed in black and in color); there were
also 35 suites of the lithographs only, printed in color
on Arches wove
Ref.: Ginestet-Pouillon E556
1972:50-142
Note: see SCMA, Modern illustrated books, *35 (Les
bucoliques).*

Maurice Vlaminck 1876-1958

(240)
UNTITLED, 1926
For Raymond Radiguet, *Le diable au corps,* plate 8
Lithograph printed in black on china paper
Image: 10 3/4 x 8 1/8 inches (272 x 206 mm)
Sheet: 11 7/16 x 9 1/2 inches (291 x 242 mm)
Printer: Marcel Seheur, Paris
Publisher: Marcel Seheur, Paris
Edition: the book was issued in 345 copies (25 on
Shizuoka japan paper with a suite on china, 320 on
Arches wove paper, including 20 *hors commerce*)
Ref.: Walterskirchen 198[b]
1972:50-143
Note: see SCMA, Modern illustrated books, *36 (Le
diable au corps).*

After Maurice Vlaminck

(241)
NOTRE PAIN QUOTIDIEN, 1963
Portfolio of twenty reproductions with an essay by
Georges Duhamel. The portfolio includes seven helio-
gravures (five after etchings and drypoints, two after
drawings) printed in brown on hand-made laid paper
(Richard de Bas) and thirteen photo-offset lithographs
(after watercolors, gouaches and ink drawings), one
printed in brown on wove paper, three printed in black
on wove paper, nine printed in color with additional
hand coloring on wove paper.
Sheets (heliogravures): 20 1/8 x 15 1/8 inches
(511 x 384 mm)
Sheets (offset lithographs): 21 3/16 x 16 7/8 inches
(538 x 429 mm)
Printer: Daniel Jacomet, Paris
Publisher: Aux Depens d'un Amateur, Paris, and Boston
Book and Art Shop, Boston
Edition: 250 numbered copies (1-50 on hand-made laid
paper with a suite of 7 heliogravures, 51-250 on Rives
wove paper); copy no. 22
1976:18-144

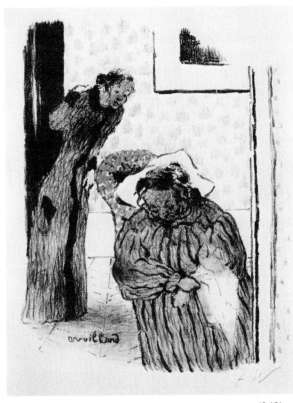

(242)

Edouard Vuillard 1868-1940

(242)

LA CONVALESCENCE, 1893

For *L'Estampe originale*, album no. I

Lithograph printed in two colors on wove paper

Image: 11⅜ x 9 inches (289 x 228 mm)

Sheet: 18¼ x 15⅝ inches (464 x 397 mm)

Initialed and numbered in pencil, l.r.: 7 EV; signed on the stone, l.l.: evuillard

Printer: Edw. Ancourt, Paris

Publisher: André Marty, Paris

Edition: 100 impressions

Ref.: Roger-Marx 2 ii/ii

1976:18-77

(243)

ROSMERSHOLM, 1893

Program for Théâtre de l'Oeuvre production of the play by Henrik Ibsen

Lithograph printed in black on light brown wove paper

Image: 8¼ x 12¼ inches (210 x 310 mm)

Sheet: 9¾ x 12⅞ inches (247 x 327 mm)

Initialed on the stone, l.l.: ev

Ref.: Roger-Marx 16

1972:50-144

Note: Miss Erving's collection includes six of the ten programs Vuillard made for Théâtre de l'Oeuvre. See nos. 243-247, 251. Rosmersholm *was the premier production of Aurélien Lugne-Poë's new theater. Under Vuillard's direction, Pierre Bonnard and Paul Sérusier designed the sets for* Rosmersholm *which opened 6 October 1893.*

(244)

AMES SOLITAIRES; *LA REVUE BLANCHE* TRANSFORMÉE, 1893

Program for Théâtre de l'Oeuvre production of the play by Gerhart Hauptmann with an advertisement for *La revue blanche*

Two lithographs printed in black on one sheet of wove paper

Image *(Ames solitaires)*: 12⅝ x 9⅝ inches (320 x 245 mm); image *(La revue blanche)*: 12¾ x 9⅜ inches (323 x 238 mm)

Sheet: 12¹⁵⁄₁₆ x 19¼ inches (328 x 490 mm)

Initialed on the stone, l.r. of each image: ev [left]; EV [right]

Ref.: Roger-Marx 19

1984:10-78

(245)

AU-DESSUS DES FORCES HUMAINES; L'ARAIGNÉE DE CRISTAL; LISEZ *LA REVUE BLANCHE*, 1894

Program for Théâtre de l'Oeuvre production of plays by Bjornstjerne Bjornson and Mme Rachild with an advertisement for *La revue blanche*

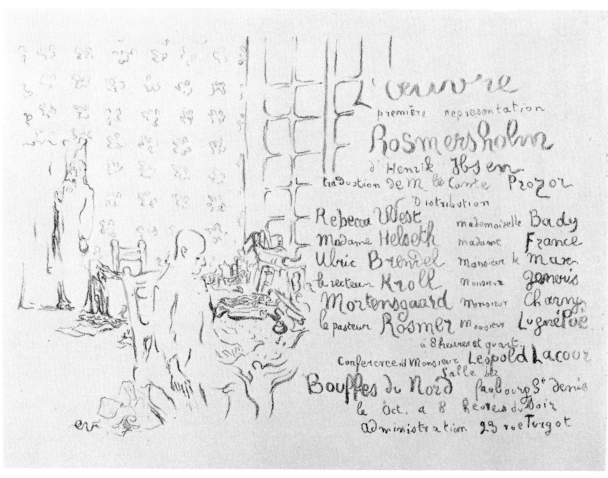

(243)

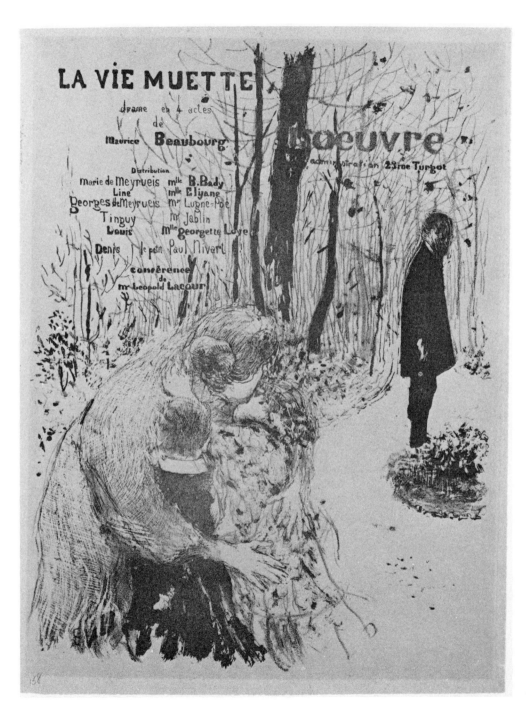

(246)

Two lithographs printed in black on one sheet of wove paper
Image (*Au-dessus des forces humaines*): 12 x 9¼ inches (305 x 235 mm); image (*La revue blanche*): 11⅞ x 9⅛ inches (301 x 232 mm)
Sheet: 12⅞ x 18⅞ inches (327 x 480 mm)
Ref.: Roger-Marx 18
1984:10-77

(246)
LA VIE MUETTE, 1894
Program for Théâtre de l'Oeuvre production of the play by Maurice Beaubourg
Lithograph printed in green-black on brown wove paper
Image: 12⅜ x 9⅜ inches (310 x 235 mm)
Sheet: 13¹/₁₆ x 9⅞ inches (332 x 251 mm)
Signed on the stone, l.l.: EV
Ref.: Roger-Marx 20
1976:18-24

(247)
UNE NUIT D'AVRIL À CÉOS; L'IMAGE; LISEZ *LA REVUE BLANCHE*, 1894
Program for Théâtre de l'Oeuvre production of the plays by Gabriel Trarieux and Maurice Beaubourg with an advertisement for *La revue blanche*
Two lithographs printed in black on one sheet of wove paper
Image (*Une nuit . . . ; L'Image*): 12¼ x 9¼ inches (311 x 235 mm); image (*La revue blanche*): 12¼ x 9⅜ inches (310 x 238 mm)
Sheet: 12⅞ x 18⅞ inches (327 x 480 mm)
Ref.: Roger-Marx 22 ii/ii
1984:10-80

(248)
LA COUTURIÈRE, ca. 1894
Lithograph printed in three colors (blue, orange, green) on wove paper, proof with hand-coloring and pencil additions

Sheet (trimmed to image): 9⅞ x 6⅝ inches (251 x 168 mm)
Signed on the stone, l.l.: ev
Ref.: Roger-Marx 13 ii/iv
1976:18-78
Note: The third state of this lithograph was published in La revue blanche, *January 1894, and the fourth state was issued in* L' Album de la revue blanche, *1895, in an edition of 100.*

(249)
INTIMITÉ, ca. 1895
Lithograph printed in black on wove paper

(248)

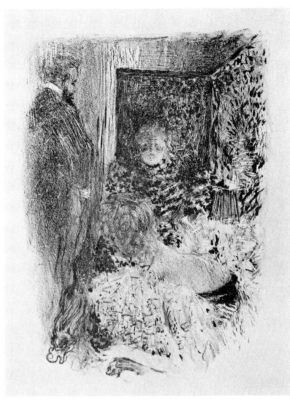

(249)

Image: 10¼ x 7⅝ inches (260 x 193 mm)
Sheet: 15⅜ x 11⁷⁄₁₆ inches (391 x 290 mm)
Signed on the stone, l.l.: EV
Edition: approximately 30-40 impressions
Ref.: Roger-Marx 10
1976:18-79

(250)
LES TUILERIES, 1895
For the album *L'Oeuvre*
Lithograph printed in black on japan paper
Image: 9½ x 10⅝ inches (245 x 271 mm)
Sheet: 13½ x 16⅝ inches (343 x 423 mm)
Initialed on the stone, l.r.: EV

Edition: 100 impressions
Ref.: Roger-Marx 27
1976:18-83

(251)
LES SOUTIENS DE LA SOCIÉTÉ, 1896
Program for Théâtre de l'Oeuvre production of the play
by Henrik Ibsen
Lithograph printed in black on wove paper
Image: 12⅜ x 19½ inches (311 x 495 mm)
Sheet: 12¹³⁄₁₆ x 19¾ inches (325 x 502 mm)
Signed on the stone (scratched in), l.r.: E Vuillard
Ref.: Roger-Marx 24 iii/iii
1984:10-79

(252)
LE JARDIN DES TUILERIES, 1896
For *L'Album des peintres-graveurs*
Lithograph printed in four colors on wove paper
Image: 12³⁄₁₆ x 17⅛ inches (314 x 435 mm)
Sheet: 16 x 22⅝ inches (408 x 575 mm)
Printer: Auguste Clot, Paris
Publisher: Ambroise Vollard, Paris
Edition: 100 impressions
Ref.: Roger-Marx 28 ii/ii
1978:1-53

(253)
JEUX D'ENFANTS, 1897
For *L'Album d'estampes originales de la Galerie Vollard*
Lithograph printed in four colors on wove paper
Image: 12¼ x 17½ inches (310 x 445 mm)
Sheet: 16¾ x 21⁹⁄₁₆ inches (426 x 549 mm)
Printer: Auguste Clot, Paris
Publisher: Ambroise Vollard, Paris
Edition: 100 impressions
Ref.: Roger-Marx 29 iii/iii
1978:1-54

(254)

COVER FOR THE SUITE *PAYSAGES ET INTÉRIEURS*, 1899

Lithograph printed in three colors on china paper
Image: 20¼ x 15⅜ inches (515 x 391 mm)
Sheet: 23⁵⁄₁₆ x 17¼ inches (593 x 440 mm)
Printer: Auguste Clot, Paris
Publisher: Ambroise Vollard, Paris
Edition: 100 impressions
Ref.: Roger-Marx 31
1978:1-55

(255)

LA PARTIE DE DAMES, 1899

For the suite *Paysages et intérieurs*

Lithograph printed in four colors on china paper
Image: 13 x 10¼ inches (330 x 260 mm)
Sheet: 13⅞ x 11⅛ inches (354 x 281 mm)

Printer: Auguste Clot, Paris
Publisher: Ambroise Vollard, Paris
Edition: 100 impressions
Ref.: Roger-Marx 32 iii/iii
1978:1-56

(256)

L'AVENUE, 1899

For the suite *Paysages et intérieurs*

Lithograph printed in six colors on china paper
Image: 12⁵⁄₁₆ x 16½ inches (312 x 420 mm)
Sheet: 13⅛ x 17¾ inches (334 x 456 mm)

Printer: Auguste Clot, Paris
Publisher: Ambroise Vollard, Paris
Edition: 100 impressions
Ref.: Roger-Marx 33 ii/ii
1978:1-57

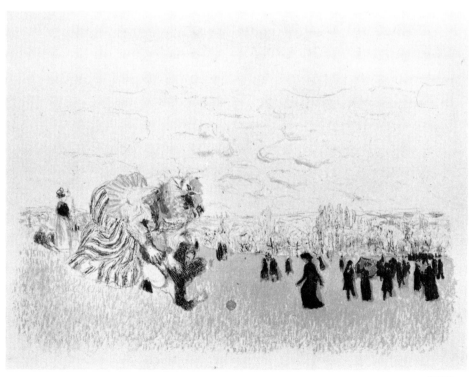

(253)

(257)

(257)

INTÉRIEUR AUX TENTURES ROSES II & I, 1899

Two proofs for the suite *Paysages et intérieurs* printed in color on one sheet of proofing paper

II. Lithograph printed in seven colors (pink, red, maroon, yellow, green, gray-green and blue)
Image: 13⅝ x 10⅞ inches (346 x 276 mm)
I. Lithograph printed in six colors (pink, red, maroon, yellow, gray-green and blue)
Image: 13⅝ x 10¾ inches (347 x 272 mm)
Sheet: 15⁹/₁₆ x 23¹⁵/₁₆ inches (396 x 609 mm)
Partially erased and illegible inscription in pencil, l.r.

Printer: Auguste Clot, Paris

Ref.: Roger-Marx 37 i/ii and 36 i/iv

1978:1-58

(258)

INTÉRIEUR AUX TENTURES ROSES III, 1899

For the suite *Paysages et intérieurs*

Lithograph printed in five colors on china paper
Image: 13⅜ x 10⅝ inches (340 x 270 mm)
Sheet: 15⁵/₁₆ x 14 inches (389 x 355 mm)

Printer: Auguste Clot, Paris

Publisher: Ambroise Vollard, Paris

Edition: 100 impressions

Ref.: Roger-Marx 38 ii/ii

1978:1-59

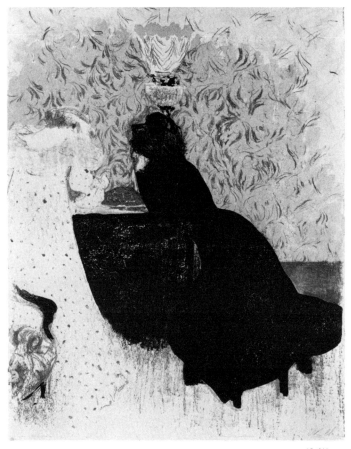

(261)

(259)

L' ATRE, 1899

For the suite *Paysages et intérieurs*

Lithograph printed in five colors on china paper

Image: 13⅝ x 11 inches (346 x 279 mm)

Sheet: 13¾ x 11¼ inches (349 x 286 mm)

Printer: Auguste Clot, Paris

Publisher: Ambroise Vollard, Paris

Edition: 100 impressions

Ref.: Roger-Marx 39 ii/ii

1978:1-60

(260)

LA CUISINIÈRE, 1899

For the suite *Paysages et intérieurs*

Lithograph printed in five colors on china paper

Image: 14½ x 11 inches (369 x 280 mm)

Sheet: 17⅛ x 11⅜ inches (433 x 289 mm)

Printer: Auguste Clot, Paris

Publisher: Ambroise Vollard, Paris

Edition: 100 impressions

Ref.: Roger-Marx 42 ii/ii

1978:1-61

(261)

LES DEUX BELLES-SOEURS, 1899

For the suite *Paysages et intérieurs*

Lithograph printed in four colors on china paper

Image: 13⅞ x 11 inches (357 x 279 mm)

Sheet: 14⅜ x 11⅝ inches (365 x 295 mm)

Signed in pencil, l.r.: EVuillard

Printer: Auguste Clot, Paris

Publisher: Ambroise Vollard, Paris

Edition: 100 impressions

Ref.: Roger-Marx 43 iii/iii

1978:1-62

(262)

LA NAISSANCE D'ANNETTE, ca. 1899

Lithograph printed in six colors on china paper

Image: 15¹⁵⁄₁₆ x 21 inches (405 x 533 mm)

Sheet: 16¹⁵⁄₁₆ x 22 inches (431 x 571 mm)

Signed in pencil, l.r.: EV

Printer: Auguste Clot, Paris

Publisher: Ambroise Vollard, Paris

Ref.: Roger-Marx 44 ii/iii

1978:1-63

(263)

LE JARDIN DEVANT L'ATELIER, 1899

For the album *Germinal*

Lithograph printed in eight colors on china paper

Image: 24¹³⁄₁₆ x 18⁷⁄₁₆ inches (631 x 469 mm)

Sheet: 26⅝ x 20⁷⁄₁₆ inches (677 x 519 mm)

Signed in pencil, l.l.: EVuillard

Publisher: Julius Meier-Graefe, Paris

Edition: 100 impressions

Ref.: Roger-Marx 45 ii/ii

1978:1-64

(264)

PAUL LÉAUTAUD, ca. 1934

Lithograph printed in black on china paper, proof

Image: 7⅝ x 5½ inches (193 x 140 mm)

Sheet: 15 x 11 inches (381 x 280 mm)

Signed on the stone, l.r.: E. Vuillard

Printer: Auguste Clot, Paris

Edition: 175 impressions

Ref.: Roger-Marx 60 iii/iii; Garvey, *Artist and the book,* 317 *(Amour)*

1976:18-20

Note: Printed in brown, this portrait appeared as the frontispiece to Léautaud's book Amour *(Paris, Editions Spirale, 1934).*

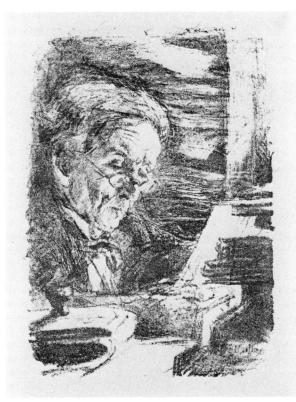

(264)

(265)

LE SQUARE VINTIMILLE, 1937

From *Paris 1937*

Etching and drypoint printed in black on wove paper

Sheet: 13 x 9⅞ inches (331 x 251 mm)

Signed on the plate, l.r.: E Vuillard

Printer: Jean-Gabriel Darangès, Paris

Edition: 500 impressions

Ref.: Roger-Marx 66 iii/iv

1976:18-81

Note: see SCMA, Modern illustrated books, *39*
(Paris 1937)

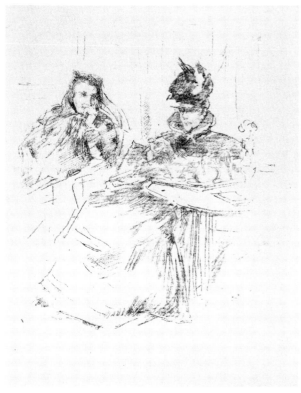

(266)

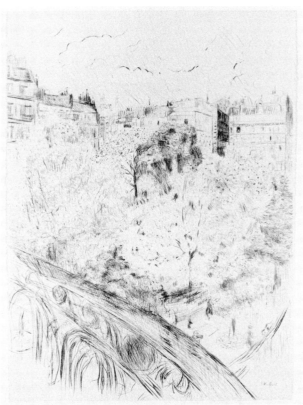

(265)

James Abbott McNeill Whistler
1834-1903

(266)

AFTERNOON TEA, 1897

For *L'Album d'estampes originales de la Galerie Vollard*

Transfer lithograph printed in black on china paper

Image: 7¼ x 6¼ inches (184 x 159 mm)

Sheet: 10 x 7¼ inches (254 x 184 mm)

Printer: Auguste Clot, Paris

Publisher: Ambroise Vollard, Paris

Edition: 100 numbered impressions on japan paper plus
several trial proofs

Ref.: Way 147

1984:10-81

Books

Henri de Toulouse-Lautrec
1864-1901

(267)

Yvette Guilbert, 1894

Gustave Geffroy

Cover-title page, 19f. incl. sixteen lithographs printed in green on wove paper, lithographed cover printed in black

Page size: 15 x 15 inches (381 x 381 mm)

Signed and numbered in green crayon on verso of flyleaf:

34 / Yvette Guilbert

Printer: Edw. Ancourt, Paris

Publisher: L'Estampe originale (André Marty), Paris

Edition: 100 impressions

Ref.: Delteil 79-95 ii/ii; Adhémar 86-102; Adriani-Wittrock 77-93 ii/ii; Garvey, *Artist and the book*, 301 *(Yvette Guilbert)*

1972:50-109

(267) (267)

EIA! EIA!

ARCHIMÈDE, *du plus loin.*
Hélène, es-tu l'étoile ? Es-tu la catastrophe ? N'approche
pas, mystère trop rapide. Ne tente pas les bords où tu n'es pas

11

(268)

After Pablo Picasso 1881-1973

(268)
HÉLÈNE CHEZ ARCHIMÈDE, 1955
André Suarès
198 p. incl. twenty-two wood engravings printed in
black after drawings by Picasso
Page size: 17^{15}/$_{16}$ x 12^{13}/$_{16}$ inches (440 x 325 mm)
Blockcutter: Georges Aubert, Paris

Printer: Marthe Fequet and Pierre Baudier, Paris
Publisher: Nouveau Cercle Parisien du Livre, Paris
Edition: 240 numbered copies (I-C for the trade; 1-140
reserved for members of the Nouveau Cercle Parisien).
Copy no. XXIX.
Ref.: Rauche 80; Horodisch B22
1975:24-3

Bibliography

The following selected bibliography is intended to supplement that found in *The Selma Erving collection: modern illustrated books*. References are not repeated except where essential to the description and understanding of the prints catalogued in this volume.

Pierre BONNARD
Bouvet, Francis. *Bonnard; l'oeuvre gravé*. Paris, 1981 (English translation by Jane Brenton: *Bonnard; the complete graphic work, London, 1981*).
Fermiger, André. *Pierre Bonnard*. London, 1970.
Johnson, Una E. "Lithographs of Pierre Bonnard; with a list of prints in the Museum," *Brooklyn Museum bulletin*, v.11, no. 2 (1950), 1-9.
Roger-Marx, Claude. *Bonnard lithographie*. Monte Carlo, 1952.
Rouir, Eugène. "Lithographs by Bonnard," *Print collector*, no. 3 (1973), 8-23.
Waldfogel, Melvin. "Bonnard and Vuillard as lithographers," *The Minneapolis Institute of Arts bulletin*, v.52, no. 1 (1963), 67-80.

Eugène BOUDIN
Alexandre, Arsène. *L'Oeuvre d'Eugène Boudin*. Paris, 1899.
Melot, Michel. *Les grands graveurs*. Paris, 1978 (English translation by Robert Erich Wolf: *Graphic art of the pre-impressionists*, New York, 1980).
Schmit, Robert. *Eugène Boudin 1824-1898*. Paris, 1973.

Georges BRAQUE
Engelberts, Edwin. *Georges Braque: oeuvre graphique original* [exh. cat.]. Geneva, Musée d'Art et d'Histoire, 1958.
Hofmann, Werner. *Georges Braque: das graphische Werk*. Stuttgart [1961] (English translation: *Georges Braque: his graphic work*, New York, 1961).
Vallier, Dora. *Braque: l'oeuvre gravé, catalogue raisonné*. [Paris] 1982.

Mary CASSATT
Breeskin, Adelyn D. *The graphic work of Mary Cassatt, a catalogue raisonné*. New York, 1948 (2nd rev. ed.: *Mary Casatt: a catalogue raisonné of the graphic work*, Washington, 1979).
Hale, Nancy. *Mary Cassatt*. Garden City, New York, 1975.
Mathews, Nancy Mowll. *Cassatt and her circle: selected letters*. New York, 1984.
Sweet, Frederick A. *Miss Mary Cassatt, impressionist from Pennsylvania*. Norman, Oklahoma, 1966.

Paul CÉZANNE
Cherpin, Jean. *L'Oeuvre gravé de Cézanne*. Marseilles, Arts et Livres de Provence, Bulletin no. 82, 1972.
Druick, Douglas. "Cézanne's lithographs," *Cézanne: the late work* [exh. cat.]. New York, The Museum of Modern Art, 1977.
Rewald, John. *Paul Cézanne: a biography*. New York, 1968.
Venturi, Lionello. *Cézanne, son art-son oeuvre*. Paris, 1936.
Vollard, Ambroise. *Paul Cézanne*. Paris, 1914 (English translation by H. L. Van Doren: *Paul Cézanne, his life and art*, New York, 1923).

Marc CHAGALL
Kornfeld, Eberhard W. *Verzeichnis der Kupferstiche Radierungen und Holzschnitte von Marc Chagall*. Bern, 1970.

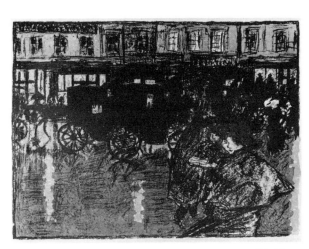

(12:11)

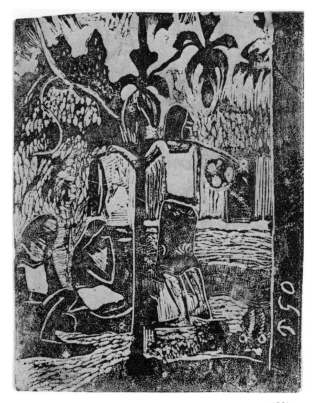

(59)

Mourlot, Fernand, and Charles Sorlier. *Chagall lithographe.* 5v. Monte Carlo and Paris, 1960-84 (English translation: *The lithographs of Chagall, 1927-1979.* 5v. New York and Boston, 1960-84).

Sorlier, Charles, ed. *Chagall's posters: a catalogue raisonné.* New York, 1974.

Sorlier, Charles. *Marc Chagall et Ambroise Vollard. Catalogue complet des gravures executées par Marc Chagall à la demande de Ambroise Vollard.* Paris, 1981.

Underhill, Elizabeth. "Marc Chagall prints 1922-1927," *Print quarterly,* v.1, no. 4, 272-276.

Edgar DEGAS

Adhémar, Jean, and Françoise Cachin. *Degas: the complete etchings, lithographs and monotypes.* New York, 1975.

Delteil, Loys. *Edgar Degas. Le peintre-graveur illustré, XIX^e et XX^e siècles.* v.9. Paris, 1919.

Galerie Manzi-Joyant, Paris. *Catalogue des eaux-fortes, vernis-mous, aquatintes, lithographies et monotypes par Edgar Degas et provenant de son atelier.* Paris, 1918.

Janis, Eugenia Parry. *Degas monotype* [exh. cat.]. Cambridge, Massachusetts, Fogg Art Museum, 1968.

Reed, Sue Welsh, and Barbara Stern Shapiro. *Edgar Degas. The painter as printmaker* [exh. cat.]. Boston, Museum of Fine Arts; Philadelphia Museum of Art; and London, Hayward Gallery, 1984-85.

Maurice DENIS

Cailler, Pierre. *Catalogue raisonné de l'oeuvre gravé et lithographié de Maurice Denis.* Geneva, 1968.

Henri FANTIN-LATOUR

Bénédite, Léonce. *L'Oeuvre lithographique de Fantin-Latour; collection complète de ses lithographies, reproduites et réduites en fac-similé.* Paris, 1907.

Druick, Douglas, and Michel Hoog. *Fantin-Latour* [exh. cat.]. Paris, Grand Palais; Ottawa, National Gallery of Canada; and San Francisco, California Palace of the Legion of Honor; 1983.

Fantin-Latour, Victoria. *Catalogue de l'oeuvre complet (1849-1904) de Fantin-Latour.* Paris, 1911.

Hédiard, Germain, and Léonce Bénédite. *Fantin-Latour; catalogue de l'oeuvre lithographié du maître.* Paris, 1906.

Mason, Rainer Michael. *Fantin-Latour, toute la lithographie* [exh. cat.]. Geneva, Cabinet des Estampes du Musée d'Art et d'Histoire, 1980.

Jean-Louis FORAIN

Faxon, Alicia Craig. *Jean-Louis Forain. A catalogue raisonné of the prints.* New York, 1982.

Guérin, Marcel. *J. L. Forain, aquafortiste: catalogue raisonné de l'oeuvre gravé.* 2v. Paris, 1912.

Paul GAUGUIN

Alexandre, Arsène. *Paul Gauguin, sa vie et le sens de son oeuvre.* Paris, 1930.

Field, Richard S. "Gauguin's woodcuts; some sources and meanings," *Gauguin and exotic art* [exh. cat.]. Philadelphia, The University Museum, University of Pennsylvania, 1969.

Gray, Christopher. *Sculpture and ceramics of Paul Gauguin.* Baltimore, 1963.

Guérin, Marcel. *L'Oeuvre gravé de Gauguin*. 2v. Paris, 1927.

Morice, Charles. *Paul Gauguin*. Paris, 1919.

Sýkorova, Livuše. *Gauguin woodcuts*. London, 1963.

Juan GRIS

Gaya-Nuno, Juan Antonio. *Juan Gris*. Boston, 1975.

Kahnweiler, Daniel-Henry. *Juan Gris; sa vie, son oeuvre, ses écrits*. Paris, 1968 (German edition: Juan Gris: *Leben und Werk*, Stuttgart, 1968; English translation by Douglas Cooper: *Juan Gris, his life and work*, New York, 1969).

Childe HASSAM

Clayton, Leonard. *Handbook of the complete set of etchings and drypoints, with 25 illustrations, of Childe Hassam, N.A.* New York, 1933.

Cortissoz, R. *The etchings and dry-points of Childe Hassam, N.A.* New York, 1925.

New York, The Metropolitan Museum of Art. *Childe Hassam as Printmaker* [exh. cat.]. Introduction by David W. Kiehl. New York, 1977.

Zigrosser, Carl. *Childe Hassam*. New York, 1916.

Paul KLEE

Annandale-on-Hudson, Milton and Sally Avery Center for the Arts, Bard College. *The graphic legacy of Paul Klee* [exh. cat.]. Annandale-on-Hudson, 1983.

Fryberger, Betsy G. *In celebration of Paul Klee 1879-1940* [exh. cat.]. Stanford University Museum of Art, 1979.

Grohmann, Will. *Paul Klee*. New York, 1955.

Kornfeld, Eberhard W. *Verzeichnis des graphischen Werkes von Klee*. Bern, 1963.

Käthe KOLLWITZ

Klipstein, August. *Käthe Kollwitz, Verzeichnis des graphischen Werkes*. Bern, 1955.

Käthe Kollwitz: Das Graphische Werk. Preface by Hans-Friedrich Geist. Essay by Friedrich Ahlers-Hestermann. Lübeck, 1967.

Sievers, Johannes. *Die Radierungen und Steindrucke von Käthe Kollwitz, innerhalb der Jahre 1890-1912*. Dresden, 1913.

Wagner, A. *Die Radierungen, Holzschnitte und Lithographien von Käthe Kollwitz; eine Zusammenstellung der seit 1912 entstandenen graphischen Arbeiten*. Dresden, 1927.

Marie LAURENCIN

Marchesseau, Daniel. *Marie Laurencin: catalogue raisonné de l'oeuvre gravé*. Tokyo, 1981.

Aristide MAILLOL

Guérin, Marcel. *Catalogue raisonné de l'oeuvre gravé et lithographié d'Aristide Maillol*. 2v. Geneva, 1965.

Rewald, John. *The woodcuts of Aristide Maillol*. New York, 1943.

Edouard MANET

Guérin, Marcel. *L'Oeuvre gravé de Manet*. Paris, 1944 (reprinted, New York, 1969).

Hanson, Anne Coffin. *Edouard Manet: 1832-1883* [exh. cat.]. Philadelphia Museum of Art, and The Art Institute of Chicago, 1966-67.

Harris, Jean C. *Edouard Manet, graphic works; a definitive catalogue raisonné*. New York, 1970.

Paris, Galeries Nationales du Grand Palais; and New York, The Metropolitan Museum of Art. *Manet 1832-1883* [exh. cat.]. New York, 1983.

Wilson, Juliet. *Edouard Manet: Das Graphische Werk: Meisterwerke aus der Bibliothèque Nationale und weiterer Sammlungen* [exh. cat.]. Ingelheim am Rhein, 1977.

Wilson, Juliet. *Manet: dessins, aquarelles, eaux-fortes, lithographies, correspondance* [exh. cat.]. Galerie Huguette Berès, Paris, 1978.

Henri MATISSE

Duthuit-Matisse, Marguerite, and Claude Duthuit. *Henri Matisse*. 2v. Paris, 1983.

Fribourg, Musée d'Art et d'Histoire. *Henri Matisse 1869-1954: gravures et lithographies* [exh. cat.]. Essay by Margrit Hahnloser-Ingold. Fribourg, 1982.

Hahnloser-Ingold, Margrit. *Henri Matisse: gravures et lithographies de 1900 à 1929*. Introduction by Hans R. Hahnloser. Pully and Bern, 1970.

Lambert, Susan. *Matisse lithographs* [exh. cat.]. London, Victoria and Albert Museum, 1972.

Edvard MUNCH

Edvard Munch: the graphic work [exh. cat.]. Preface by B. Shaw and A. Smith-Meyer. Essays by Paul Hougen and Richard Francis. Oslo, The Munch Museum, 1972.

Glaser, Curt. *Edvard Munch*. Berlin, 1917.

Heller, Reinhold. *Munch. His life and work*. Chicago, 1984.

Oberlin, Allen Memorial Art Museum. *The prints of Ed-vard Munch: mirror of his life* [exh. cat.]. Oberlin, Ohio, 1983.

Prelinger, Elizabeth. *Edvard Munch: master printmaker,* [exh. cat.]. New York and London, 1983.

Schiefler, Gustav. *Edvard Munch; das graphische Werk 1906-1926.* Berlin [1928?].

Timm, Werner. *The graphic art of Edvard Munch.* Greenwich, Connecticut, 1969.

Willoch, Sigurd. *Edvard Munchs raderinger.* Oslo, 1950. (English translation, *Edvard Munch etchings.* Oslo, 1950).

Pablo PICASSO

Baer, Brigitte. *Picasso the printmaker: graphics from the Marina Picasso collection* [exh. cat.]. Dallas, Museum of Art, 1983.

Bloch, Georges. *Pablo Picasso: catalogue de l'oeuvre gravé et lithographié.* 3v. Bern [1968-].

Czwiklitzer, Christopher. *Picasso's posters.* New York and Paris, 1970.

Fox, Milton S. *Picasso for Vollard.* New York, 1956.

Geiser, Bernhard. *Picasso, peintre-graveur, catalogue illustré de l'oeuvre gravé et lithographié, 1899-1931.* 2v. Bern, 1933-68.

Goeppert, Sebastian, Herma Goeppert-Frank, and Patrick Cramer. *Pablo Picasso, the illustrated books: catalogue raisonné.* Geneva, 1983.

Horodisch, Abraham. *Pablo Picasso als Buchkünstler.* Frankfurt a.M., 1957. (Expanded trans. by I. Grafe, *Picasso as a book artist,* London and Cleveland [1962]).

Los Angeles County Museum of Art. *Picasso: sixty years of graphic works* [exh. cat.]. Preface by Ebria Feinblatt. Forewords by Daniel-Henry Kahnweiler and Bernhard Geiser. Los Angeles [1966].

Mourlot, Fernand. *Picasso lithographe.* 4v. Monte Carlo [1949-56].

New York, Museum of Modern Art. *Pablo Picasso* [exh. cat.]. Edited by William Rubin. New York, 1980.

Wallen, Burr. *Picasso aquatints* [exh. cat.]. St. Petersburg, Museum of Fine Arts, 1984.

Camille PISSARRO

Cailac, Jean. "The prints of Camille Pissarro; a supplement to the catalogue by Loys Delteil," *Print collector's quarterly,* 19 (1932), 74-86.

Delteil, Loys. *Camille Pissarro. Le peintre-graveur illustré, XIX^e et XX^e siècles.* v.17. Paris, 1923.

Shapiro, Barbara S. *Camille Pissarro: the impressionist printmaker* [exh. cat.]. Boston, Museum of Fine Arts, 1973.

Shapiro, Barbara S. "Prints," *Camille Pissarro 1830-1903* [exh. cat.]. London, Hayward Gallery; Paris, Grand Palais; and Boston, Museum of Fine Arts, 1980-81.

Shikes, Ralph E., and Paula Harper. *Pissarro; his life and work.* New York, 1980.

Jean-François RAFFAËLLI

Alexandre, Arsène. *Jean-François Raffaëlli, peintre, graveur et sculpteur.* Paris, 1909.

Delteil, Loys. *Jean-François Raffaëlli. Le peintre-graveur illustré, XIX^e et XX^e siècles.* v.16. Paris, 1923.

Fields, Barbara Schinman. *Jean-François Raffaëlli (1850-1924): the naturalist artist* [unpublished dissertation]. New York, Columbia University, 1979.

Odilon REDON

Mellerio, André. *Odilon Redon.* Paris, 1913.

New York, The Museum of Modern Art; and The Art Institute of Chicago. *Odilon Redon. Gustave Moreau. Rodolphe Bresdin* [exh. cat.]. Essays by John Rewald, Harold Joachim, and Dore Ashton. New York and Chicago, 1962.

Pierre Auguste RENOIR

Delteil, Loys. *Auguste Renoir. Le peintre-graveur illustré, XIX^e et XX^e siècles.* v.17. Paris, 1923.

Roger-Marx, Claude. *Les lithographies de Renoir.* Monte Carlo, 1951.

Stella, Joseph G. *The graphic art of Renoir.* New York, 1975.

White, Barbara Ehrlich. *Renoir. His life, art, and letters.* New York, 1984.

Diego RIVERA

South Hadley, Mount Holyoke College Museum of Art. *Grabados Mexicanos: an historical exhibition of Mexican graphics 1839-1974* [exh. cat.]. South Hadley, 1975.

Wolfe, B. D. *Diego Rivera: his life and times.* London, 1939.

Zigrossser, Carl. "Mexican graphic art," *The print collector's quarterly,* v. 23 (1936), 65-82.

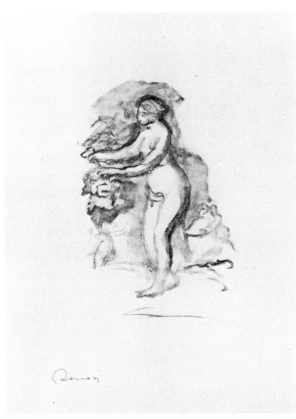

(157:10)

Georges ROUAULT

Chapon, François, and Isabelle Rouault. *Rouault oeuvre gravé.* Monte Carlo, 1978.

Wofsy, Alan. *Georges Rouault: the graphic work.* London, 1976.

Paul SIGNAC

Cachin, Françoise. *Paul Signac.* Greenwich, Connecticut, 1971.

Kornfeld, E. W., and Peter Wick. *Catalogue raisonné de l'oeuvre gravé et lithographié de Paul Signac.* Bern, 1974.

Alfred SISLEY

Delteil, Loys. *Alfred Sisley. Le peintre-graveur illustré, XIXᵉ et XXᵉ siècles.* v.17. Paris, 1923.

Théophile-Alexandre STEINLEN

Cate, Phillip Dennis, and Susan Gill. *Théophile-Alexandre Steinlen* [exh. cat.]. The Jane Voorhees Zimmerli Art Gallery, Rutgers University, New Brunswick, 1982 [published by Gibbs M. Smith, Inc., Salt Lake City].

Clément-Janin. "Steinlen," *Print collector's quarterly,* v.18 (1931), 33-55.

Crauzat, Ernest de. *L'Oeuvre gravé et lithographié de Steinlen.* Paris, 1913.

Gill, Susan. *Théophile Steinlen: a study of his graphic art 1881-1900* [unpublished dissertation]. New York, City University of New York, 1982.

Jan TOOROP

Amsterdam, Rijksmuseum. *De grafiek van Jan Toorop* [exh. cat.]. Catalogue by J. Verbeck, essay by Bettina Spaanstra-Polak. Amsterdam, 1969.

Polak, Bettina. *Het fin-de-siècle in de Nederlandse schilderkunst; de symbolistische beweging 1890-1900.* The Hague, 1955.

Henri de TOULOUSE-LAUTREC

Adhémar, Jean. *Toulouse-Lautrec: his complete lithographs and drypoints.* New York, 1965.

Adriani, Gotz, and Wolfgang Wittrock. *Toulouse-Lautrec: das Gesamte Graphische Werke* [exh. cat.]. Kunsthalle, Tübingen, 1976.

Delteil, Loys. *H. de Toulouse-Lautrec. Le peintre-graveur illustré, XIXᵉ et XXᵉ siecles,* v.10-11. Paris, 1920.

Dortu, M.G. *Toulouse-Lautrec et son oeuvre,* 6v. New York, 1971.

Joyant, Maurice. *Henri de Toulouse-Lautrec: dessins, estampes, affiches.* 2v. Paris, 1926-27.

Knoedler and Co., New York. *Toulouse-Lautrec, 1864-1901, his lithographic work* [exh. cat.]. New York, 1950.

Schimmel, Herbert D., and Phillip D. Cate. *The Henri de Toulouse-Lautrec, W. H. B. Sands Correspondence.* New York, 1983.

Thompson, Richard. *Toulouse-Lautrec.* London, 1977.

Wick, Peter. *Toulouse-Lautrec book-covers and brochures* [exh. cat.]. Cambridge, Massachusetts, Department of Printing and Graphic Arts, Harvard University, 1972.

Maurice UTRILLO

Beachboard, Robert. *La trinité maudite; [Valadon, Utter, Utrillo].* Paris [1952].

Fabris, Jean. *Utrillo, sa vie, son oeuvre* [Paris, 1982].
Tabarant, Adolphe. *Utrillo*. Paris, 1926.

Suzanne VALADON
Beachboard, Robert. *La trinité maudite; [Valadon, Utter, Utrillo]*. Paris [1952].
Pétrides, Paul. *L'Oeuvre complet de Suzanne Valadon*. Paris, 1971.

Jacques VILLON
Auberty, Jacqueline, and Charles Perusseaux. *Jacque Villon. Catalogue de son oeuvre gravé*. Paris, 1950.
Ginestet, Colette de, and Catherine Pouillon. *Jacques Villon; les estampes et les illustrations*. [Paris, 1980].
Goldschmidt, Lucien, Inc., New York. *Jacques Villon; a collection of graphic work 1896-1913 in rare or unique impressions* [exh. cat.]. New York, 1970.
Light, R. M. & Co., and Helene C. Seiferheld Gallery, Inc., New York. *Jacques Villon; master printmaker* [exh. cat.]. Introduction by Francis Steegmuller. New York, 1964.

Maurice de VLAMINCK
Walterskirchen, Katalin von. *Maurice de Vlaminck: Verzeichnis des graphischen Werkes*. Bern, 1974.

Edouard VUILLARD
Marguery, Henri. *Les lithographies de Vuillard*. Paris, 1935.
Roger-Marx, Claude. *L'Oeuvre gravé de Vuillard*. Monte Carlo, 1952.

James Abbott McNeill WHISTLER
Levy, Mervyn. *Whistler lithographs. A catalogue raisonné*. London, 1975.
Lochnan, Katharine A. *The etchings of James McNeill Whistler* [exh. cat.]. New York, The Metropolitan Museum of Art; and Toronto, The Art Gallery of Ontario [publ. by Yale University Press, New Haven and London], 1984-85.
Lochnan, Katharine A. "Whistler and the transfer lithograph: a lithograph with a verdict," *The print collector's newsletter*. v.12, no. 5 (1981), 133-7.
Pennell, Elizabeth Robins. *The life of James McNeill Whistler*. 2v. 3rd ed. London, 1909.
Way, Thomas R. *Mr. Whistler's lithographs. The catalogue compiled by T. R. Way*. London, 1896.

GENERAL
Adhémar, Jean. *L'Estampe française. La lithographie en France au XIXe siècle*. Paris [1942].
Adhémar, Jean. *La gravure originale au XXe siècle*. Paris, 1967 (English translation by Eveline Hart: *Twentieth century graphics*, New York and Washington, 1971).
Adhémar, Jean, Michele Hérbert, and Jacques Lethève. *Les estampes*. Paris, 1973.
Antreasian, Garo, and Clinton Adams. *The Tamarind book of lithography: art and techniques*. New York, 1971.
The avant-garde in theatre and art: French playbills of the 1890s [cat. of exh. circulated by the Smithsonian Institution Traveling Exhibition Service]. [Washington, D.C., 1972].
Baas, Jacquelynn, and Richard S. Field. *The artistic revival of the woodcut in France 1850-1900* [exh. cat.]. Ann Arbor, University of Michigan Museum of Art; and New Haven, Yale University Art Gallery, 1984.
Bersier, Jean E. *La lithographie originale en France*. Paris, 1943.
Bouchot, Henri. *La lithographie*. Paris, 1895.
Burch, R. M. *Colour printing and colour printers*. New York, 1911.

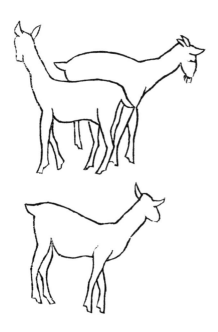

Carey, Frances, and Antony Griffiths. *From Manet to Toulouse-Lautrec: French lithographs 1860-1900* [exh. cat.] London, British Museum, 1978.

Castleman, Riva. *Prints of the twentieth century: a history.* New York, 1976.

Cate, Phillip Dennis, and Sinclair Hitchings. *The color revolution: color lithography in France 1890-1900* [exh. cat.]. New Brunswick, Rutgers University Art Gallery; and Boston Public Library, 1979.

Chapon, François. "Ambroise Vollard éditeur," *Gazette des beaux arts,* 2 parts, v.94 (1979), 33-47; v.95 (1980), 25-38.

Delteil, Loys. *Manuel de l'amateur d'estampes des XIXᵉ et XXᵉ siècles (1801-1924).* 31v. Paris, 1925.

Druick, Douglas, and Peter Zegers. *La pierre parle: lithography in France 1848-1900* [exh. booklet: text panels and labels]. Ottawa, National Gallery of Canada, 1981.

Garvey, Eleanor. *The artist and the book 1860-1960 in Western Europe and the United States* [exh. cat.]. Boston, Museum of Fine Arts; and Cambridge, Harvard College Library, 1961 (rev. ed., Boston [1972]).

Gautier, E. Paul, "Lithographs of the 'Revue blanche,' 1893-95," *Magazine of art,* v.45, no. 6 (1952), 273-78.

Groschwitz, Gustave von. "The significance of XIX century color lithography," *Gazette des beaux-arts,* v.44, no. 6 (1954), 243-66.

"The house of Mourlot," *Lithopinion,* v.3, no. 2 (1968), 28-48.

Ives, Colta Feller. *The great wave: the influence of Japanese woodcuts on French prints* [exh. cat.]. New York, The Metropolitan Museum of Art, 1974.

Johnson, Una E. *Ambroise Vollard éditeur.* New York, 1944 (rev. ed., New York, 1977).

Kovler Gallery, Chicago. *Forgotten printmakers of the 19th century* [exh. cat.]. Chicago, 1967.

Lang, Leon, and Jean E. Bersier. *La lithographie en France, des origines à 1914.* Mulhouse, 1946-52.

Laran, Jean. *L'Estampe,* 2v. Paris, 1959.

Leymarie, Jean, and Michel Melot. *Les gravures des impressionistes.* Paris, 1972 (English translation by Jane Brenton: *The graphic works of the impressionists; Manet, Pissarro, Renoir, Cézanne, Sisley,* New York, 1972).

La lithographie en France des origines à nos jours [exh. cat.]. Paris, Fondation nationale des arts graphiques et plastiques, 1982.

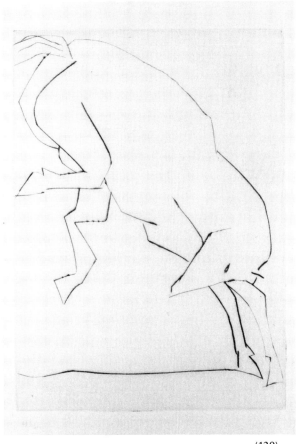

(129)

Lugt, Frits. *Les marques de collections de dessins et d'estampes.* Amsterdam, 1921.

Lugt, Frits. *Les marques de collections de dessins et d'estampes. Supplément.* The Hague, 1956.

Man, Felix H. *150 years of artists' lithography, 1803-1953.* London, 1954.

Man, Felix H. *Artists' lithographs.* New York, 1970.

Marty, André. *L'Imprimerie et les procédés de gravure au vingtième siècle.* Paris, 1906.

Mayor, A. Hyatt. *Prints and people.* New York, 1971.

Melot, Michel. *L'Estampe impressionniste* [exh. cat.]. Paris, Bibliothèque Nationale, 1974.

Melot, Michel. *Les grands graveurs.* Paris, 1978 (English translation by Robert Erich Wolf: *Graphic art of the pre-impressionists,* New York, 1980).

Melot, Michel, Antony Griffiths, Richard S. Field, and André Béguin. *Prints. History of an art.* New York, 1981.

Mourlot, Fernand. *Gravés dans ma mémoire: cinquante ans de lithographie avec Picasso, Matisse, Chagall, Braque, Miró.* Paris, 1979.

Mourlot, Fernand. *Souvenirs et portraits d'artistes.* Paris, 1973.

Munich, Staatliche Graphische Sammlung. *Bild vom Stein. Die Entwicklung der Lithogaphie von Senefelder bis heute* [exh. cat.]. Munich, 1961.

Northampton, Smith College Museum of Art. *The Selma Erving collection: modern illustrated books* [exh. cat.]. Northampton, 1977.

Passeron, Roger. *La gravure française au XXᵉ siècle.* Fribourg, 1970 (English translation by Robert Allen: *French prints of the twentieth century,* New York, Washington and London, 1970).

Passeron, Roger. *La gravure impressioniste: origines et rayonnement.* Fribourg, 1974 (English translation: *Impressionist prints,* New York, 1974).

Pennell, Joseph, and Elizabeth Robins Pennell. *Lithography and lithographers.* New York, 1898.

Porzio, Domenico, ed. *La litografia.* Milan, 1983 (English translation by Geoffrey Culverwell: *Lithography: 200 years of art, history and technique,* New York, 1983).

Roger-Marx, Claude. *La gravure originale au XIXᵉ siècle.* Paris, 1962 (English translation by E. M. Gwyer: *Graphic art of the nineteenth century,* New York, Toronto, and London, 1962).

Roger-Marx, Claude. *French original engravings from Manet to the present time.* London, Paris, and New York, 1939.

Roger-Marx, Claude. "La lithographie en couleurs," *Arts et métiers graphiques,* no. 22 (1931), 193-200.

Sachs, Paul J. *Modern prints and drawings.* New York, 1954.

Stein, Donna M., and Donald H. Karshan. *L'Estampe originale: a catalogue raisonné.* New York, 1970.

Stubbe, Wolf. *Graphic arts in the twentieth century.* New York, 1963.

Rochester, Memorial Art Gallery of the University of Rochester. *Artists of "La revue blanche"* [exh. cat.]. Essays by Bret Waller and Grace Seiberling. Rochester, 1984.

Vallotton, Maxime. *The graphic art of Vallotton and the nabis* [exh. cat.]. Chicago, Kovler Gallery, 1970.

Wallen, Burr, and Donna Stein. *The cubist print* [exh. cat.]. Santa Barbara, University Art Museum, University of California at Santa Barbara, 1981.

Weber, Wilhelm. *A history of lithography.* London, 1966.

Weber, Wilhelm. *Saxa loquuntur. Stein reden. Geschichte der Lithographie.* Heidelberg, 1961-64.

Weisberg, Gabriel, Phillip Dennis Cate, Gerald Needham, Martin Eidelberg, and William Johnston. *Japonisme. Japanese influence on French art, 1854-1910* [exh. cat.]. Cleveland, The Cleveland Museum of Art; New Brunswick, The Rutgers University Art Gallery; and Baltimore, The Walters Art Gallery, 1975.

Woimant, François. "La lithographie et les ateliers d'imprimeurs au XXᵉ siecle," *Nouvelles de l'estampe,* no. 24 (1975), 15-18.

MUSEUM VISITING COMMITTEE

Current Members
Mrs. Morton I. Sosland (Estelle Glatt '46), Chair
David S. Brooke
Charles E. Buckley
Joan Lebold Cohen '54
Priscilla Cunningham '58
Professor Colin Eisler
Barbara Jakobson (Barbara Petchesky '54)
Douglas Lewis
Dorothy C. Miller '25 (Mrs. Holger Cahill)
Elizabeth Mongan
Mrs. Raymond D. Nasher (Patsy Rabinowitz '49)
Mrs. John W. O'Boyle (Nancy Millar '52)
Mrs. James E. Pollak (Mabel Brown '27)
Sue Welsh Reed '58
Morton I. Sosland
Joanne Melniker Stern '44 (Mrs. Alfred R.)
Mrs. Charles Lincoln Taylor (Margaret R. Goldthwait '21)
Enid Silver Winslow '54
Mrs. John Wintersteen (Bernice McIlhenny '25)

Former Members
Jere Abbott: 1965-1974
W.G. Russell Allen: 1951-1955
Mrs. Leonard Brown: 1979-1983
Mrs. Malcolm G. Chace, Jr. (Beatrice Oenslager '28):
 1956-1982
Mrs. Ralph F. Colin (Georgia Talmey '28): 1951-1970
Mrs. John Cowles (Elizabeth M. Bates '22): 1951-1954
Charles C. Cunningham: 1963-1979
Mrs. Charles C. Cunningham (Eleanor A. Lamont '32):
 1951-1960
Mrs. Henry T. Curtiss (Mina Kirstein '18): 1963-1969
Dorothy Dudley (Mrs. John M. Ginnelly): 1969-1975
Selma Erving '27: 1966-1980
Ernest Gottlieb: 1956-1969
Philip Hofer: 1951-1968
Sigmund W. Kunstadter: 1976
Mrs. Sigmund W. Kunstadter (Maxine Weil '24):
 1969-1977
Mrs. Maurice Lazarus (Nancy Stix '42): 1951-1969
Stanley Marcus: 1955-1962
A. Hyatt Mayor: 1969-1977
Agnes Mongan (AM '29, LHD '41): 1951-1970
Beaumont Newhall: 1974-1977
James Thrall Soby: 1951-1979

STAFF OF THE MUSEUM

Charles Chetham, Director, Chief Curator
Betsy B. Jones, Associate Director, Curator of Painting
Kathryn Woo, Assistant Director for Administration
Christine Swenson, Associate Curator of
 Prints and Drawings
Linda Muehlig, Assistant Curator of Painting and Sculpture
Ann H. Sievers, Assistant Curator of Prints and Drawings
Michael Goodison, Archivist
David Dempsey, Preparator/Conservator
Louise Laplante, Registrar
Nancy Sojka, National Endowment for the Arts Intern
Michael Floss, National Endowment for the Arts Intern
Constance Ellis, Assistant for Membership,
 Publicity and Events
Drusilla Kuschka, Secretarial Assistant
Ann D. Johnson, Secretary/Administrative Assistant
Janice St. Laurence, Receptionist and Museum Members
 Secretary

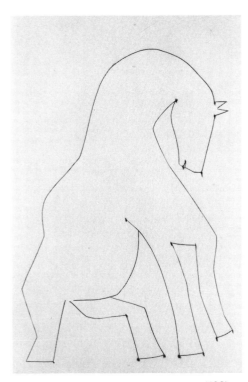

(129)

(129)